The Technique of

MOSAIC

Dedicated to
all who would put the pieces together
to make a whole

The Technique of
MOSAIC

Arthur Goodwin

with contributions by E.M. Goodwin

B.T. Batsford Ltd London

Acknowledgements

I wish to acknowledge the assistance of Exeter
College of Art & Design for facilities, and in
particular Michael Adams and the library staff.
For permission to reproduce work, thanks go to
Somerset County Museum, Taunton; Hull
Archaeological Museum; Leeds City Museum;
The British Museum; The Museum of Mankind
and The Mansell Collection. I am also grateful to
Eric Cleave and Margaret and Michael Snow
for proof reading, and to students too
numerous to mention who have participated in
workshops and group projects and to Paul
and Paula San Casciani for suggestions.

ISBN 0 7134 4551 3

Typeset by Servis Filmsetting Ltd, Manchester
and printed in Great Britain by
Anchor Brendon Ltd
Tiptree, Essex
for the publishers
B.T. Batsford Ltd
4 Fitzhardinge Street
London W1H 0AH

Contents

Illustrations

This book is an attempt to re-think and to shape
ideas about mosaics. Work by the author and
his wife is used as the most immediate source
and to establish a working communication.
Other work comes from student projects and
from history. Because mosaic is often burdened
with ancient tradition, few historic examples
have been used and the famous oft-repeated
examples have been avoided. Individual works
by Elaine and Arthur Goodwin are as follows.

A. Goodwin
10, 11, 15, 25, 26, 28, 29, 35, 37, 38, 45, 47, 50, 53,
54, 55, 58, 59, 60, 61, 69, 82, 91, 94, 103, 104, 105,
106, 107, 108, 109, 110, 111, 112, 113, 116.

E. Goodwin
12, 16, 18, 49, 50, 57, 64, 65, 67, 68, 74, 81, 83, 84,
86, 87, 88, 89, 90, 92, 93, 114, 115.

Preface

Pictures are painted, drawings are done, photographs are taken and mosaics are made. The emphasis of this book is on the making. It is a guide to practice; but the thing made is also a picture and belongs to the world of art.

Mosaic is a mid-way point between many things – between art and craft, between domestic utility and fine art, between the ancient and the modern. From such a position it can share the characteristics of a wealth of activities. It is ideal for those seeking a simple craft skill, yet it can involve aesthetic considerations of the highest order. One can be as personally involved in 'expression' as the painter and one can have the detachment of the workman doing a necessary job.

At one extreme there is the simple function of a tiled floor or table top; at the other there is the contemplative object, the picture. Somewhere between is the wealth of decoration that may surround and embellish aspects of our daily lives.

So it has been in history. There were pavements to be walked over, durable against wear and weather. There were complex patterns and symbolic images to engage the eye in dining rooms. These still surviving fragments of Roman antiquity are often the first things that come to mind at the mention of mosaics. There were also the holy icons of Byzantium, inseparable from the architecture and providing the imagery of early Christian understanding.

Mosaic is an ancient craft, perhaps much associated in our minds with museums or archaeological sites; yet it is applicable to modern situations and functional use. The technique, in one sense, is transparently obvious – you can see how it is done almost as though it were being done live before your eyes. This directness and simplicity of execution has a strong appeal to modern artists. For all its simplicity there are important questions of materials and techniques, to be answered in later pages. There are questions of style and content too, taking us into the territory of the painter and into art at all levels of experience. We may be consider-ing patterns ranging from the simplest repeating shapes to the most intricate forms of design. The most searching questions of abstract art, problems of representation and simple matters of decoration, all fall within the orbit of the mosaicist.

Mosaic can be used as a medium for all manner of styles and ideas and yet can be a simple craft. In this way it may seem more the servant of art than an art in its own right – a means of reproducing or repeating designs already drawn out in other materials. It can certainly be used in this way, but one of my aims will be to present a case for mosaic as a self-sustaining creative medium with its own distinct possibilities. The liberal and expansive nature of modern art has made us look again at many techniques and has given an open-minded approach to them all. No longer is painting confined to the use of paint alone; mixed media and collage have widened visual and conceptual possibilities, so naturally the making of pictures from pieces of glass or stone may rightly take a place among modern art techniques.

Mosaic as a means of expanding ideas about colour, form, texture and composition is a welcome addition to an educational programme. It can relate to much modern practice. But while the open situation of modern art and modern education offers so many possibilities, so the simple craftsmanship of mosaic can bring relief from too many open options. It can bring a concentration of attention in which the mind is as much involved as the hands.

The movement of the brush in painting may seem to be the ideal freedom, especially the gestural sweeps of the abstract expressionist. Yet this very freedom can spill creative energy and an excitement in dynamic movement be only brief. Slowness is the characteristic of mosaic often commented upon; it seems the very opposite of 'free' painting. Yet this very slowness brings a sustained focus of attention, giving a different kind of intensity. The mosaic picture is made knowingly, piece by piece, and there is no glossing over any part.

The process of mosaic, like that of any art, absorbs the whole person. Looking, doing, thinking, reflecting – the process becomes a complete life-style. What may be claimed for painting or sculpture may be claimed for mosaic. Yet there is a simplicity and, perhaps paradoxically, a freedom from the stylistic concerns of the apparently more liberal arts. For this reason there is a timeless quality about mosaic; it has a fundamentalism which takes us to the very essence of art – the artist being simply a maker.

It is possible to approach mosaic from any level of artistic experience. The beginner will find in it a way of artistic initiation and exploration. The experienced artist from another medium, say painting or sculpture, will find new possibilities for projecting and expanding ideas.

Apart from activity there is another aspect of any art. It is the awakening of the eye for other work and other ages. Museum exhibits, which once may have been mere illustrations to an historic age, come alive. The person who does something understands other examples of that thing in a way that the passive observer never does. The maker will look through the surface of mosaic to the creative acts that have brought them into being, and will feel an empathy with artists of other ages and no doubt want to seek out great examples of the art. The doer also becomes appreciator at a new level of awareness.

This book is addressed to all who have an inclination to make and to look. It is an invitation to the reader to enter a new and also very ancient world of ideas and activity. So, why not make a mosaic?

CHAPTER I

What is a mosaic?

Beginning at the beginning: basic experiments

As this book is concerned with making, let us begin by making. We will learn and discover by doing.

Take a piece of coloured paper – any colour, not necessarily an 'art' paper. Brown wrapping paper would be fine. Cut it with scissors into small squares – say each about 1cm (⅜in) square. They need not be exactly equal. Don't measure

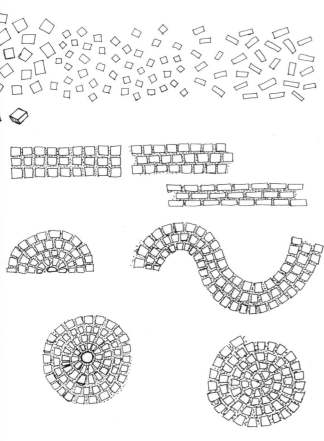

1a *Order from disorder: the basis of mosaic*

them. They should just look approximately equal. Make plenty, 50 or 60 to start, more if needed.

Now draw with them on a light surface such as a white paper background. Draw? How? By making them into lines and into a simple shape. Do no preliminary drawing with a pencil. Simply place the pieces one by one into lines. There should be no overlapping. Every piece should be separate from the others, with a small space around it.

What shall we draw? The simpler the image the better. A fish or a bird, for example – maybe a flower. The more ambitious may attempt a face. But, whatever it is, it must be simple. It must be stripped of detail. You may be capable of drawing the most complex thing with a pencil but here you must be simple. The need for simplicity is forced upon us by the nature of the material.

There are several important things to notice. For example, we can only put the pieces down one at a time. Having placed one, we move on to the next. A line, generally thought of as thin (by strict definition it should have no thickness), here becomes thick – as thick as the thickest piece. Yet it will be acceptable as a line if it moves the eye along with it. Notice that each piece is isolated by an area of surrounding background. This background may seem at first to be merely accidental – that which is left uncovered by the pieces. As we look more closely it will become an important or even an essential part of what we have done; like the white untouched areas in a drawing it is a necessary part of the whole.

Look carefully at what you have done; look carefully while you are doing it. The eye and the hand should become attuned. The placing of each piece will become important. Do not worry about getting it 'right'. The right place for each piece is the place that looks right. Do not worry if the image looks crude, childlike or 'primitive' – it will probably look all of these, indeed it should. It is primitive, being a 'prime' act. It is a right

9

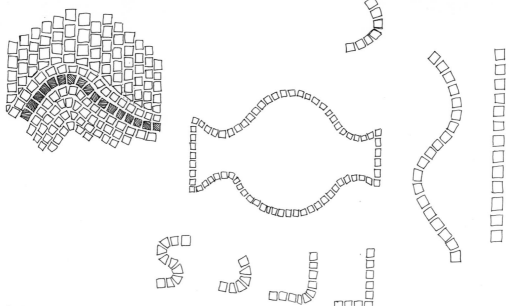

1b *Lines and directions from squares*

beginning based firmly on an understanding of materials and what they can and cannot do.

If, for example, you have chosen to make a bird, it is no use thinking of all the details of a real live bird. You can only manage to grasp those essentials of shape that will make you look and say 'bird'. It will not be a particular kind. It will not have colour or details of plumage. It will be just the simplest of shapes recalling the concept of 'bird'.

If you do several pieces of work in this way you will become acutely aware of shape, of the way in which every piece affects every other piece and of the way in which they relate to the whole – including the blank pieces of paper which you have not touched. If all this seems too simple, remember that the most involved piece of design is no different in essence from this. There may be much more of it and it may be much more complex, but whatever its size or complexity it is about shapes and relationships of shapes.

Beginning with simplicity, or returning to the simplicity of the beginner if you are already an experienced artist or craftsperson, is always good. In returning to beginnings we are going to the roots and not attempting to imitate the fruits of labour. From good roots great things may grow.

To return to the pieces of paper. A puff of wind or a jolted table may scatter them, so stick them down with some simple paper gum. Then several examples can be kept safely for the important process of looking, and the consequent process of criticism.

Criticism! Having introduced this heavily loaded word at an early stage it is necessary to clarify it. It is easier to say what, in my terms, criticism is not than what it is. It is not the judgement of our work against some pre-ordained standard – a measurement of how 'good' or 'bad' a piece of work may be. Unfortunately, criticism is often taken to mean just this, and as a result many pieces of work are condemned as 'bad' for having failed to meet 'standards'. Many works can be killed before they have had time to grow. They are killed by constant reference to some external standard without being allowed to grow from within. Mosaics, like people, are things that grow. Criticism is the realization of the uniqueness of everything. Seeing each piece as unique leads to awareness of relationships with other work. It leads to comparisons, not to show 'better' or 'worse' but to realize (i.e. to make real) each work as it is. This may sound as though there is nothing to be said by way of criticism. On the contrary, there is a great deal to be said – much more than if we are only concerned with goodness or badness, rightness or wrongness.

To return again to our pieces of paper stuck to the paper background – the more of them we do,

10

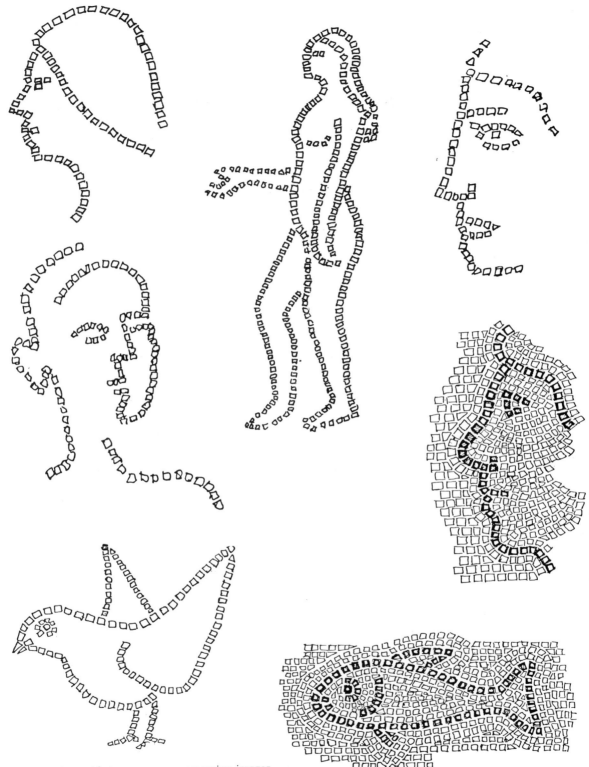

2 Drawing with tesserae: some emerging images

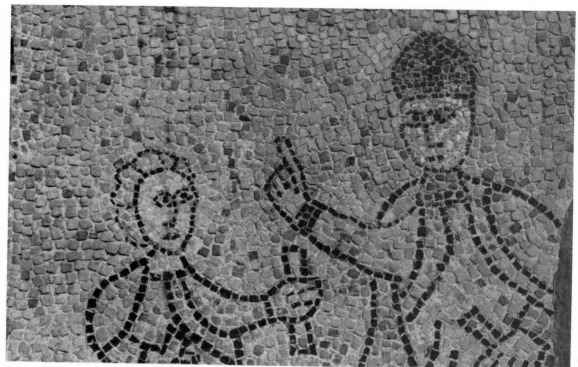

3 *Mosaic panels in the Church of San Giovanni, Ravenna*

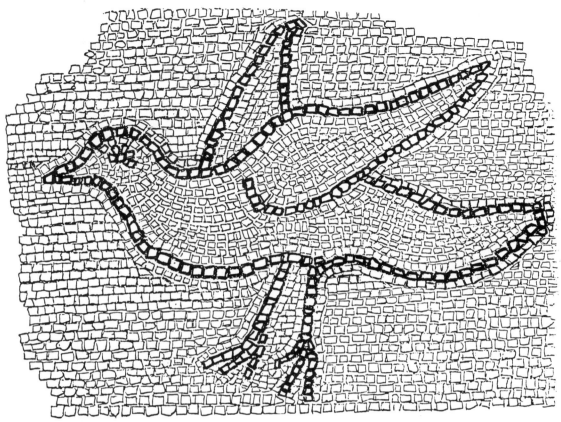

4 *Images: drawing with pieces*

the more each one will seem different from each other. Looking at them together we can compare – and prefer. We are being critical. In discovering preference we are developing a critical process of selectivity. If we are forming any standards they are at least from within and not exterior yardsticks to be measured against.

It is possible to elaborate on this paper work by using two colours plus a background – say black and white on a sheet of brown or grey ground. Now we can draw our image – bird or whatever – with the black piece in line (outline) and, having done this, fill in all the rest, the interior parts of the image as well as its surrounding areas, with the white pieces. We can continue in this way until the sheet is filled. But it will be easier, more natural and more progressive, if we move on from piece to piece instead of placing pieces anywhere at random just to fill up the space. Around the black outline of the bird, for example, we can place a surrounding line of white pieces which will follow the same direction as the black. We can add a further line outside

13

this, and so on, until there is a substantial area of white background surrounding the bird; each line will, so to speak, visually echo the original shape and reinforce it. As we get further away, correspondence with the original shape may lessen, and eventually we will have to find ways of accommodating these directional lines to the limiting edge of the paper – perhaps by gradually adjusting directions until the rectangular shape of the paper is also echoed in the directional lines of the pieces.

From the above it will be seen that the resulting picture, if so it may be called, will have a directional 'flow'. The important shape, that of the bird or chosen image, is echoed and re-echoed and so emphasized by repetition. Here is the great strength of images made in this way and the fascination of having the construction of the picture surface clearly revealed. The attention wavers between seeing the image (bird) and understanding (or reading) an orderly construction. Perhaps this is the whole appeal of mosaic. If we have begun at a humble and simple level, we have begun at the right place for an understanding of the real nature of mosaic and of the methods to follow and for any appreciative viewing.

Pebbles and mud – beauty and function

But what is mosaic? It is not usually made with paper. We can easily substitute for the paper, pieces of solid material – glass, ceramics, stones, beads, pebbles – anything which is available in a sufficient number of small pieces or units. Number is important and you will probably underestimate quantity at first. An obvious way of producing small units is by cutting them down from larger pieces, but this important process of cutting is reserved for later.

A very obvious and convenient material supply is pebbles. Again, these may not be as easy to find in convenient sizes and colours as is at first imagined. Beaches can offer the pleasure of beachcombing along with the useful practice of studio stocking; but quantity is important for a complete uncut pebble mosaic. You may be lucky and know of places with such treasure.

Let us do a pebble mosaic – for real if you have the necessary materials and conditions – in our imaginations if not.

Imagine an earthen floor, the problems of keeping it clean and the problems of mud in wet weather. Given a convenient supply of pebbles, it would be easy to press them into a mud base, thereby making the floor much more solid and durable. When dry, the pebbles would be firmly held by the dried earth, and even when wet they would probably stay put and lessen the muddiness. Some consider this to be the origin of mosaic.

If this is indeed the origin, it establishes an origin in utility and a relationship with a living environment. Certainly many of the early mosaics are to be found on floors and were made to be walked over.

If our source of pebbles, real or imaginary, includes different colours, we will most likely want to group the colours in some way. If there are two colours, then ways of putting together the groupings will be found. They can be organized into patterns. Even if we have only one colour, we will doubtless put the pebbles down in some systematic way, probably in lines following the available surface, rather than just higgledy-piggledy. A textured pattern will result even without colour.

This organizing, systematizing tendency reflects a human need. Pattern in its many forms is the reflection of mental order. Pattern is often denigrated in the visual arts to a minor position, one not claiming the full attention of, for example, a picture isolated in a frame. Yet, the ubiquitous existence of patterns refers us to a psychological necessity – a sense of ordered stability in our surroundings.

From the orderly laying down of pebbles in the mud, two needs have been fulfilled: one, the improvement of a physical condition, the pebbled surface being better to walk on than muddy earth; and two, the orderly surface is more pleasing to the eye because it endorses our preference for order over chaos.

To spell out the origins of mosaic in these elementary terms is to relate remote history to ourselves. Education is a living rediscovery of inheritance in terms of present needs – not simply the banking of information. Through it we can rediscover some of the basic needs of life, both practical and aesthetic. Perhaps this is why mosaic is often described as having a timeless quality: it can refer us to a distant past in ways which seem relevant to the present.

Carrying out the simplest exercises in placing a few pieces relative to one another (our paper pieces or pebbles) will awaken our sensibilities

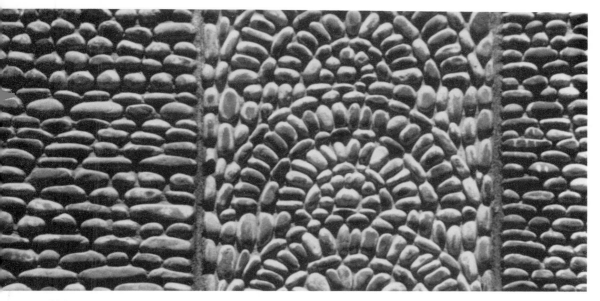

5 *Pebble patterns, the Rock Garden, Chandigarh, India*

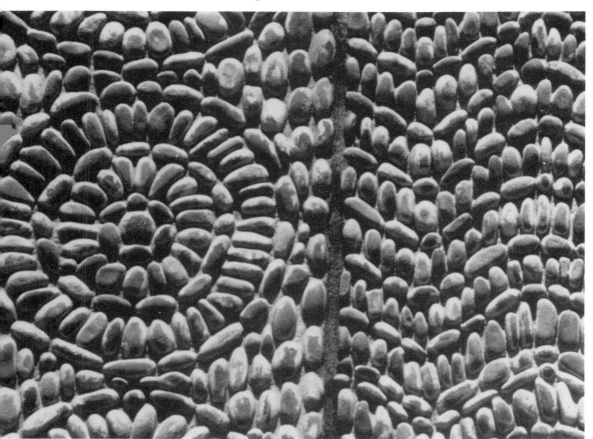

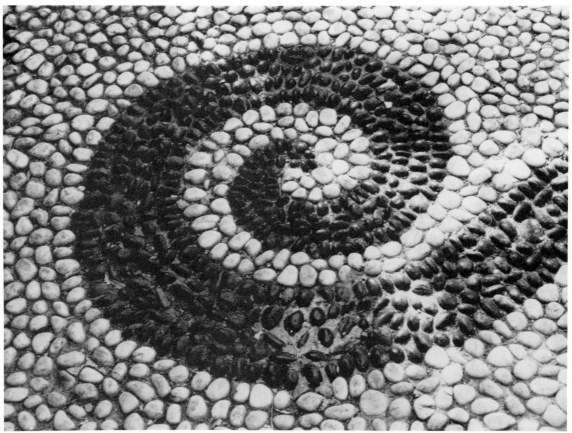

6 *Pebble patterns, Brunate, Italy*

to a number of things. We begin to discover the importance of pattern and structure at a basic level of real experience; we acquire more insight into historic examples (Why were they made? How were they made? What were they made for? etc.) and we may find analogies for our acts at other levels – for example, structure patterns in nature, cellular structure, even atomic structure, which is perhaps the most basic of all mosaics.

From speculations on historic origins and from practical experiments, we have established a base for mosaic. We see a dual aspect of it in utility and aesthetic pleasure.

Mosaic – the name

In asking the question 'What is mosaic?', the name itself can be enlightening. It is believed to have come from the Greek word for the muses.

This implies that it is inspired work, the muses being the guiding spirits of the liberal arts. The distinction between the 'liberal' arts and the 'vulgar' arts was an important one in antiquity and in the medieval world. If mosaic was admitted to the noble assembly of liberal arts, which in fact were the more theoretically based activities as distinct from the 'manual' skills, then this was to raise it above the merely praiseworthy to the status of an honourable art.

Such distinctions are meaningless to us today but at least this interpretation of the word shows an expectancy that mosaic should be inspired as well as simply utilitarian. Not only should our floor be good to walk upon, durable and clean, but it should offer access to the world of the spirit. The idea of a source of poetic imagination beneath our feet is an appealing one. The need for release into another level of awareness is clear. There is the order of pattern and there is often a pictorial image – a symbol, head, animal, bird or fish, god or goddess. So it was in much Roman

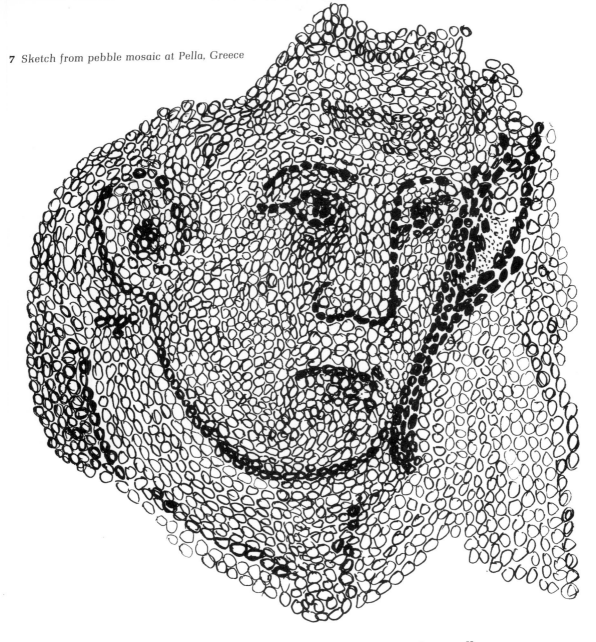

7 *Sketch from pebble mosaic at Pella, Greece*

work and so, in contrast to the laying of bricks, the setting of stones or the plastering of walls, was mosaic the work of the muses. I like to think it is still so, and the panels that we will make, if modest in scale by Roman standards, will none the less be a door for the imagination amidst all the standardized mass-produced goods of the modern world.

The great from the small

We now have a glimpse of what mosaic can mean, but what, in simple, practical terms, is it?

Surely the essential character is assembly. It is the putting together of small units to make a whole. We have used fragments of paper (for convenience) and pebbles (as consistently sized material units), but stone, ceramics or glass are the common traditional materials, and these will need cutting to shape. Two of these materials

(ceramics and glass) are manufactured, and it is possible to buy them as mosaic 'tiles', although these will generally need cutting into smaller pieces.

Smallness and regularity of the pieces is important to the character of mosaic. The smaller the piece, the finer the detail, and the more the line can approximate to a real line, as drawn or painted. If they are too small, however, they become difficult to handle and may require the use of tweezers; the work then becomes more a test of patience and application than of natural creative manipulation. There are so-called micro-mosaics, but they are usually imitative works and are sometimes mistaken for paintings.

Identification of mosaic with trials of endur-ance is a perverted understanding of the tech-nique. The question of 'How long did it take?' or 'How many pieces are in it?' — questions quite commonly asked — are foreign to genuine aes-thetic appreciation, and the dedicated artist or craftsperson is indifferent to them. True, mosaics take a long time, maybe longer than some paintings, but this is unimportant and the person doing them is unaware of time. The process is obsessive, more difficult to stop, once started, and one is carried along by it. A tedious routine as a self-imposed and painful discipline is not the way of the artist or craftsperson. There is much work to do but it is, or will become, a labour of love, not measured by the hour.

Mosaic is a making of great from small: it must proceed from point to point; it must grow; it is not instantaneous. It is the making of a large thing from small units, a kind of building, and we can, therefore, give close attention to every part. For the painter, or other picture-maker, this brings new insight into pictorial composition. We are concerned with constructing every part. There is no background which is of lesser importance, no fading off at the edges, no suggestions or acciden-tal effects. Everything must be clearly made. Because it grows slowly, you can watch over your work in mosaic more closely than in many other techniques.

If material is available in large sheets — for example, paper, glass, ceramics or marble — an obvious suggestion might be to cut down on labour and time by using larger uncut pieces. Why not cut out a whole area as a slab of colour and put this together with other pieces like pieces in a jigsaw puzzle? This is possible and indeed is done as a specific technique, as we shall

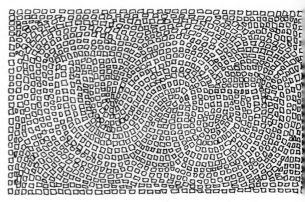

a

b

8 *Some structural patterns:* **a)** *directional variations with approximately equal units;* **b)** *variations in size and proportion on basic vertical/horizontal grid*

see later, but it is not really in character with mosaic. It would be nearer to marquetry, and would lack any of the directional structure which we get by building up with small pieces. We would not, as mosaicists, have the same intimate piece by piece contact with the image; nor, as observers, would we have the same optical fascination in texture.

If the building of the large from the small is essential for the maker of mosaic, it is also the main element seen by the observer of mosaics. The closer you get, the more you see separate pieces; the further away you are, the more you will see the overall picture or pattern — like viewing an oil painting painted with vigorous brushwork.

This dual aspect of mosaic is its real character. It enables the mosaicist to deal with each part of the design with concentrated attention. Yet each part is related to an overall scheme. The viewer is

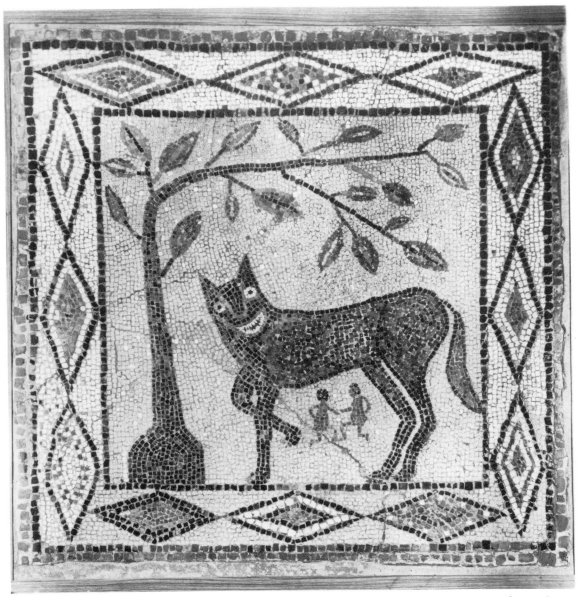

able to see and enjoy the process frankly revealed, but, by a switch of attention, or walking back from the work, is also able to take in the whole picture. Perhaps we all have a childlike enjoyment in seeing how things are made – it makes us feel as though we are making them ourselves. In mosaic we have the gratification of seeing separate parts take meaning by becoming a whole.

It is hoped that readers of this book will have this experience many times in viewing mosaics

9 *'Romulus and Remus', Romano-British mosaic, Leeds City Museum. A wonderful example of naïve drawing in terms of mosaic. The elements of Roman mosaics are present, i.e. imagery plus geometric border, but interpreted by local craftsmen who, fortunately, were not inhibited by any problems of drawing, or we would not have this delightful piece*

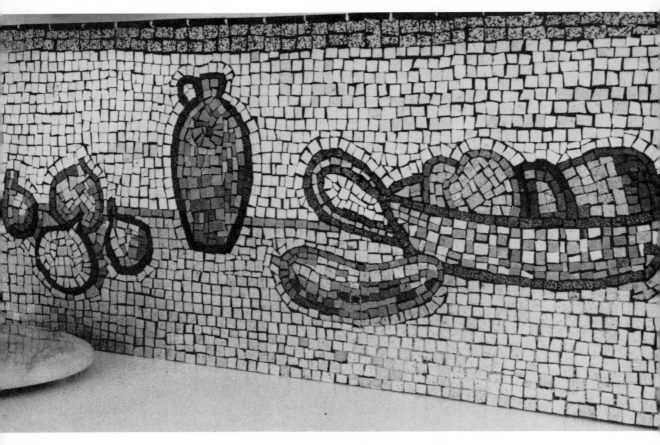

10 *Mosaic in the kitchen: a still-life panel as background to a work surface*

and, more than that, will discover it in making them.

Subjects for mosaics

What shall be the subject of our picture? A question of this importance is often answered by personal preferences – a kind of re-making of the real objects we admire – and a good enough reason. In mosaic, as we have seen, the method will make some things more suitable than others, such as simple, well-defined shapes rather than landscapes, for example.

The process can give birth to the image: the flow of mosaic structure will influence our choice. The flow in itself may be sufficiently interesting as pure pattern, and that rift between the 'figurative' and the 'abstract', which has dogged the history of modern art, hardly exists for us mosaicists. The structural qualities are abstract values, enjoyable for themselves alone. The images they are capable of conveying are pictorial and in many cases are enjoyable as evocations of their real counterparts.

But mosaics can be compartmentalized so that in one area we are responding to geometric invention while in another we look at a picture. Many great Roman schemes contain a full stylistic range from abstract inventions to portraiture. Such a variety is rare in any other medium. Following such precedents we can, not necessarily in a single piece, explore many artistic possibilities through mosaic.

Looking and doing – history and practice

Our purpose is making mosaics, but the learning process comes from an understanding of what has been done before. Much is to be learnt, therefore, from studying historic examples, par-

20

ticularly if the study is an enquiring scrutiny of specific examples. This is not the same as copying.

However, one approach to mosaic is by copying, and this is, in fact, the traditional method of the academies – the making of a piece by copying a famous example. Doing this in the location of ancient mosaic traditions has its appeal, especially when combined with the delights of a holiday, but it is educationally out-moded for a seriously intentioned modern artist. Copying is the way of the apprentice not the student. It was the way of entry into a craft, via a master with whom one might gain employment and perhaps ultimately supplant. Present day educational method and intention is totally different.

I am proposing a way of creative experiment with materials – an investigation into what can reasonably be done with what we have available and in our present conditions. We began by doing this, and consequently we are able to see how things 'work'. Far from being opposed to the use of historic examples, this method gives enormous insight into them. We go to ancient examples with understanding, reading new meaning into them and relating them to our own needs.

Scrutiny of the historic pieces may open a door onto far-ranging enquiries from how the Romans made cement to the complexities of Byzantine church history. Mosaic can be a central educational experience and my methods in no way oppose present practice against historic precedent.

Doing, looking, enquiring and learning lead back and forth because we are actively involved, and the true aims of art education – the linking of hand, eye and mind – are well served.

11 *Mosaic in the bathroom: detail from a decorative scheme*

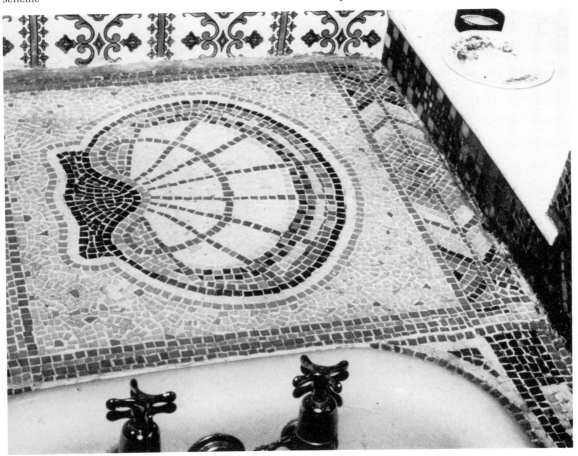

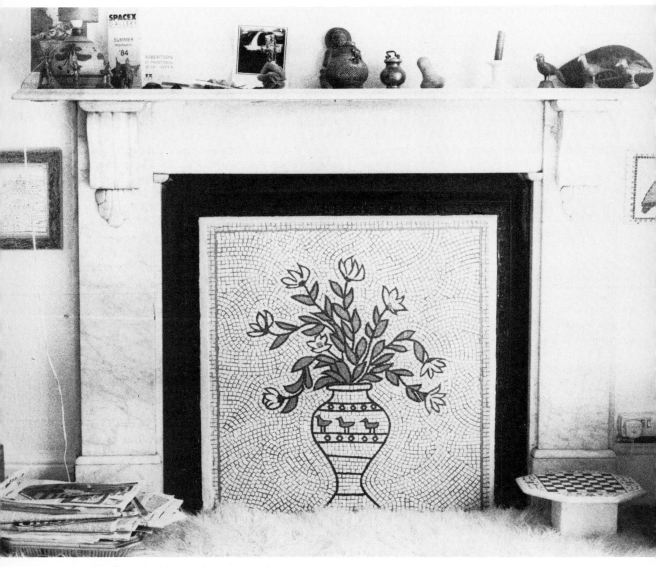

12 *Fireplace mosaic panel: a removable summer-time panel for filling an unused grate*

CHAPTER II

Methods and styles

The Romans and what we can learn from them

The greatest development of mosaic art in antiquity was from the Roman period, and for many people mosaic is almost exclusively a Roman art. This is not surprising since mosaics were made throughout the Roman Empire in great numbers and in some cases they were of great size. Many are extant and in good condition. Many more must have vanished.

The style and method of execution is remarkably consistent over widespread geographic locations. The art, craft or trade of mosaic-making must have featured large among the various building techniques. In spite of this, actual information on how to make them is sparse. Pliny has some descriptions of their manufacture, Vitruvius mentions them in his famous treatise on architecture, but otherwise we are left to scrutinize the actual examples, to deduce and speculate. We do, however, inherit a vocabulary for mosaic from the Romans.

The Roman examples have become definitive prototypes for styles, and a careful study of these examples will reveal many possible ways of handling both the physical materials and the imagery of the mosaicist.

The vocabulary of method and style

The small unit of mosaic is the *tessera*, plural *tesserae* (Latin *tessera* – a cube). Being cubes they were seen in the surface result as squares. Three-dimensionally they were not always cubic but could be long and peg-like, in which case the end of the stone peg was the visible area, but would still appear square.

The styles go under the general name *opus* (Latin – a work). The styles are listed below.

Opus tessellatum
This is the laying of tesserae in regular straight lines – as with a tessellated or tiled pavement. It is

a little like the laying of bricks, and simple ways of bonding can be achieved, i.e. having vertical divisions out of alignment while the horizontals are in straight lines. The regularity of opus tesselatum gives a sense of stability to a design.

Opus regulatum
When the vertical and horizontal lines are all in straight lines, giving a regular grid over the whole surface, it is said to be opus regulatum. Papered mosaics for commercial use are assembled and applied in this way. Many artists will find it too mechanical and lacking in expression.

Opus vermiculatum
This is the wriggling worm-like following of shapes by flowing lines (Latin *vermiculus* – a little worm). This style has great expressive possibility, and in my view it is the real essence of fine mosaics. It is like brush work in painting.

A kind of drawing unique to mosaic can be achieved by opus vermiculatum. The lines of tesserae can express the solidity of an image in the way that shading or cross-hatching might in a drawing. When fully used, the entire surface becomes expressive of the image, every part contributing to the whole effect. This style is most engaging to the eye. Work carried out in it warrants detailed scrutiny. A contrast may be formed between opus vermiculatum used, for example, on a head, and opus tesselatum on a surrounding background. The first line of tesserae in the background colour is made to follow the outline and provide a buffer between image and background. This will make an image stand out clearly.

Opus musivum
This is the use of vermiculatum over the entire area of a picture. Image and background are structurally inseparable, thus producing an excellent sense of flow.

Opus sectile
This consists of the cutting of large shapes to correspond to the actual shapes of an image. It is

13 *The basis of mosaic: the grid pattern (a student's project)*

not true mosaic but closer to inlay or marquetry. Occasional use in a work of mixed styles can be effective.

Opus palladianum
This is the use of irregularly shaped tesserae in the way in which they will most easily fit – like crazy paving. Used against the other styles it can have an invigorating effect.

Andamento
(Italian *andare* – to go) This is a term used to describe the movement of the tesserae – the flow, the way in which they are laid in the making of the mosaic and the way in which the eye eventually follows them.

Terrazzo
This is often associated with mosaic because it also utilizes stone pieces in a bed of cement. The pieces are a random mix, and the pattern is produced by grinding the surface level to show a cross section through the mixture. The pattern is entirely accidental. It may have an attractive decorative finish but it is a mechanical process linked with mosaic only by similarity of materials.

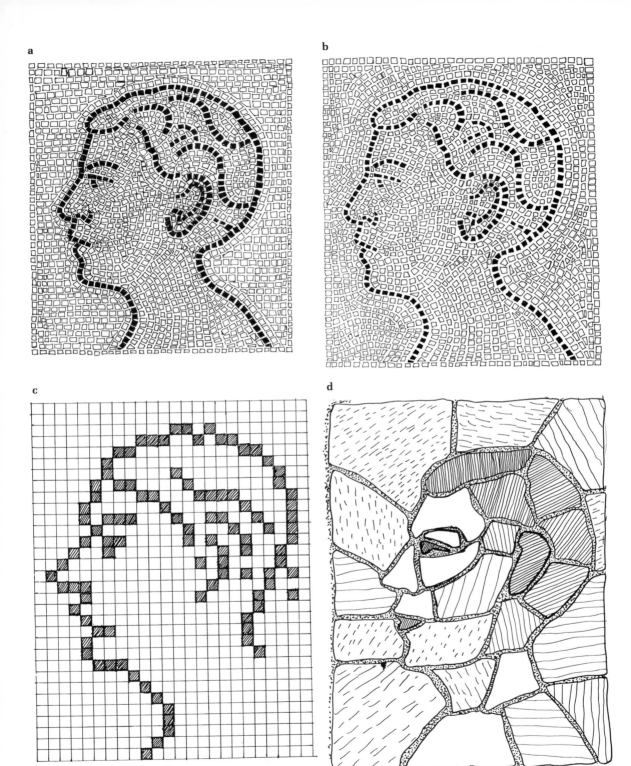

14 Four heads in mosaic: **a)** opus vermiculatum,
b) opus musivum, **c)** opus regulatum and **d)** opus
sectile

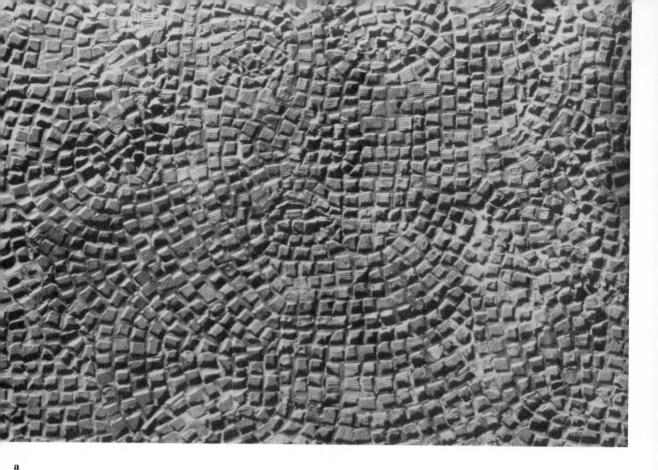

a

15a *Andamento: the flow of tesserae seen here in a cast from an incomplete mosaic*
15b *Expressive possibilities with tesserae using only shape and direction. This is the basic mosaic structure which carries colour*

b

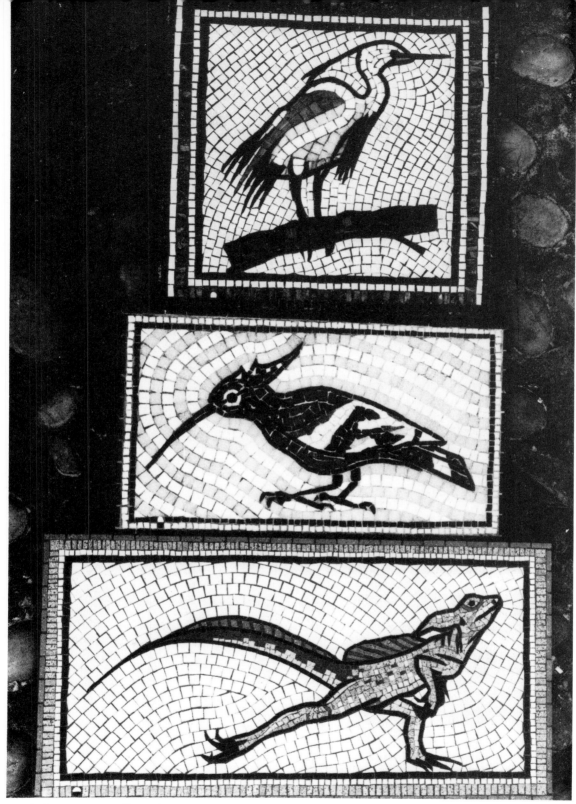

16 *Andamento in small panels: egret, hoopoe, basilisk*

17 *'Rivers'. Too many gaps aligned produce a crack-like dividing line or 'river'. Tesserae should be well interlocked*

The naming of these styles is not just a matter of antiquarian interest – it gives us an insight into important practical considerations of how to place the tesserae ourselves. The question of the structural surface pattern is, as we saw in the first chapter, central to the character of mosaic. The way in which we did the paper experiment was, in fact, opus musivum. I believe that the flowing on and echoing of contours is a very sound way of constructing mosaic and one which is visually attractive. It allows for creative improvisation and takes its form from the initial drawing of the image. Because each line of tesserae is influenced by the direction of the preceding line, the work is integrated – a truly composed piece in which all the parts belong to the whole.

There are occasions when opus tesselatum can seem appropriate to a large flat area, for a more routine infilling, or, best of all, as a sharp contrast to an area of opus vermiculatum when we want our image to stand out against a flat background.

Making the tesserae

The raw material

Roman tesserae were usually made from natural stone – at best marble. Large slabs of stone were reduced to tesserae. Today we are more likely to be faced with manufactured tiles of glass or ceramics. These are supplied for use in commercial mosaics and come in standard regular shapes. They are intended as wall cladding or floor surfacing and are often stuck on to sheets of brown paper so that they can be pressed into wet cement as manageable units – generally about 30cm (12in) square. The paper method will be considered later, but, for the present, the tiles are simply our raw material. They must be soaked off the brown paper in water, if they have been supplied prepared for use as cladding. Separately they are small tiles of standard size (usually 20mm ($\frac{3}{4}$in) squares). They could, of course, be used at this size in a big mosaic, but for most purposes they are too big. A more serious

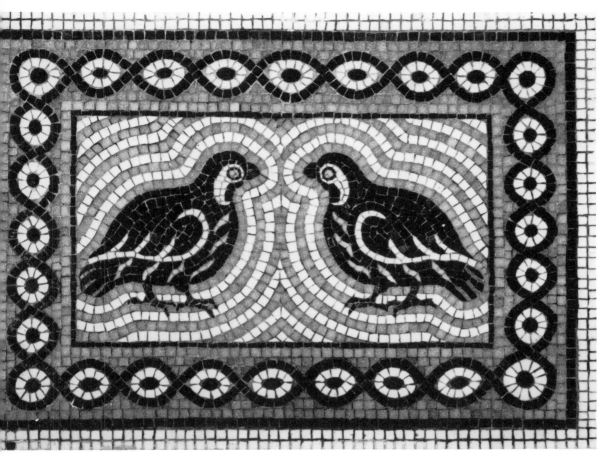

18 *Two quails: a wall panel in glass tesserae*

objection is that they are too mechanically regular, and therefore we use them as raw material to be cut down.

Cutting

Tiles can be cut down to size in two ways: by the use of a pair of nippers or by means of the hardie and hammer. The more usual modern practice is by nippers – a simple hand tool like a pair of pliers but with cross cutting edges in the jaws. Any pair of nippers can be used, such as those sold at the average tool shop for cutting and stripping electrical cable. The ones specially designed for tile or mosaic are recommended, however, because of two special features: one, they do not completely close – the jaws in fact do not need to touch in order to bring pressure on the tile; and two, a spring is incorporated be-

tween the handles, pushing them apart so that they constantly return to the open position when pressure is released. This last point is important in continuous rapid work. All you need to do is open your gripping hand and the nippers open with it. Otherwise you have to keep pulling the nippers back to the open position with the fingers – a small but irritating action in a long session of continuous work.

Cutting is achieved by squeezing the edge of a tile in the jaws of the nippers. Hold the piece of tile in the left hand, the nippers in the right (or vice versa for left-handed people), and firmly grip a very small bit of the tile. Exert pressure on the handles with the right hand. The tile will crack into two pieces. Cutting is really cracking – you are directing a crack across the tile from one edge to the other. This is why it is only necessary to grip a tiny fraction of the total width. Too much tile held in the jaws makes cutting much harder, greater pressure being required on the handles.

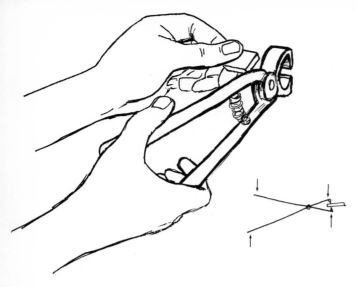

19 *Cutting with nippers: handles gripped near their ends for better leverage*

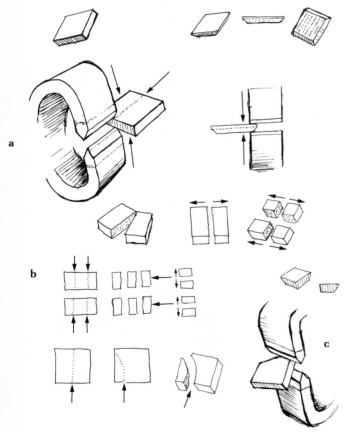

20 *Cutting:* **a)** *nippers grip the tile only at the edge;* **b)** *some possible cuts and lines of fracture;* **c)** *'nibbling' with centre of cutting edges*

The results are also less accurate and can result in shattering.

The line of cracking will generally be a straight line across the tile in the continued direction of the jaws. The crack is most cleanly and controllably achieved when it is at right angles to the edge of the tile. Angles away from the right angle are progressively less predictable as a cut and become more and more just a breaking of the tile into a number of bits.

The nipper handles should be held as near their ends as possible. This gives the most efficient leverage, a relatively gentle squeeze from the hand producing high pressure in the jaws. If you hold the handles far down near the pivot the result is harder work, blistered hands, and less accurate cutting.

After these elementary instructions there is only one way to learn – by doing. Very quickly you will see what is possible with the nippers. The simplest exercise is to reduce a number of the standard-sized 20mm (¾in) square tiles to quarters. This means three cuts per piece: first halved and then each half cut again. The result is four more or less equal square tesserae. This is the operation you will probably use most. The first attempts will produce a few shattered and unequal 'halves' and maybe crack-lines not at right angles, or even curved cracks, but the proportion of such results to good clean squares soon diminishes. Cutting is a simple act easily learnt, and practice soon brings the accuracy you need.

What you are really discovering are the ways in which ceramics and glass will break under pressure. The good craftsperson does this by developing a sense of material more than by a precise carrying through of a set of instructions.

Sizes and shapes

The size of tesserae is to an extent influenced by the available standard tiles, and the most obvious reduction process is halving and re-halving. Thus a single square can be easily quartered, giving square tesserae of about 10mm (⅜in). These are very convenient to handle in fairly large scale work and are optically satisfying, but a good experiment is to try reducing a standard tile to the smallest possible tesserae. The quarters can be quartered again without much difficulty, making the original tile yield 16 tesserae. This takes us down to about 5mm (³⁄₁₆in) squares.

It will soon be found that very small pieces are

difficult to hold in cutting and that the jaws of the nippers are too coarse to deal accurately with very tiny cuts. One discovers the natural size for tesserae by an understanding of the material and the tool. Larger tiles, unlimited sheets of material, or natural stones, will lead to different procedures for reduction to manageable tesserae. For portable studio panels, tesserae of a quarter or sixteenth of the average standard mosaic tile will generally be most manageable. Large scale work *in situ* may use much bigger pieces, but these would be cut by different means.

Halving gives the most reliable cut for any one piece of tile. This is because equal amounts of material on each side of the cutting jaws at the moment of pressure invite the crack to run in a straight line across from side to side. It is difficult to cut a narrow strip off a tile with nippers – the crack will frequently run in a curve towards the side. Try cutting a few square tiles in progressively narrower strips, using both ceramic and glass tiles. The ceramic are more manageable; the glass soon shatters as you move your line of cut nearer to the edge, but both will be less predictable once you move away from the centre halving line.

If we are dealing with an oblong piece rather than a square, conditions are different. Cutting lines will more easily run across from side to side in a parallel series. The half square oblong obtained by the first division of the standard piece can easily be reduced to thirds and quarters and, with care, perhaps even smaller. From such cutting the shapes will, of course, be different. The tesserae, although we continue to use the same name, will not, strictly speaking, be cubic but elongated pieces. These, when assembled in the mosaic, can produce more directional 'flow' patterns.

It is good to do much experimenting with cutting to get the feel of the materials and to acquire natural handling of the tool. This is the basis of much work in mosaic. You will soon be handling a pair of nippers and the tiles in an unconscious and instinctive way. At first expect some wastage of material by shattering (especially with glass) and by pieces flying off. It may be too time-wasting to search for them. The thumb and fingers of the hand holding the tile at the time of the cut are very important. Grip the whole piece firmly. This ensures accurate application of the cutting edges to the secured piece; it also prevents the resulting halves from flying off.

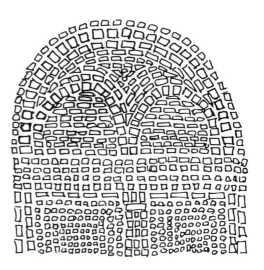

21a *Shapes, size and structures*

31

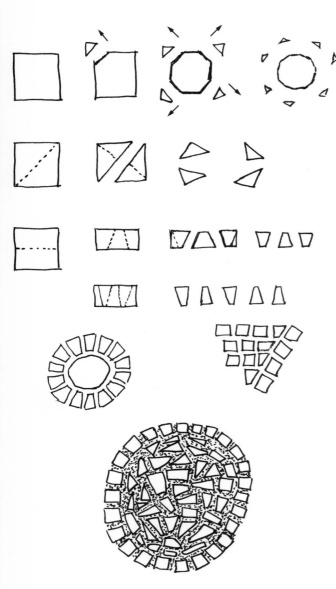

21b *Breaking down and building up*

So you should be left with two halves still firmly held between thumb and finger after the cut.

Other cutting methods

We do not always need only large numbers of regular tesserae; sometimes we need a specially shaped one for a particular place – a triangular piece, for example, or, on rare occasions, a rounded one.

For such purposes nippers can be used differently. Instead of simply nipping at the edge to produce a crack across the whole piece, place the tile in the middle of the jaws entirely within the cutting surface. Harder pressure is needed but now the two cutting edges will actually slice through the material more like a guillotine. This can be done only with small pieces easily held within the width of the cutting edges. In this way small fragments can be removed from a tile and, by a kind of nibbling, a controlled reduction is possible, giving almost any shape. Try changing a square into a circle. First snip off each corner to give an octagon. Then remove further angles. By progressive small snips the straight lines begin to look curved and we have at least an approximate circle.

The only way to acquire skill in cutting is through practice and experimentation, and with the above as a guideline and a little care and patience, you can discover what can be done with a pair of nippers and various kinds of standard tile. Very soon you will recognize the qualities of different materials and the different kinds of grip and pressure required for glass or ceramics. Ceramics themselves can vary from a tough high-fired porcelain-like density to light earthenware. A fluency in cutting should be aimed at; this is valuable when producing large numbers of tesserae. The technique of cutting is rapid even though the whole production of a mosaic may seem slow.

The hardie and hammer

We have begun with nippers for cutting because they are most commonly used today, but the traditional technique is that of the hardie and hammer.

The hardie is a cutting edge, rather like a stone mason's chisel. It is fixed into a firm heavy block – often a log of wood or a concrete block.

You can set up a very satisfactory hardie by taking a stone chisel, preferably with a tungsten tip, and setting this in a bed of concrete contained in a large tin, for example a large empty paint drum. Make sure that plenty of the chisel shaft is under the surface of the concrete for good stability. Only a small piece of the chisel need stand above the surface.

The mosaic hammer has a cross cut chisel edge on either side or, preferably, both sides of the hammer head. To use this method of cutting you hold the piece to be cut across the fixed hardie or

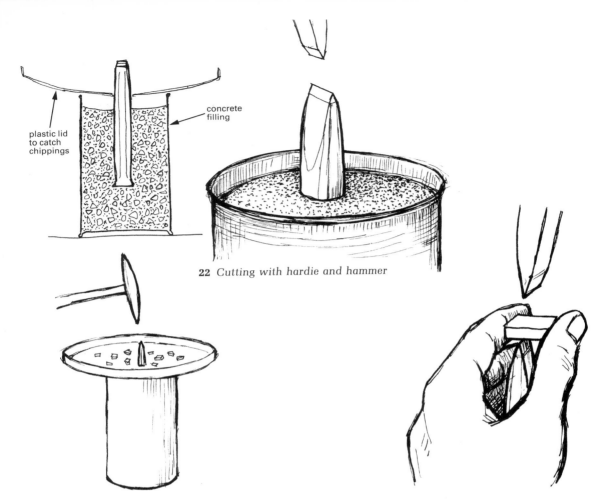

plastic lid to catch chippings

concrete filling

22 *Cutting with hardie and hammer*

chisel edge and strike it firmly with the hammer directly above the underneath cutting edge. Like the jaws of the nippers the two edges come together, cracking and breaking the piece. Some mosaicists maintain that this is the true way to cut tesserae. It is certainly the oldest, and probably requires more practice than the handling of nippers.

There is more hazard to the fingers with the hardie and hammer and, in cutting small pieces, the fingers are close to the impact area. Care must be taken in aiming the blow to strike directly above the lower edge, but such difficulties can be overcome with practice. Special care must be exercised until accuracy and confidence are acquired.

A distinct difference in the actual cut is the fact that, with the hardie and hammer, the cut results from a blow, whilst with the nippers it is from a high pressure. On these grounds the second method would seem to be more controllable and predictable. We may feel that the modern nippers have now superseded the hammer, although this may just be a matter of training. Those who have been given the traditional hammer training feel that it is the 'proper' method of mosaic cutting, and such people will, no doubt, find greater competency in this method. Debate concerning the relative merits of the traditional and innovative methods will be resolved by personal preference alone.

For a thorough exploration of mosaic you should certainly try out cutting with hammer and hardie, but for contemporary use, especially with manufactured tiles, you will probably find nippers offer greater efficiency and convenience.

There are some special cases to be made for hammer and hardie use. One is in using natural stone (such as pebbles or rocks) since these are usually impossible to cut with nippers. This splendid source of mosaic material was the source for ancient work and can still be attractive

today, although its drawback is time and labour. Not everyone can find and collect these materials for themselves and, even if one can, the labour of reducing them to manageable tesserae is great. One needs something more akin to the stone mason's techniques. If you are an enthusiast for natural stones do not be deterred by my comments. This book is for those more interested in the technique of assembling mosaics than in actually making their own materials. I see mosaic making largely as an end product process – an art of utilizing materials which, for the main, will come from stockists, just as painting has become the art of using the pigments, not the process of grinding them from basic materials.

Another material which may be more susceptible to hammer and hardie treatment is smalti – the manufactured enamel-type Venetian material. More will be said about this very special material later (pp.57–61).

Safety measures

While mosaic is not conspicuously dangerous, there are certain possible hazards to health and safety which should be considered.

The most obvious danger is to the eyes from flying fragments when cutting. There is always a possibility of some sharp little piece flying out and hitting the eye, and it is sensible, therefore, to observe the simple precaution of wearing goggles when cutting. Spectacle wearers get some protection, but not enough. There are now many good plastic eye shields available, so guarding against this danger should be no problem.

There is a less obvious but possible health danger from dust. Try cutting a tile with the nippers in a ray of sunlight: each snip produces a tiny explosion of extremely fine dust, almost like smoke. In close, unventilated conditions this may be inhaled. One precaution is to keep the face well back when cutting; good ventilation will also help, perhaps even cutting in the open air when possible. The safest and simplest precaution, however, is the use of a mask – another readily available item. This may seem a drastic measure for a minor danger but remember that, if you have long or frequent sessions of cutting, the amount of fine glass or ceramic dust could be considerable. I make this point about dust to alert mosaicists to the potential danger. It may not have been observed in manuals on mosaic in the past, but one does not know what long term adverse effects on health may have been suffered.

Cutting mosaic does, of course, produce dust on a much coarser level, as will quickly be seen in any area where you work. There will be many small chips around and they will easily get under foot. These should be swept up regularly as a matter of general studio maintenance. Vapours from certain adhesives, particularly resins, have distinct dangers. Whenever such materials are used, the manufacturers' advice and directions should be closely followed. Many adhesive materials, and certainly wet cement, have detrimental effects on the skin, and contact should be avoided. In any cases of doubt, rubber gloves should be worn.

Direct method – a modern version

There are two main methods of working – the direct and the indirect – the basic difference between them being that one is done from the front (direct), and the other is done from the back and reversed (indirect).

The direct method is the most obvious way of working and was, as we have seen, a probable origin of the craft, i.e. the simple placing of stones into some kind of support such as mud, clay or cement.

In principle this is the procedure to be followed now, but I will relate this to modern studio conditions and show how we can produce a small portable piece by this method. Later, the traditional methods of making a mosaic in situ will be considered, but it is better to make a start using available modern materials than to follow an antiquarian's approach for the sake of historical accuracy. I am concerned with mosaic as a living art and craft.

The base

For portability we need a base. For relative lightness, strength and durability I recommend wood in the form of plywood. For small pieces, boards of 12mm ($\frac{1}{2}$in) ply are suitable; for larger panels above 1m (39in) square, 18mm ($\frac{3}{4}$in) is recommended.

Plywood boards should be of good quality. Most are water resistant but for work exposed to continual dampness, e.g. garden or bathroom pieces, marine ply should be used for increased durability. Remember that mosaic, though a very permanent medium, as the many ancient examples will show, is none the less only as good as its support.

There are several alternatives to plywood. Block board, if of good solid quality, can be used; well-seasoned wood-plank is suitable for small areas, and even a thick rigid hardboard is possible for small pieces. Chipboard should be avoided as it has a marked tendency to warp

when carrying mosaics even in quite small areas. Warping is induced by temperature changes and can happen long after completion if the work is kept in rooms with a high level of heating.

The base should be given a coat of wood sealer on both sides before work is started. Do this according to the brand instructions.

Adhesives

The tesserae are going to be stuck on to the base board with an adhesive or a tile cement, and here we have a large range of possibilities. Advances in modern chemistry have made available many excellent adhesives and one should choose a good proprietary brand. The polyvinyl acetate (PVA) glues are very good. Some adhesives are designed for cement adhesion in the building trade and are particularly good. In Britain, Unibond is recommended; it is available in small quantities, though purchase in larger amounts is proportionally cheaper.

Tile cements are thick pastes intended for bonding tiles to floors and walls. These make ideal adhesives for vertical surfaces because they will hold the work in place and prevent it from sliding down. The more fluid PVA adhesives are only suitable for working on horizontal or low angle surfaces. They will allow tesserae to slide down vertical surfaces – sometimes slowly but enough to give your carefully placed tesserae a droop. So, if you prefer to work like a painter at an easel, use a stiff tile cement. If you work on a table top, the slipping problem does not arise and you can choose any adhesive capable of bonding ceramics or glass to wood. Waterproof ones are preferable.

The drawing

A good starting size for your base board might be about 30cm (12in) square in area – off the square format if preferred or according to the design.

Draw your design boldly and simply on to this.

The image should be of the kind already considered in Chapter I, i.e. very simple in shape and able to be expressed in strong outline. Birds, fishes, butterflies, flowers, perhaps a head, could all be suitable. Those who paint should avoid the temptation of pictorial effects with suggestions of space, atmosphere or deep perspective.

The materials for drawing can be important visually and technically. For boldness and sim-plicity, charcoal is an obvious choice but, if you do use this excellent drawing material and especially if you draw heavily with it, it will give a dusty surface. This could reduce adhesion with glues or cement, so any heavy charcoal drawing should be dusted down and sprayed with fix-ative, or you can give a coat of sealer after doing the drawing, thus fixing and sealing in one operation. The board should be scored with criss-cross scratches for good adhesion.

Placing tesserae

To work over the drawing simply stick the tesserae on to it one by one following your original lines. The need for boldness and simpli-city is immediately apparent but further modifi-cation to the image may be needed, and these changes can be made as you lay the tesserae. Remember that the lines of tesserae now become the drawing — they and they alone will convey the idea. To place them you will have to apply your adhesive or tile cement to the back of each individual piece. A small stick, spatula or palette knife is suitable for this. You need simply to place a dab of the adhesive on the back of the tessera, making sure it is sufficient to cover it completely. When the piece is pressed lightly on to the base, a small amount should be squeezed out all around the piece.

This may seem a slow and tedious means of application, and the alternative of applying adhesive to the base in larger areas and then placing the tesserae on a bed of adhesive may seem quicker; there are, however, disadvantages. The adhesive will obscure the drawing — particu-larly in the case of tile cement which is dense and opaque; unless your work exactly covers the area of adhesive put down you will have to clean away the surplus — perhaps awkwardly around irregu-lar edges, and if the adhesive remains exposed to the air for a considerable time before being impressed with the tesserae, its adhesive proper-ties can diminish due to evaporation. In contrast, the 'buttering' of each piece, if slower, gives a very controlled method of handling and may be

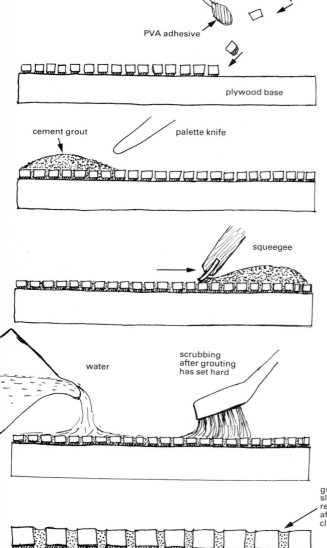

PVA adhesive

plywood base

cement grout palette knife

squeegee

water scrubbing after grouting has set hard

grout is slightly recessed after cleaning

23 *Direct method on wood base with grouting*

easily interrupted at any time without inconvenience. The matter of evaporation from the supply while working can still be an important point to consider, so do not have large amounts exposed to the air, for example in a wide-mouthed open pot of tile cement. Always take out only a small amount, sufficient for about 15 minutes' work at most. This can be put in or on any non-porous convenient receptacle – small saucer, tile, jar, etc. It should be remembered that most tile cements are designed for single operation, large scale application, when drying out during working would be unimportant; the longer working period of the mosaicist makes this drying out or 'going off' during work a point to be watched.

Andamento

Having put down the main lines of drawing – these will usually be the outlines –you can then proceed to cover the remaining areas. It is at this stage that you will become very conscious of the importance of the direction or flow of the work. This is, in fact, what is meant by andamento – the way in which the work 'goes'. This will involve all areas of the mosaic; a background is not merely an unimportant filling up of space, but an integral part of the mosaic.

At this stage much improvisation is needed, according to how the work 'goes'. The preliminary drawing cannot take into account the existence and place of every tessera – indeed, if it did, the execution of the mosaic would be just a dreary matter of copying. Regrettably this was often the case when a divorce between designers and craft workers took place and mosaic was just a reproductive medium. Creative work in mosaic entails consideration over the placing of each tessera and great awareness of the means of assembly results. The need for the opus styles is discovered by studio experiments, if not learnt in advance from the Romans.

Many decisions have to be made concerning directions. From the main lines of the drawing the next obvious line to lay down is one following as near parallel as possible. This is the opus vermiculatum. It may surround the image with further and further repetitions of the same direction gradually adjusting to the space to be filled. Continued indefinitely, this procedure becomes the opus musivum. Alternatively, after surrounding your image with a line of background colour to stabilize and contain it, you might like to strike up a complete contrast by running horizontal straight lines of tesserae against the curving line, cutting these across diagonally to fit where they meet. This is the use of opus tesselatum as a general background filling. It can make your image stand out in contrast, giving sharp distinction between image and background. On the other hand, the former way of harmonizing all directions makes for a unity where background and image flow together in related rhythms. The method of use is a matter of personal choice according to subjects and intentions. Many Roman examples do use the more formal tessellated background against the expressive outline. However, the first line of background will invariably follow the outline, since otherwise the isolation would be too stark.

Many delightful rhythmic lines will develop as you work, and these will fascinate the eye of the observer after the work is finished. You may have to cut individual tesserae and depart from the basic square units but do not yield to the temptation to do this often. Fit the squares in as best as you can. The size of gaps between may vary slightly when, for example, you follow a sharp curve. If the squares seem clumsy and too big to accommodate, an occasional trimming will help. Here and there you may reduce them to triangles if this helps them to fit, but consider the retention of the shape and size of the unit piece as valuable to the overall effect. Changes of size may also be helpful for details.

Grouting

You have a base board with your mosaic virtually finished. The tesserae are all securely in place held by adhesive or tile cement. They will have gaps between and it is these which must now be filled.

If you have been applying the tesserae to the board with tile cement, the cement may to some extent have been forced up between the tesserae, but this should not have risen to the level of the surface. If you have been using an adhesive such as PVA liquid adhesive, this will not occupy space in the gaps to a noticeable extent; it does, in fact, shrink on drying and so will leave the tesserae firmly fixed by their back surface but with a completely clear gap between each. It also changes from white opacity to colourless transparency on drying.

The filling used to occupy the gaps is called

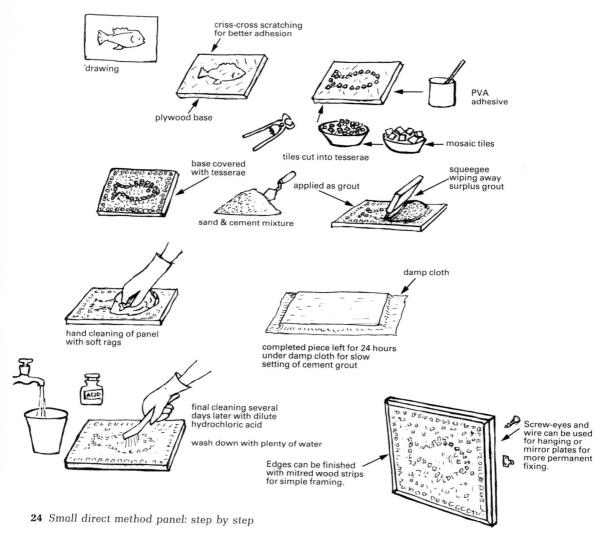

24 *Small direct method panel: step by step*

grout and the process is grouting. The grout will give a double security to the tesserae by preventing any sideways movement and adding a certain side to side adhesion. It will also produce a more level and smoother overall surface to the mosaic. As with any tiling job, it will give a better finish and be a structural part of the mosaic, therefore making it more sound.

A second aspect of grouting is the visual one. When the work is seen in its completed state, the areas of grouting will be a considerable proportion of the total area. It will, therefore, be a component of the colour scheme. The actual colour of the grout used can have a big influence on the total harmony. As we have already seen,

the lines between the tesserae are vitally important in mosaic, indeed they may be said to be the very essence of mosaic. The choice of grout and whether or not it emphasizes or minimizes the structural pattern is clearly a key factor. Colour effects will be considered later, but first let us examine the purely material and functional nature of grouting.

Cements for grouting

Portland cement, the normal grey material used by builders, makes an excellent grout in its unmixed form. To grout with this you should mix it into a smooth paste with the minimum quantity of water. For a small panel, convenient amounts

can be mixed on a smooth board or tile with a palette knife or small trowel. It is then applied firmly with a downward pressure to the entire surface of the mosaic. This can be done with a springy knife or spatula or preferably spread over the surface with a rubber squeegee. This will force the cement down into the cracks and, to some extent, wipe the surface of the tesserae.

The cement should not be handled with bare hands as, in a wet state, it produces the effect of corrosive alkali on the skin. This may not be immediately apparent in a rapid handling but the effects can be very unpleasant, especially on any cracks or scratches on the skin. It is advisable to wear rubber gloves or barrier creams if your hands are likely to be in contact with wet cement.

Mixing cement

The area of grout which is finally visible can be a considerable proportion of the whole picture, and thus has a big influence on colour. Also, in surrounding each tessera, it is acting like a frame or mount for a picture, reacting visually with the colour it surrounds. It can heighten a colour by contrasting with it, or reduce its effect by harmonizing with it. So grouting is an ingredient of aesthetic as well as structural possibilities.

In using unmixed Portland cement you are adding a pure neutral grey to the work. This, from the point of view of colour effects, is the safest thing to do. It will enhance any colour it surrounds by being not a colour. It will dry out as a middle tone, i.e. midway between black and white, and again provides the safest average effect for any colours, either dark or light. The one thing it will tend to lose visually is any grey tesserae you may have used.

Cement is usually mixed with sand for reasons of strength, but you can also use the mixture to determine its colour. A sand mixed with the cement will obviously modify its grey colour. The most common yellow sand will make it look warmer in colour, and grouting carried out with a sand and cement mixture will be suffused by a warm glow of colour. The range of colours in sands may be limited but sand can give an added colour quality to grouting and is the ideal addition to cement.

With regard to proportions, large amounts of sand can be added without detriment to the setting strength. In fact the body of the concrete, as the mixture should be called, is made more durable. The usual builders' formula of three parts of sand to one of cement is very suitable. In this mixture the sand will obviously predominate in colour over the grey cement. One of the most emphatic colours is red sand. This, too, is often of very fine grains and gives a smooth buttery mixture.

Mixing the two components should always be carried out dry. To mix with water, put the dry mixture on a board in a heap, make a hollow crater in the middle and pour in some water. Gradually knock the mixture into the water until it absorbs all the water. The solid and liquid components should be mixed up to make the stiffest paste that is manageable. It is quite hard work mixing if you use only the minimum amount of water. The less water used the stronger is the final setting. The procedure is, of course, just the same as the builder would follow. A small trowel is the right tool for the job but a painter's palette knife is useful for small amounts. The final damp mixture should be very smooth.

Pigments as additive

If the natural sands do not provide all you want in colour variations, it is possible to use actual pigments. Pigments specially prepared as cement colourants can be bought and mixed, according to the manufacturer's instructions, with the cement. A considerable range is available, resulting in many possibilities for mosaics. The dry powder pigments, as used by artists' colourmen, can be incorporated but these are very finely ground and are less satisfactory than the coarser ones intended for cement mixture. The coarse pigment will also act as a strengthening aggregate in the same manner as a sand. Sand, too, can still be added as a third component.

There are no hard and fast rules about colour and grouting and there is much scope for experiment. Tests on unimportant trial pieces are advisable, however, as grouting is not reversible and, as with most things in mosaic, the simpler the technique the better. Remember that, while grouting can influence colour schemes, too much reliance should not be placed on it as a corrective. The basic colour scheme must be established in the use of the tesserae.

Cleaning

With water

After wiping over with a squeegee, the surface of the tesserae is still far from clean. You must

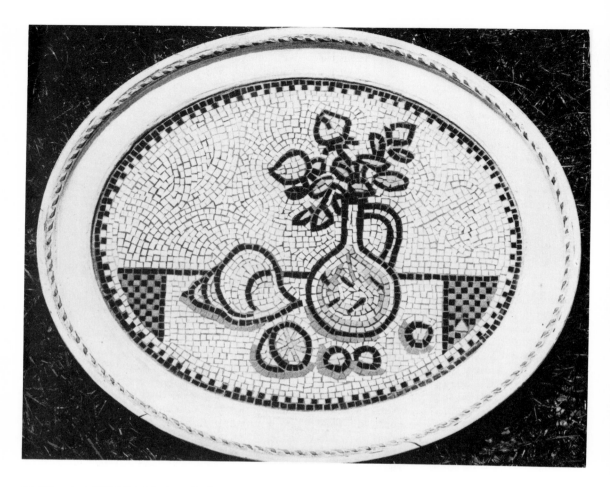

25 'Classical Still Life': black and white plus a short range of colours. Although using images, the design was developed entirely from proportional systems and abstract structure, e.g. interplay of verticals, horizontals, straights and curves. The images are simply references; they never existed as 'real' models

therefore clean the surface with a damp cloth; soft rags are useful for this, and the spongy wiping cloths used for cleaning down sinks and kitchen surfaces are excellent for the purpose.

The wiping should be done with great care and, if done thoroughly, will take longer than you think. Do not rush this part of the work as it is going to have an important visual effect at the end. It must be done sensitively, i.e. attempting to wipe all the surplus cement off the surface without wiping it out of the cracks. Vigorous wiping or excessive pressure will force the grouting out of the gaps and leave you with a rugged surface. On the other hand, insufficient wiping will leave patches of cement on the surface and these are difficult to remove once dry. Wiping can be an enjoyable and rewarding labour, as it brings the first revelation of the finished work. Sometimes a second gentle wipe over can be useful about an hour after the first. The cement in the gaps will have settled and be less movable and a very light damp wiping of the tesserae is possible. You will come to feel that you are only touching the tesserae with your cloth and not the embedded grout.

After wiping, leave the cement to set (or cure) for about 24 hours. During this period, leave it covered over with a damp cloth – this allows a slow set to take place, resulting in harder cement. Remember that the cement is not drying out but changing chemically under the action of water, and therefore a quick drying out of all the moisture present will not produce a good set.

Only when set may you remove the cover and allow the whole work to dry completely.

If the wet wiping of the grout was an exciting revelation, now take warning because the first appearance of the dried out work may be a disappointment – a bit like seeing wet pebbles dried. However, this is a temporary condition and there is a remedy to the apparent dullness. On drying, the cement leaves a very thin scum which is almost impossible to remove by wiping with rags. When the mosaic is thoroughly set and dried – say a few days later – you can give your mosaic a really good clean up using a soft nail brush and kitchen detergent. This may restore much of the pristine brightness of the tesserae. If it still does not bring the desired brightness there is another method you can try.

With acid
Cement dissolves in acid by chemical action. If you wash over the finished result with an acid of suitable strength, all the cement scum will be removed. This is a fairly drastic action and precautions are needed, especially if you buy the acid in a concentrated form and dilute it yourself. The acid to use is hydrochloric acid (HCl). The strength to use is from 10 to 25 per cent acid to water, i.e. one part of concentrated acid to between 9 and 3 parts of water. It can vary according to the job and how quickly you want to do it, but the strength must never exceed 25 per cent. The concentrated hydrochloric acid (sometimes sold under the names 'spirits of salt') is very dangerous, being highly corrosive to skin and clothing and giving off acrid poisonous fumes. For safer storage it is better to reduce it to the diluted state, though you will need a correspondingly larger container, and even the diluted acid must be treated with care. Always label bottles clearly and keep them in a safe place, well above any child's reach. If you have difficulty in buying hydrochloric acid (the days of packaged products have almost eliminated chemicals from chemists' shops), the acid packaged as 'descalent for kettles' will do the same job. It is, in fact, formic acid.

If possible, it is better to do acid cleaning of mosaic outside, in the garden or yard, for example. You should put an appropriate amount of the diluted acid in a jar. Then, wearing rubber gloves, pour it over the work, which is placed either flat on the ground or at a slight angle of tilt so that the liquid will flow over the surface.

Using a light scrubbing brush, such as a nail brush or washing-up brush kept for the purpose, you can lightly rub the whole surface. As soon as the acid comes in contact with the work it produces a great fizzing effervescence. It is reacting with the carbonate of the cement to produce bubbles of carbon dioxide gas. The acid should not be in contact for long – about a quarter of a minute at the most. The action is instantaneous on the cement scum and, of course, prolonged contact results in the grouting being reduced. As soon as all parts have had a quick light scrub over, wash the mosaic down with plenty of water and leave to dry. Your work will now be restored to its original freshness and no further treatment is needed.

It is fortunate that mosaics are made of robust materials and, whenever they get dirty from normal exposure, can simply be washed as for any tiled surface.

Groutings without cement
It is also possible to use sand and a PVA glue instead of cement. This is a quick and easy method, and smooth sands generally handle better. In this case, simply mix the sand with one of the PVA glues diluted with about three to four times its volume of water. The glue will act as a strong binder and the mixture will dry out very hard.

Cleaning must be carried out immediately and thoroughly, as parts that dry out on the surface of the tesserae are very difficult to remove, and there can be no final clean up with acid with this method. The cleaning is done with damp rags and finished off with almost a polishing, using drier and drier cloths.

The glue will deepen and enrich the colour of the sand and will even retain this richness of colour when dry. Too much binder can give an unpleasant glossy shine to the grouting.

Direct method without grouting

A mixture of sand and resin glue can be used as a direct medium of application. A good glue is, in fact, the PVA binder used for acrylic paints and sold as an art material for use as a painting medium or as adhesive in collage techniques. The Unibond adhesive, as used with cements, is also suitable.

Mix a fairly smooth sand with the binder to make a stiff paste. The design should be drawn

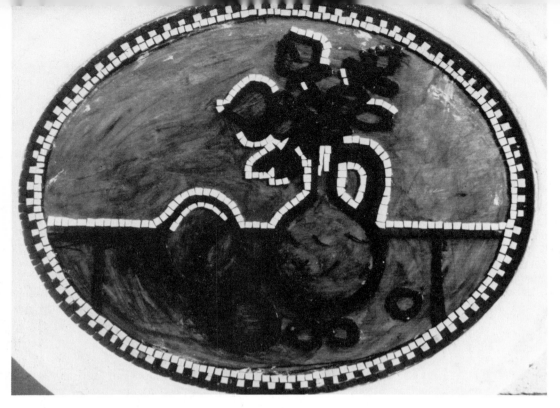

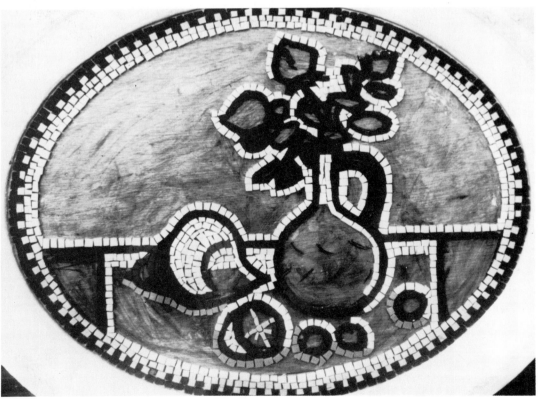

42

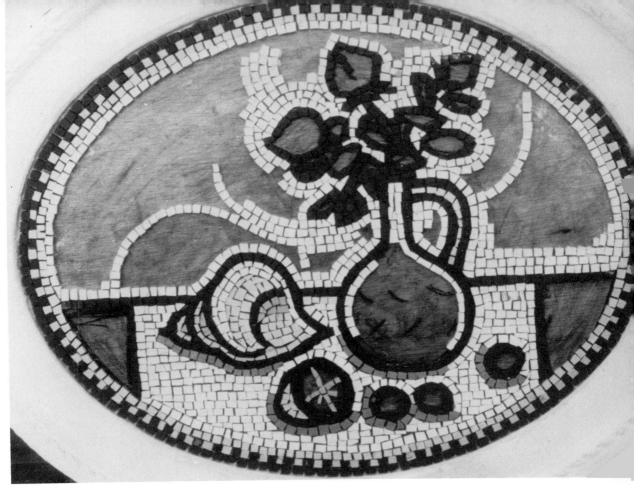

26 Three stages in the making of 'Classical Still Life': the oval shape was the starting point; the drawing was developed within this using bold black lines, and lines of tesserae were laid over these

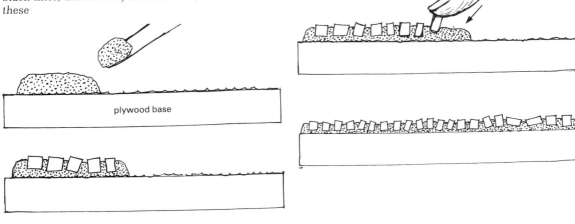

plywood base

27 Direct method with adhesive cement on wood base

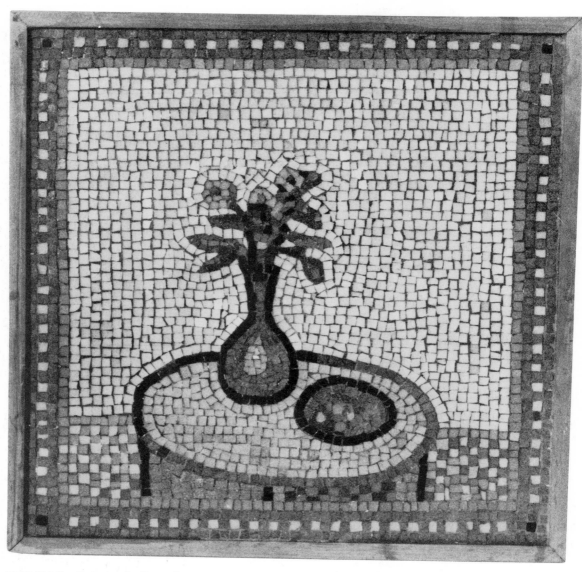

28 *Still Life: direct method panel*

on the base board as before. The surface of the wooden board should be slightly roughened by making criss-cross scratches across it with a metal point. The mixture is then applied to the surface in convenient workable amounts – say a few square centimetres (inches) at a time, or in convenient sections of the design. It should be firmly pressed on to the board, perhaps even being scraped on and off several times to ensure good contact, then a thickness of at least 6mm

($\frac{1}{4}$in) should be left on the board. It can be trowelled to a fairly smooth surface using a palette knife, small trowel or scraper.

Now gently press your tesserae, one by one, into the soft mixture. It will rise around each piece and this can be adjusted by pressure, which is why you must have sufficient depth of the mixture on the board. You can press the tesserae in so that the mixture rises to the level of their surface; in this way the need for any grouting is removed and the work is virtually finished bit by bit as you proceed. There is nothing further to do – you arrive at the final

effect directly as you work. It is exactly the way in which many ancient wall mosaics seem to have been made, i.e. pressing pieces into a soft receptive ground.

There are several points to note. The work will not finish up as smooth in surface as when pieces of equal tesserae are stuck on to the base and later grouted. There may be slight variations in the angles of the surfaces, and the gaps may have slightly different bands of filling. It is not necessary to use pieces of standard thickness, like tiles; in fact the method is particularly good when using irregularly shaped smalti pieces. The irregularities of surface reflect the light in different directions, giving glitter when viewed with movements of the head. This method should be a positive use of non-grouting for specific ends.

29 *Still Life: direct method panel*

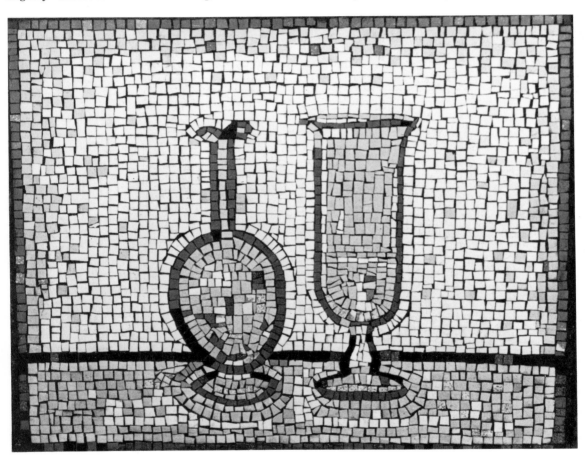

Indirect and double reverse methods

The indirect method of mosaic making has distinct advantages and disadvantages relative to different requirements. It results in smoother surfaces – useful for floors or table tops, and can be assembled remote from a site and installed quickly in one application – useful for certain types of mural. As usual, its special characteristics are best discovered by doing an experimental piece.

The essential advantage of the indirect method is that it is carried out on a temporary support and later transferred to its permanent support or site. The usual temporary support is brown paper, the tesserae being stuck on to it face downwards with a water soluble glue. When completely covered, the sheet of paper can be lifted, turned over and pressed into a prepared bed of setting concrete or a spread of tile cement. Time is allowed for setting and then the paper is thoroughly dampened and peeled off the secure pieces. More time is allowed for complete setting and then the work can be grouted and cleaned as with the direct method.

Some important points to note are:

1 The design must be carried out in reverse. You do not see it the right way round while working.
2 The tesserae used must have at least one face flat and smooth for adhesion to the paper.
3 Large areas must be sectioned into smaller units for convenience of lifting the paper – about 30cm (1ft) square being the largest area of paper that can be easily handled when covered with glued tesserae.

A simple trial piece

You will need a piece of brown paper 30cm (1ft) square and some gum arabic, which is still obtainable as old-fashioned paper gum. Several types of glue can be used, for example wallpaper pastes, but they must easily re-dissolve in water. It is possible to obtain from mosaic suppliers sheets of ready gummed paper which simply need wetting and the tesserae sticking to them.

The tesserae can be either glass or ceramic. Glass has a conveniently smooth surface which sticks very easily to paper and also allows easy stripping of the paper from it. Let us use glass for this first piece. Glass tiles have a distinct back and front – the front being completely smooth, the back being possibly textured and with a bevelled edge. Clearly it is the front side which must be stuck down on to our brown paper sheet. When the sheet is completed it will be quite obvious that we are viewing the reverse side of the mosaic.

The glass tesserae are cut in the same way as the ceramic, except that greater care may be needed since there is more likelihood of pieces shattering under pressure of the nippers. This may mean a slightly higher wastage. Exact cutting of very small pieces is more difficult with glass and very small pieces make for difficulties when placing them on paper. It would be well to use approximate square quarters of whole tiles with perhaps occasional halving to suit the design, perhaps into triangles. Pieces of this size can be handled reasonably well and have sufficient surface to ensure adhesion to the paper.

The drawing

Do not forget that the drawing must be reversed. If the drawing has been done as a preliminary sketch and is actual size, then it can be traced on to the brown paper. You can place a piece of tracing paper (or any strong semi-transparent paper) over your sketch (an actual size preliminary sketch is called a cartoon), then trace over the main lines of your drawing. Rub some charcoal, or shade over your tracing and place it on the brown paper, then draw over all the lines again using heavy pressure from the pencil. You will then have a faint image on the brown paper which can be reinforced by working over – perhaps with an ink or marker line for clarity. You will now have your drawing on the brown

30 *Indirect reversal method:* **a)** *tesserae glued to paper;* **b)** *paper sheet with tesserae pressed into cement bed using wood block to disperse pressure;* **c)** *paper damped with sponge and removed after partial setting;* **d)** *gaps between tesserae filled by grouting*

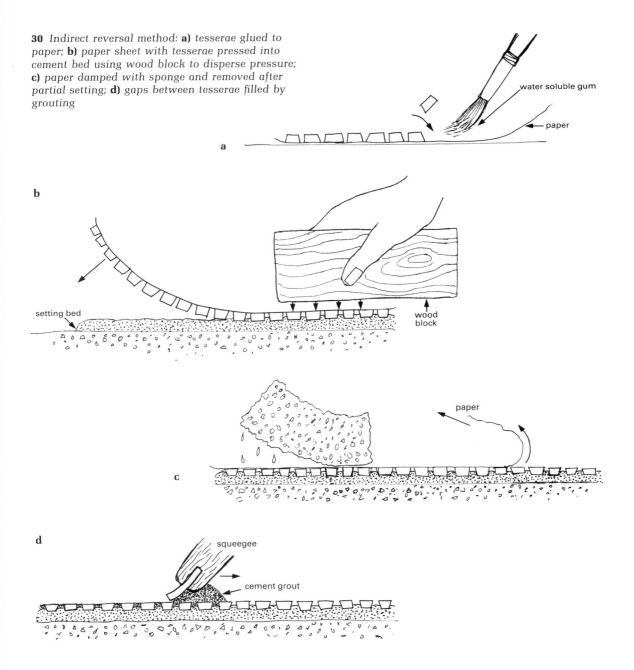

paper in reverse and ready to have tesserae stuck on to it face downwards.

Sticking tesserae to paper

If you have gummed paper, all you need do is wet each tessera and then place it on the paper. There must be sufficient water on the tesserae to wet

the paper and cause union with the paper on drying. However, too much water will make a pool in which the tesserae may slide sideways and you will lose any precision in placing. As usual, it is a matter for experimentation and you will find the way in which you can best manage the problem.

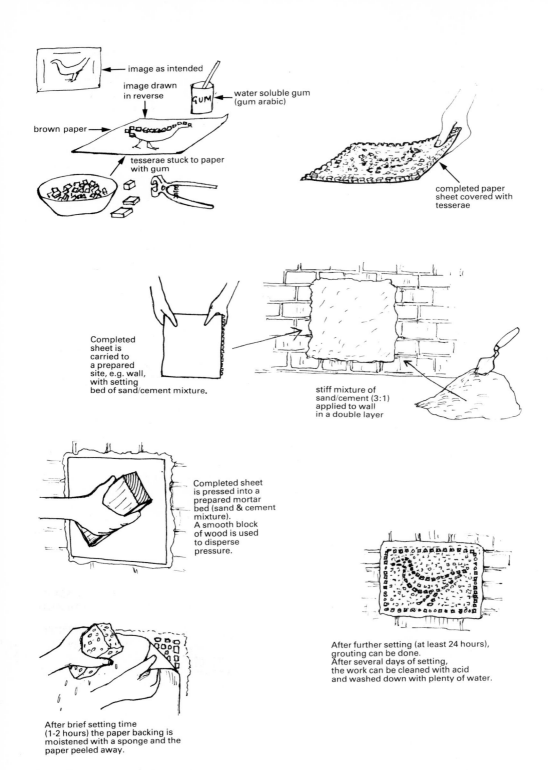

image as intended

image drawn in reverse

water soluble gum (gum arabic)

brown paper

tesserae stuck to paper with gum

completed paper sheet covered with tesserae

Completed sheet is carried to a prepared site, e.g. wall, with setting bed of sand/cement mixture.

stiff mixture of sand/cement (3:1) applied to wall in a double layer

Completed sheet is pressed into a prepared mortar bed (sand & cement mixture). A smooth block of wood is used to disperse pressure.

After further setting (at least 24 hours), grouting can be done. After several days of setting, the work can be cleaned with acid and washed down with plenty of water.

After brief setting time (1-2 hours) the paper backing is moistened with a sponge and the paper peeled away.

31 *Making and siting a small panel – step by step*

An alternative way, which can be very convenient, is to wet small areas of the paper with a soft watercolour brush and place the face of the tesserae downwards on to the sticky surface. This can be quicker because you will have made a large enough sticky area to take a small group of tesserae and, for each wetting operation, a number of placings can be done. Avoid the temptation to wet too much, since this will result in drying out as you work and a need for re-wetting and weakening of the gum. Gummed paper can be convenient to use but care is needed to control the amount of paper wetted at one time and the means of applying the water.

You may find that, when all things are considered, it is better to apply a liquid glue (gum arabic solution or wallpaper paste) bit by bit as you work. This can be done tessera by tessera, as described in the direct method, except that now the glue is applied to the front surface instead of the back. Alternatively, you can spread the glue on the paper in small areas and put the tesserae face down on to the sticky surface.

When paper is used as the working surface in any of the ways described above, a source of trouble is the cockling of the paper, which results in an unpleasantly undulating surface. The effect is accentuated when the design is dealt with piecemeal in small areas. It is caused by the expansion of the damp paper which unfortunately, on drying, rarely returns to its former flatness. If the completed sheet is intended to be pressed into a rigid surface, such as a wall, floor or portable base, cockling may not be of much consequence as the pressure on to the firm surface will flatten out the undulations in the sheet. If you intend, as is possible, to leave the sheet flat and pour a semi-liquid mixture (e.g. cement or plaster) over the paper sheet from the back, then, unless it is very heavy, the weight of the setting bed is insufficient to flatten the paper and so undulations may remain in the final result. These may not always be detrimental, indeed they may be welcomed, but it is important to be aware of this tendency of papered work, especially if the method is being used to achieve a flat finish.

Paper and how to handle it
The paper generally used is a good strong, not too thick, brown paper such as is used for parcel wrapping. In fact, household brown paper is good for this purpose.

Convenient sheets of it, preferably without creases, can be laid flat on a board or smooth table top. One way of eliminating the cockling mentioned above is to stretch the paper, as is done in watercolour painting, i.e. damp the entire paper, lay it on the board and then stick it down securely with gummed strip around its entire edges. Allow it to dry slowly. You will then have a smooth sheet which should not cockle with reasonable amounts of gluing. When finished, the sheet can be released by cutting with a sharp knife. Thicker paper will respond to this treatment better and, of course, it is limited to small pieces of paper – say 0.18m² (2sq.ft) at most. It must also be remembered that areas of more than 30cm (1ft) square of papered work cannot be lifted or carried easily, so larger work in this method must be divided into smaller sections.

Corrections
One advantage of the indirect method is the possibility of making corrections. When the tesserae are all gummed down on the paper, you can consider the scheme as a whole. Any bits that look wrong can now be altered fairly easily by pulling any offending tessera from the paper and sticking another one in its place. Remember that the design is still in reverse, but viewing in a mirror will give you a corrected image and is useful at this point.

Although necessary corrections can now be made, do not over indulge this possibility. A great quality of mosaic lies in its decisiveness and, if you start making numerous corrections and adjustments, you will lose something of the directness of the medium.

Completing the trial piece
To return to the trial piece, imagined as 30cm (1ft) square – we can deal with this in several ways.

1 After all the tesserae have been stuck to the paper and any corrections made, take a piece of 12mm (½in) ply board, slightly larger than the design (6mm [¼in] in both directions). Roughen its surface by some criss-cross scratching with a blunt metal point, then cover it completely with tile cement. The board with its cemented surface can then be placed on top of the papered sheet, cemented surface downwards, and pressed firmly on to the backs of the tesserae. The whole can then be lifted and overturned, perhaps sliding a sheet of hardboard under the paper for greater

security in lifting and turning. When turned, the paper surface can be given some extra firm but gentle pressure. This should be done via another board or by gently rubbing over with a large smooth wood block – not by finger pressure, which will dislocate individual tesserae. Let the cement dry (as per brand instructions). When completely dry and secure, dampen the paper and peel off, and your design will appear for the first time the right way round. Grout as usual. (Finishing of edges will be dealt with later.)

2 The reverse method is most advantageous for placing the work into a permanent site on a wall or floor. Perhaps a location can be found on a garden path or wall for a first small trial. You will first need to have rendered an area of wall with a sand and cement mixture (three to one) or have laid a bed of concrete. The bed or rendering should be criss-cross scored when wet. After setting, it should be further rendered with a final surface about 6mm ($\frac{1}{4}$in) deep.

Lift the sheet of papered mosaic which you have already completed and, being very careful to place it exactly where wanted, press it into the wet rendering. Two pairs of hands are useful for the placing; movement is not possible once contact is made. The sheet with its cargo of tesserae should be firmly pressed in with a dispersed pressure, achieved by use of a broad wood block. A few hours later the tesserae will be held in the cement bed and the paper can be damped and peeled off. If any piece has become misplaced in setting, it is possible at this stage to correct and patch up with touches of cement. This is the advantage of removing the paper reasonably early (but not so early that tesserae may be pulled out with it). When the whole piece is finally set and cured it can be grouted and cleaned up in the usual way, finishing off with acid as described earlier (*p.41*).

3 To set your piece of papered mosaic in concrete or plaster by pouring from the back, you can leave it flat on the board. All you need do is place around it a simple frame of four wooden pieces nailed together. The frame should allow at least 6mm ($\frac{1}{4}$in) between it and the mosaic surface and be at least 25mm (1in) in depth. A sand/cement mixture is then spread over the backs of the tesserae, completely covering them and going

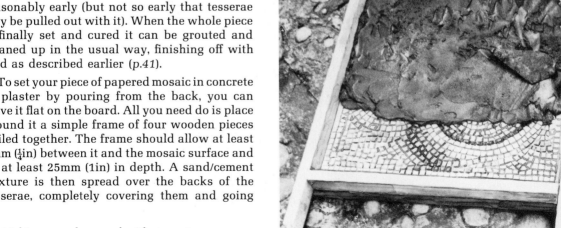

a

b

32 Making a garden panel with concrete: reverse method

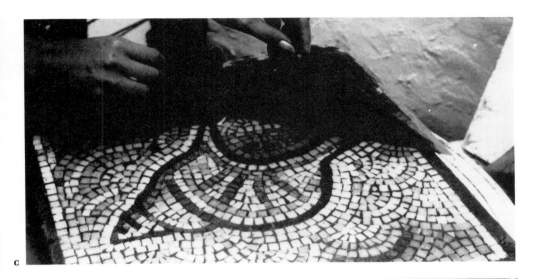

c

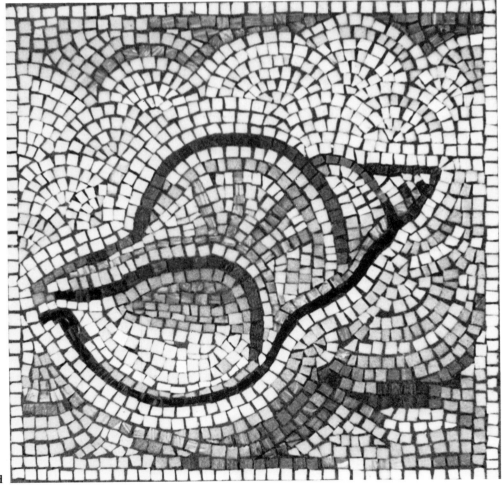

d

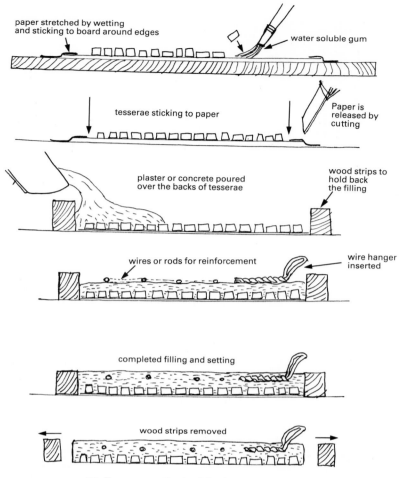

33 *Reverse method with plaster or concrete*

down into the cracks between. When they are covered, some scraps of thick iron wire or expanded metal should be laid over the first covering; this is for strength and reinforcement of the block. Then continue to lay a further covering to make the whole about 25mm (1in) in thickness. Some metal supports or hooks can be bedded into the cement while wet and later used for hanging it on a wall.

Allow the slab to set for at least 24 hours before turning it and removing the wood frame. Dampen and remove the paper as in the other examples. You will have a concrete slab with your mosaic embedded. Such slabs are convenient to handle in sizes of about 30cm (1ft) square. They are not too heavy for hanging with metal hooks or brackets up to this size and are

ideal for open air or garden locations.

For indoor placing, the above procedure can be followed with plaster of Paris instead of concrete. A liquid mixture of plaster can be easily poured over the sheet of tesserae, allowed to set for several hours and then turned in the same way as for cement. Again, some metal reinforcement and hooks for hanging can be incorporated. The method is quick and easy compared with cement. The result is lighter in weight but more fragile, and is only suitable for indoor and permanently dry situations.

An additional problem that should be guarded against is that the liquid plaster, being more runny and penetrating than the concrete, can creep underneath the tesserae and engulf them. This is most likely to happen if you pour the

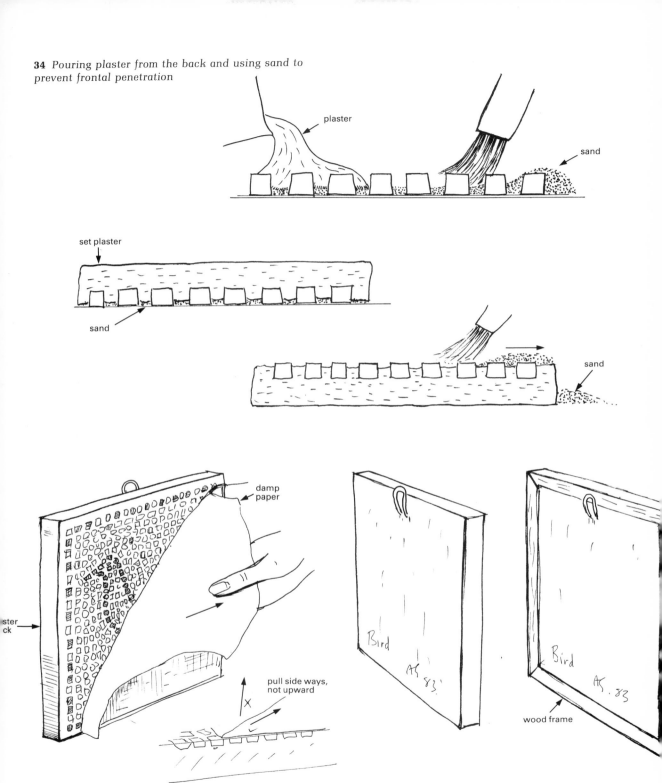

34 *Pouring plaster from the back and using sand to prevent frontal penetration*

plaster

sand

set plaster

sand

sand

damp paper

pull side ways, not upward

plaster block

Bird

A5. 83

Bird

A5. 83

wood frame

35 *Portable panel: reverse method in plaster block*

plaster too soon after mixing. You could find that, on removing the damp paper, some hardened plaster is obscuring areas of the mosaic. To avoid this, sprinkle a little sand over the entire papered sheet before pouring the plaster. The sand can be brushed about so that it gets in the cracks, ideally half filling them. This will prevent penetration of plaster to the front. When the paper is peeled off you will have a dust of sand in the cracks which can be brushed out, leaving clear cracks between all tesserae. These can be filled with a final grouting of plaster or filler (not cement) and polished clean. Acid or other strong cleaning methods must not be used with plaster.

Note on the mixing of plaster
The plaster should be the fine white plaster (plaster of Paris) as used by sculptors for mould making and casting. To mix, take a wide shallow plastic bowl, half fill with water and add the plaster, without agitation, until it stands up as an island of dry powder above the water. Allow it to settle for a few moments and then mix the powder and water together by hand. A smooth creamy liquid will result. For greater strength a further handful might be added and mixed in. Allow the mixture to stand for several minutes until it begins to thicken. When it is like thick whipped cream, it can be poured over the backs of the tesserae and left to harden and dry.

4 For setting with resin and glass fibre, follow the method for plaster of Paris, but replacing the plaster with any of the two component epoxy resin fillers (the kind used for car body repairs is suitable). If a runny variety is used, it can be mixed with the inert filler supplied for the purpose or with sand. The warning about penetration to the front surface is needed even more than with plaster, as any that sets on the front of the tesserae is very difficult to remove. The interstices can again be half filled with sand to prevent penetration. Reinforcement is now provided by mats of glass fibre, which are laid into the resin before setting. Several of these can be incorporated.

There is another important warning to be observed with any use of resin, namely a health and safety one. Toxic vapours surround these resins before setting so they should be used only in completely ventilated conditions. They are highly flammable and one component can be fire inducing on other materials, e.g. paper and cloth. Manufacturers' instructions must be followed.

Resins of this kind offer a modern extension of mosaic possibilities – an interesting combination of ancient and modern. There are some advantages, such as lightness in weight, which make them ideal for portable panels. They are strong, waterproof, permanent and can be quite thin. The material is expensive compared with the traditional ones and there are dangers in handling, although it is safe once the chemical action of setting is complete. Setting is rapid and difficult to control accurately, being much influenced by small temperature changes. Grouting can be carried out in any of the usual ways. Resins have possibilities for experiments and the adventurous mosaicist will want to investigate them.

A double reverse method

Double reversal means that we can work from the front with the mosaic appearing the right way round from the start. To do this, the work must have two temporary supports before it is set.

First you need a soft material into which you can press the tesserae. Plasticine is a good non-drying material well suited to this purpose. Ordinary clay, as used for pottery or modelling, is equally good if not easier for holding tesserae, but it will dry out unless kept moist, and might be more difficult to remove.

Roll out a flat bed of plasticine or clay on a board to a size a little larger than the mosaic you intend to make. The drawing can be lightly scratched on the surface if necessary, being transferred as before from a cartoon. Now, simply press the tesserae into this surface as in the direct method. If clay is used, it should be covered with damp cloths and a plastic sheet when left between working periods. Plasticine does not dry out and can be left uncovered.

An alternative bed for the temporary first placing of the tesserae is a lime putty – a stiff mix of slaked lime and water. This has good resilience and will take the tesserae easily at a gentle pressure. It is a brilliant white, making it easy to see drawings transferred to it from tracing paper. It does not set hard while damp but, if left for long periods, does change chemically by absorbing carbon dioxide to become calcium carbonate, a firm chalky solid. Remember that slaked lime is a mild caustic alkali and should not contact the skin. This material is much used by the schools at Ravenna today.

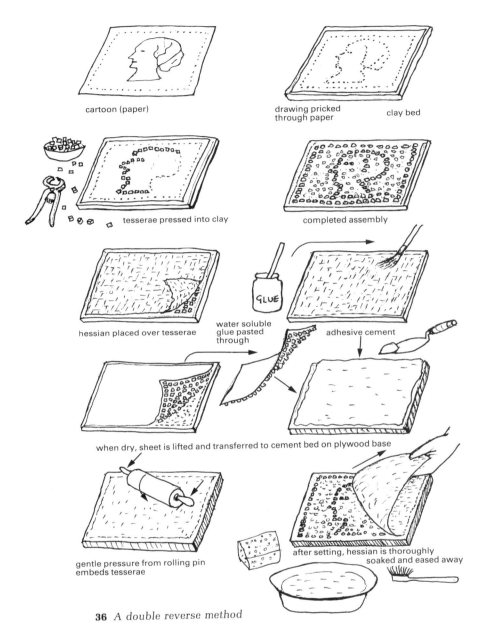

cartoon (paper)

drawing pricked through paper

clay bed

tesserae pressed into clay

completed assembly

hessian placed over tesserae

water soluble glue pasted through

GLUE

adhesive cement

when dry, sheet is lifted and transferred to cement bed on plywood base

gentle pressure from rolling pin embeds tesserae

after setting, hessian is thoroughly soaked and eased away

36 *A double reverse method*

Tesserae need not be of equal thickness but you should aim for a level surface. This can be achieved by pressing them in varying distances to compensate for any variations in thickness. A rolling pin might be lightly rolled over the complete assembly to achieve a level surface. This is to facilitate adhesion to the paper support.

When all is completed and the work is just as you want it, stick gummed paper, or an open-weave fabric such as hessian or burlap, over the surface of the tesserae (the ready gummed sheets of mosaic paper would be very convenient). Alternatively, coat a sheet of strong brown paper or fabric with a gum arabic solution or strong wallpaper paste. Make sure that the paper is thoroughly covered (or the fabric soaked) and is wet at the moment of application, then lay it over

the mosaic, lightly touching all its surface with finger pressure to make sure all the tesserae are in contact. After this, leave it to dry out – a few hours are recommended for complete drying. Do not be tempted to test too early.

When it is completely dry, you can ease the support away from the bed of clay or plasticine with the tesserae sticking to it. This is a delicate operation. If clay has been used and it is still in a soft condition, the tesserae should come away easily. With plasticine or semi-dry clay, it may be easier to turn the whole piece over with the paper lying flat on a table and ease the bed away from it. Sometimes it will roll away easily, but if it sticks, or is deeply held in the cracks, you may be faced with a slower job of picking it out bit by bit. It is difficult to give any guaranteed procedure, but the method required will be self-evident in each circumstance.

The result should be a sheet with tesserae firmly held by their front faces. This can be handled as for any of the indirect method procedures already described.

There are several points worth noting about this method.

1 You see the work as it will be seen while working.

2 You can work vertically at an easel, if preferred to table top working.

3 The completed assembly before papering has unlimited scope for alterations and corrections – you can take tesserae in and out for trials of colour, for example. This practice should not, however, be overindulged as it can lead to an indecisive and uncommitted design.

This method is also valuable for its use in restoration. Basically, it is the way in which a deteriorating mosaic can be lifted and transferred to a new bed. For large scale or heavy work, fabric would be used instead of paper. Many Roman works now in museums have been lifted from the ground in this way. The finer points of restoration are beyond the scope of this book, but it can be seen that the above is, in principle, the basic method.

CHAPTER V

Direct method again – texture and smalti

Inspirations from history

A careful look at a great historic example is more than just passive pleasure – it will give you a sense of participation, a feeling that you are following the movements of the mosaicist in placing each tessera. Mosaic as a medium is obvious. There are no essential secrets or mysteries – all is revealed.

We may not know the exact consistency of a cement used or details of what was mixed with it or how it was applied, but these are matters for inventive improvisation. We see each piece held in a matrix. This simplicity makes a strong appeal to the creative imagination, for we sense the act of placing as though we were actually making the mosaic afresh. The technique is manipulative. No special or unusual tools are needed, and simply looking often makes fingers restless to be doing.

Few can resist the temptation to touch a mosaic. If it is in reach, the fingers over the surface will often accompany the movement of the eye; if it is out of reach, then through the eye alone we experience inwardly the sense of doing. The mosaic is perfectly still but it is also frozen action – the result of movements – and can be an invitation to go and do likewise. This is why looking itself is a cause of action, and historic examples become more than just objects for detached admiration or scholarly information. There is a performance-like dimension which leads to a real understanding of the static surface. It is re-lived with each viewing and we come to read a mosaic tessera by tessera, as a musician might read a score note by note and mentally hear a structure of sound.

For reasons such as these, observing examples from history can rightly be called an inspiration. Nowhere is this more apparent than with Byzantine work. Its existence on walls or vaults precludes a necessity for smoothness, and the tesserae can therefore be left as directly placed in the cement, but with those variations in angles which naturally result from handling. The appearance is texture and glitter. The tesserae can be deliberately angled to exploit these possibilities. This means that, for the observer, any movement of the eye will pick up differing reflections of light; the still object will acquire a vibrancy according to our movements and there is a sense of life generated by our moving presence.

All this argues for on the spot experience of mosaic. There is no substitute for being in front of the real thing and with Byzantine mosaics this is most evident. As with sculpture, there is no absolute definitive view. None the less, the remarkable quality of modern reproductions can convey a sense of the textured surface, and, if we lose the physical presence, we can gain a detail of information from a photograph, because not all mosaics are easy to see. Many are high up and situated in dark churches, and special lighting and modern cameras have brought intimate knowledge of otherwise remote effects. A study of good reproductions will stimulate the imagination – particularly if we are using the materials ourselves.

Texture and colour are obvious qualities of Byzantine work. As we have seen, surfaces can have a ruggedness unlike the level Roman floor, and colour is more rich and varied than the palette which natural stone can sustain. The colours are, in fact, synthetic – a term which sounds modern and indeed is used for a material which can look modern in its brilliance. The material is known as smalti – a product made for decorative use and almost entirely identified with mosaic.

Smalti

Smalti is something between glass and enamel. It is melted in a kiln like glass – hence the name (Italian *smalto* – melt). It is pigmented and, unlike glass, becomes densely opaque. At a glance it resembles the colours of modern plastics, yet it is

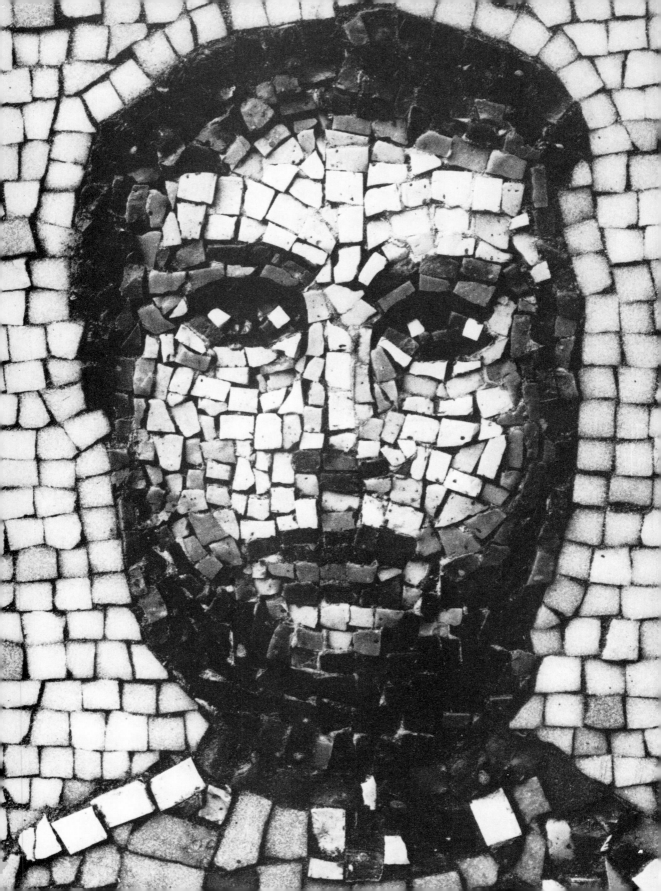

produced by an ancient process and has been made for centuries in the region of its origins – around Venice. As a mosaic material it is unique. There have been attempts to duplicate it in other places but nothing seems to match the qualities of Venetian smalti.

The hot molten material is poured on to flat metal plates where it spreads and then sets into thin sheets. These are broken up and cut by hand into tesserae – not, strictly speaking, cubes but oblong blocks about 15mm ($\frac{5}{8}$in) × 10mm ($\frac{3}{8}$in) × 5mm ($\frac{1}{4}$in). They approximate to these dimensions but, being hard to cut and allowing for the refractory material, they have slight natural variations distinguishing them from the standardized glass tiles.

The other important distinguishing feature is colour. Not only can this be very brilliant but it is possible to produce a great range of colours with many slight nuances – thousands of different ones are claimed. Smalti can easily match the range of possibilities of artists' paints to become a kind of palette for the mosaicist. If we do not have the possibility of controlling colour minutely by mixing one paint with another, we still have a limitless range of shades and tones to choose from. In fact, the effects of painting are more easily imitated with this material than with any other. But a word of warning: this possibility of far-ranging choice can be a pitfall. The aim in the best mosaics has not been the imitation of paintings but the use of the material for its own peculiar values. Smalti is a wonderful material but some colour limitation should be imposed upon it.

No material is so admired in its unused state as smalti. Jars or dishes of the different colours have a great attraction for anyone who has never seen them before. The little blocks of brilliant colour are irresistible – one must handle them. It is from these materials that mosaic gains the popular reputation for being a colourful medium – a bit like stained glass. Yet it is not in the sheer numbers of colours used that colour is achieved but in the way they are used. More detail will be given on this when we consider colour harmony.

Contrary to popular belief, there is an inherent danger in beautiful or valuable materials for the artist. The value of art lies in what is done with the materials not in the value of the material

37 *Head in smalti and glass*

itself. In using smalti be discerning. Select the few colours you really need and you will find these a great joy to use.

There is another regrettable deterrent to the excessive use of smalti – expense. It is far more costly than other mosaic materials. A job carried out with smalti must be much higher in price – hence its comparative rarity in modern work.

Using smalti

Because of roughness and irregularities in the tesserae, smalti can only be used in the direct method. Even then it is best used without grouting. The most satisfactory use of smalti is in the most direct of methods – that of simply pressing the tesserae into a soft bed of cement and allowing this to rise with the pressure to fill the cracks to whatever extent you want. As you gently press, so the cement will rise around the tesserae. You may only want it sufficient to hold the piece, or you may want it close to the top, giving a more or less level surface. You can even cause the cement to rise slightly above the level of the tesserae and perhaps make a special textural feature of this.

So long as the cement has enough grip on each piece there are no strict rules to follow. Experimentation and personal taste should be the guide. Scrutiny of great examples – in real life or via the many excellent photographs – will be your inspiration.

It is possible to grout a smalti mosaic even if its texture is very rough, but it is a difficult and tedious business requiring a piece by piece cleaning technique. The material itself is pitted with little bubble holes and these retain the grout. However, if you can make an actual feature of this, not a mistake for apology, then it could be a special effect. I prefer to avoid grouting smalti as, for me, its use means the freshness and simplicity of direct method at its best. The work is done with the transparent simplicity of mosaic technique and is direct not only in method but in thought and feeling. There are no secrets or mysteries.

One aspect of smalti does have secrecy and mystery – its manufacture. This derives from family traditions stretching back through generations. As I am interested only in the assembly of the mosaic, and not in making the materials, I am content to leave the secrets of smalti making where they have always been, with the Venetians. It is often thought that, as a mosaicist, you

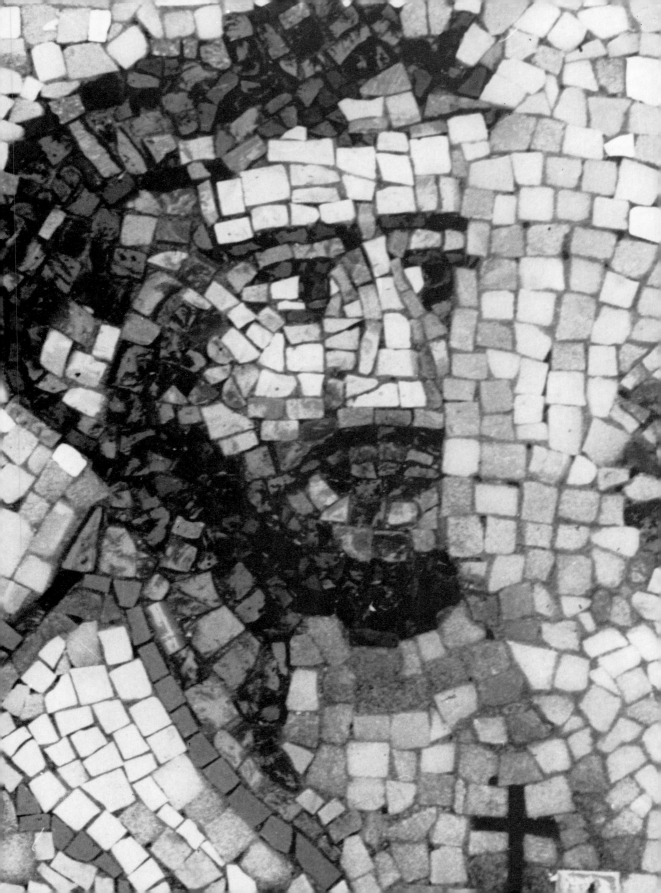

will make the materials, but this is no more likely nowadays than for a painter to make his own paints. The art of mosaic is the art of using the materials, not of making them.

Smalti – cut and uncut

The hand-made irregularities of the smalti obtained from suppliers make them an acceptable material in themselves. They lack the mechanical regularity of glass or ceramic tiles, so may be used direct without cutting – that is to say cutting in the studio, since, as we have seen, they have already been cut from the original solidified cake. Their size and shape too are pleasing units for assembly – not squares or cubes but well-proportioned little blocks.

For large-scale work, direct application can be most convenient and pleasing. There is also a possibility of using them edge on instead of flat, and thus the thin smooth edge would be the one seen. In this case you would be dealing with longish visual units – dashes of colour with very accentuated direction. The overall effect will be very textural, though the actual edge of each tessera will be smooth. At the mundane level of economy, excessive use in this way is not efficient, since the bulk of the precious smalti piece remains invisible. For the rare money-no-object piece with visual effect the priority, such a technique is possible.

More often, you will need to cut smalti. It can be cut in the same way as other materials, with nippers or hammer and hardie, but the direction of fracture is less predictable. You will probably have more wastage than with other materials, and you may find fragments more likely to fly off from cracking, so the usual precautions are emphasized.

Smalti scraps

When the solidified cakes of colour are cut up to make the tesserae, many imperfect edge pieces are left over. These are often sold off by suppliers at much lower rates – usually as batches of mixed colour scraps. Although the shapes are very irregular, the colour is exactly the same as the tesserae passed for sale as perfect. It is worth getting some of these scraps. Colours can easily be re-sorted and the chunky pieces can, with

38 *Head of Christ: detail from the Stations of the Cross, The Church of St Boniface, Crediton, Devon*

care, be cut to manageable pieces or, for an intentionally rugged textural work, they may be found most suitable as they are. To the inventive artist, imperfection can be transformed into the character of the work. They can become special visual effects.

Silver and gold

Grouped with smalti one finds silver and gold. These are actually square glass tiles into which metal leaf has been incorporated. Genuine gold or silver leaf is suspended in glass just below the surface. The effect is one of incomparable richness, having all the lustre of gold and the smooth shine of glass. The tiles have another admirable quality: the glass used as support is a deep green or blue and so, from the back, one sees the reflecting metal leaf through a transparent colour. Used back way on, they produce a wonderful, deep, colourful glitter.

These gold and silver glass tiles cut easily and accurately. In every way they are an admirable material, except, as one might expect, in cost. They are the most expensive of mosaic materials, but they are visually enriching. Even small amounts, discreetly introduced into a large area of colour, will give lively emphasis, like the highlights of a painting. Large solid areas of gold or silver may be necessary for certain high-costed designs. Such use always has a sober, enriching effect and does not result in the paradoxical vulgarity of expensive material used for sheer ostentation.

It is always good to have at least a little silver and gold in stock for colour highlighting.

A small direct panel

For a small panel you can use wood as before (p.35). Apply your soft cement in convenient areas and simply impress it with tesserae – the simplest of direct methods. But a few points need careful attention.

The cement used must be adhesive and must bond well to the base. The usual mixture of sand and cement will not adhere reliably to wood (even though it always seems to do so when you attempt to clean surfaces on which it has been unintentionally left!). It can be used on wood with a reinforcement of expanded metal, but, for the moment, we will consider a simpler method. (I am using the word 'cement' here to mean a

bonding material for the tesserae, whatever it is composed of – not just Portland cement as used in concrete.)

You will need a small 12mm ($\frac{1}{2}$in) thick plywood panel as before – about 30cm (1ft) square is a useful size to start with. Its surface should be roughened by criss-cross scratching. The cement will be a self-prepared mixture of sand and acrylic adhesive. This can be the binder sold for use in acrylic painting. It can be bought in small jars or tubes as a painting medium, but it is more economic to buy it in larger quantities – a litre (1$\frac{3}{4}$ pints) or even larger amounts are useful to have and the relative cost will diminish with quantity. The material has an unlimited shelf life so long as it is kept well stoppered. An alternative can be any of the strong bonding glues, such as Unibond, or any of the polyester resin glues.

Make a stiff mixture of sand and glue with a palette knife on a smooth slab or piece of glass; fine sand is better for this than sharp sand. Colour preference may influence choice, and remember that the mixture will be visible as part of the finished result. Only mix up enough for the foreseeable period of work. Any left over when you break off can be covered with a damp cloth and kept for the next session. The binder dries by evaporation and must, therefore, be kept airtight. Whilst wet, these resin glues mix with water, but once they dry they are no longer water soluble. Your cement mixture will dry rock hard. It is extremely adhesive – clinging to the wood surface and gripping the embedded tesserae.

You should draw your design on the wood panel with any easily visible material. As usual, a good, bold, simple design is very suitable. Charcoal is excellent visually, but, if used, should be well fixed (i.e. sprayed with the usual pastel fixative), since its dusty surface can reduce adhesion.

For this piece use glass tesserae or make it a trial piece with smalti.

Proceed by applying pats of the mixture over convenient areas of the design and impressing them with tesserae. Cutting can be done as before and as preferred – either piece by piece or a considerable number cut in readiness. Aim to have about 1–2cm ($\frac{3}{8}$–$\frac{3}{4}$in) depth of the cement. Gently press the tesserae into it. A sensitive touch is needed to allow the cement to rise to a suitable extent round each tessera. As you bring row after row close together, you will find that the cement seems to have a living unity, some-times rising in adjacent cracks. A slightly vibratory touch will often ensure good bedding of tesserae into the cement, but all this is a matter for personal experimentation and preference. Placing tesserae is a personal touch like the brushwork in painting.

Angles of surfaces will not all be the same. This can be deliberately exploited to produce reflection in certain directions – an effect suited to work done *in situ* – but on a small trial piece the natural variations of the hand placing will of themselves give you a glittering surface which changes with the angle of viewing.

When you have covered the board in this way, there is nothing else to do, and so you arrive at the result directly and simply – a method that will appeal to painters who want to try their hand at mosaic. However, if you work on this piece vertically at an easel, like a painting, take care that the cement is stiff enough to stay put while drying. A soft mixture can (even very slowly) droop down the surface before drying. Small panels are better done by this method flat on a table, or at a low angle.

Some points to note

As carried out above, the work has the great advantages of directness, simplicity, comparative speed of execution and, perhaps most important, visibility of effects as you proceed: there is no need to estimate effects in the future, as with grouting or reversal. For many purposes it will be ideal.

A possible disadvantage to bear in mind is that alterations are difficult to make and should, if possible, be avoided, even while the bed is still wet (the whole body of the tesserae and cement settles into a unity and withdrawal of a piece upsets the assembly, making it difficult to relocate). The work has a spontaneity which is apparent in the finished work.

Though resin glues are not soluble in water once they have dried, they are not generally waterproof – prolonged exposure to wet conditions softens them, so the work is not suitable for open air or places with regular condensation.

Colour and texture

The cement enclosing the tesserae in this method can be made even more conspicuous by allowing it to stand above the level of the tesserae. This is done by pressing each tessera well home and

forcing up the cement into a surrounding ridge. If you try this, take care not to touch the cement. It can easily be smudged while wet, resulting in a blemish that is difficult and tedious to remove. With such prominent use of the cement any alteration should be avoided. A single touch technique for each tessera is best.

The cement (here again used in the general sense of the bedding mixture) has great possibilities for colour variation. It is, in effect, like a thick paint, the resin being the binder and the sand the pigment. Powder pigments can, in fact, be introduced for strong colour effects but should not be used excessively. Because of the fineness of their grains, they do not have the same supporting body as sand. Sand can supply bulk, and small amounts of pigment adjust the colour. The pigments need not be special cement colourants – ordinary dry powder pigments, as obtainable from art suppliers, are suitable. Many possibilities for experiments are invitations for personal preferences and developments.

Results – appearance and presentation
The method just described is the most pictorial – it most resembles that of picture-making by painting techniques. The result is a small mosaic picture – a panel of perhaps 2–3cm (approx. 1in) in total thickness but still of modest weight and therefore capable of being hung like a picture from a wall hook.

You can screw into the wooden back so long as you are careful not to exceed the thickness of the wood in penetration. Two screws or screw-eyes joined by a wire or nylon string provide the simplest way of hanging your work from a wall hook. Make the string or wire fairly short so that the panel will cover the hook and you will have an isolated unit against the surrounding wall.

The whole surface needs to be seen, which means that framing mosaics is a matter of dealing with the edges only. Four strips of mitred wood, fitting tightly round the panel and tacked, screwed or glued on to it, provide an adequate and effective finish.

The framing of portable mosaics should be as simple as possible to leave the entire visual effect to the surface; it is more a matter of a neat and acceptable edge to the work than a contributive visual effect.

For other methods of finishing edges see 'Edges and finishing' (p.107).

CHAPTER VI

The studio and working methods

Where to work

Mosaic is a simple technique but it does involve the use of bulky and heavy materials and it does produce mess.

I have not dealt with studio organization until this chapter so that any newcomer to mosaic, having read so far, will know something about working methods and be in a position to consider practicalities with more understanding. The planning and organization of a big studio or even a small temporary work space is largely a matter of commonsense and personal preference; what this chapter offers is some basic guidelines.

The studio is your place of work. Ideally it should be a spacious room set aside for the one purpose, but I am sure many people will want to start mosaic who do not have these ideal conditions. I have myself at times done mosaics under all kinds of conditions. The activity may have to be carried on in daily domestic situations, perhaps alongside other work.

Organization is important and to achieve this we must recognize the two facts mentioned above – there will be things to store and there will be mess. Fortunately, the mess is mainly dry – in the form of chippings and dust – and can be swept and vacuumed away. Storage will relate to ambitions. You can do modest pieces with a limited colour range but you will need containers in which to keep your colours. There will be adhesives, boards and tools – and these are only the basics.

Extreme limitations

Given no specific studio, you might set aside a corner of a room with perhaps several shelves for storage and a table top for work surface. Lighting should be good – either daylight or some of the many directional lights available.

To limit the spread of mess under these circumstances, you might make a portable working box out of three vertical boards, each about 1m (39in) square, fixed around one base board of the same size. This open box can be placed on a table and you can sit in front of it, leaning inside to do cutting and sticking. This can provide good conditions for small work, and certainly limits the spread of chippings, but, because of the more confined conditions, greater attention should be paid to safety precautions from flying chippings and from dust. Goggles and mask are doubly recommended when working in this way.

A light could be set up above the box and, for anyone working at home and without a special studio, you could have a kind of portable studio box, perhaps folding for storage when out of use. Various ways for putting together such a contrivance can easily be found by any capable handyman. Ideas such as this show that, if you really want to do it, there are ways and means of doing mosaics under all kinds of circumstances. The medium is most adaptable. Restrictions on materials can be imposed if necessary – black and white instead of multicolour – for ease of storage. For the dedicated it is better to do any mosaic than no mosaic at all. Even situations of temporary residence or travel can be utilized with ingenuity and flexibility.

The permanent studio

Storing tesserae

Under more ideal circumstances you will want to set up a studio for regular work and perhaps for larger or more ambitious projects. Then space becomes important – not so much the actual area of working (as we have seen that this can be curtailed) as the volume of storage which goes with mosaic.

39 *Studio: Elaine Goodwin with work in progress. Trolley is useful for jars of tesserae in use; note chippings*

40 *The portable studio for small work: a simple way of limiting the spread of chippings*

Shelving is most important for keeping tesserae and raw materials, and these should, preferably, be easily visible. Organization is important. Different kinds of material should be separated, for example ceramics, glass, smalti, natural materials. Colour grouping is a good scheme within the larger divisions of material types. Each colour can have an area of shelf reserved for it.

For visibility, the obvious way to store tesserae is in glass jars. Large bottles containing several pounds of glass, smalti or ceramic tesserae are convenient for quick handling. They also make an attractive colourful feature in the studio, easy for reference if discussing a scheme with a client, or, for those of us who are stimulated to work by the sight of materials, a possible source of future colour schemes.

If tesserae cannot be stored in transparent jars, then the contents should be clearly shown on the outside, for example by sticking a specimen of the contents on the outside of a box or tin to give instant reference. Searching through boxes to find what you need is very frustrating.

Larger quantities of tesserae may have to be stored differently, perhaps in bags or cardboard boxes. Stocks for longer term plans might be held in this way, while small quantities for immediate use can be bottled and shelved.

Some tiles (glass and ceramic) intended for commercial use are sold ready stuck to brown paper sheets. This can be a compact way of storing them, as the sheets lie easily on top of one another. When needed, they have to be soaked off the paper and can then take their place in the jars.

Some mosaic suppliers sell (often at much reduced prices) boxes of random mixtures, some of which may be imperfect for commercial use. You take a chance on what colours may be in the mix but stocks of these can be excellent for our use. They can be sorted into main colour divisions, and the odd accidental piece which you may never have thought of ordering can be an interesting variant in colourful compositions. A rummage through such a box has the fascination of a treasure hunt. A box of randoms always has a useful place in a studio. You will, of course, accumulate your own scrap after working sessions, some of which is rescuable, although much will be waste. You have to make your own decisions on what is or is not worth keeping.

Other storable materials are natural stones. These may be cut marble tesserae – increasingly hard to get outside Italy. Discoveries of these are treasures. Natural materials in the form of pebbles can be a great temptation to collect and store. Unless you are able to get very large numbers of reasonable consistency in size and colour, however, they are not so likely to be useful except perhaps as variations in a collage-type mosaic. Pebbles, too, can be kept visibly in jars. Another use of the pebble is for splitting into sections. This involves long, difficult work with hardie and hammer. If you have the time and energy, and know a good source in nature, then it could be worthwhile to collect, cut and store your own natural stones.

Perhaps a more common source of unconventional tesserae will be in scrap pottery and china. This can involve much storage space but, once you become a collector, you will find it hard to resist the odd bonus from a kitchen breakage or bits redeemed from the scrap heap. Sometimes these can be cut up and stored as materials in the same way as any other tesserae. Sometimes you may want to keep a whole large piece because of an image on it – flowers, words, decorative features, for example. With this kind of material, and with the collage-like use in mind, you will want to keep bags of broken crockery. There is always the temptation to keep anything for

41 *The author in the studio. Shelving is priority —
note use of glass jars for small amounts of
materials and easy recognition*

future use, and the mosaicist easily becomes a
magpie. The fact is that bits and pieces do
sometimes 'come in useful', even a long time after
being collected. There are no rules here, and any
decisions will be dependent on the type of work
you want to do and the storage space you have.

Storing adhesives and cement

Various cans and tubes of adhesive might be on
shelves or in a cupboard for tidiness and safety.
You accumulate quite a number of materials of

this kind but certain favourites will no doubt
establish prior claims on your space. You should
note the shelf life of adhesives and check them
from time to time. Always take care to put lids
and stoppers firmly back on containers of adhe-
sives. Manufacturers' instructions should be
carefully followed.

Cement has its special problems in dry storage.
It is most economically bought in the large bags
or sacks for builders' use, but it does not last
indefinitely and so you should judge stockage
according to needs. The large bags should be
stored flat on their sides – not upright (extra
weight on the bottom ends presses the powder).
A small slit in the side allows removal of required
quantities in convenient containers. Dryness is

the essential condition for storage. Keep bags off stone or tile floors and, if possible, store on wooden shelves, preferably slatted. Cement should be a very fine powder. If, however, it has compounded into solid lumps, do not immediately discard it. If the lumps crumble easily or can be ground into powder then it has not set and is still usable. If the lumps are rock hard, it is useless.

Wet cement disposal

You will often have surplus wet cement left over, or watery 'slurry' after clearing out containers used for mixing, but do not be tempted to pour it down drains or toilets, even if it is watery. It can settle and lodge in pipes and, over a period of time, can cause serious blockage.

Cement and safety

Cement should never be handled with bare hands: it is alkaline and affects the skin. Sometimes its effects are not immediately noticeable, making you believe it is harmless, but it can produce unpleasant 'burns', so keep rubber gloves or protective barrier cream in the studio.

Sand storage

Sand is another bulky item. Dryness is not essential, so it is easier to store than cement. Large plastic bags standing upright on the floor are good for the most generally used sands. Sand can also be a good colourant in mixtures, especially for grouting, so you will very likely accumulate a range of smaller quantity stocks in favourite colours as they occur – perhaps from chance finds in nature. Choose glass jars for easy storage and identification.

Visual stimuli

This may be only studio decor, but a pin-up board can be useful as a reminder of mosaic imagery. It may be postcards you have gathered in travels, snippets from books or papers, your own drawings, or photographs of work (your own and others). These things around the working place may remind you of themes for mosaics, stimulate future projects and, in the long term, contribute to your development as a mosaicist when development concerns life and ideas as well as skill with tools.

Other stimulants might be found objects. These are things that few artists can resist. Some of the stones, broken fragments, etc. may be destined for inclusion in mosaic collage, whilst others are just to delight the mind.

Every artist or craftsperson will accumulate their collection of visual stimuli, as unique as a diary; my intention is only to draw attention to the value of such magpieism and suggest a place for it in studio planning.

Work storage

Another ever-growing problem is the storage of finished pieces. Mosaics are heavy and less easily stored than paintings. Shelves or racks are useful to a studio, but a happier disposal is to place them around the house to be enjoyed and shared. Pieces suitable for outside might go in a garden and thus extend the sharing. Happier still, some will go further afield as sales and commissions – the best solution to a storage problem.

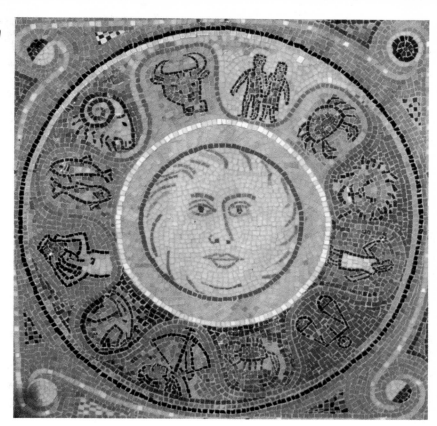

'Zodiac' — *vitreous glass* — 91cm (3ft) x 91cm (3ft)

'Offering' — *mixed media*

Yantra (detail) — vitreous glass — 91cm (3ft) x 91cm (3ft)

'Tree of life' — mixed media — 3m (10ft) x 4.5m (15ft)

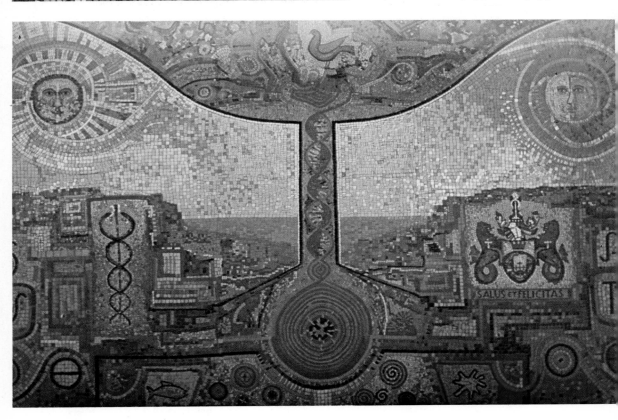

CHAPTER VII
Studio work for remote siting

It would be rare today to do a mosaic mural by direct method on the actual wall. Time required on the site would make it highly inconvenient for both the artist and others using or working on the building. The indirect method is one modern answer, but when the special qualities of the direct method are needed, ways of completing or nearly completing the work in the studio and then installing it on the site must be found. Plywood again is a good base for such work. For work exposed to weather or regularly damp conditions, marine plywood should be used and resin bound cement avoided.

For panels up to a maximum of about 1.5m² (16sq.ft) a single piece of plywood can be used. This is about the largest size conveniently manageable from the point of view of weight and availability of boards. Larger pieces must be done in sections and fitted together on site.

A single panel can be conveniently made in the studio in the way described in Chapter V. If you want it to be a permanent feature of the wall, you should plan for this in advance and avoid using visible supports such as mirror plate screws. Before working the mosaic, but after drawing the design on the board, decide on convenient points to place screw holes through the board. Drill and countersink holes in the board – at least four of them. Convenient points will probably be near the four corners, not necessarily symmetrically, and not coinciding with key points in the design.

Work can now proceed as before. Using a PVA adhesive cement, the entire work can be carried out in the studio. Remember to seal the board and roughen up the surface with criss-cross scratchings. The only parts not covered will be small areas over and around the screw holes.

When completed, move to the site. Drill and plug holes for the screws. Place the panel (you will need some assistance in holding it in place) and screw it tightly to the wall. If there is any likelihood of damp in the wall, use brass screws.

To finish the mosaic, cover the screws with the same cement mixture and place a few tesserae needed to fill these gaps. If you match these carefully in colour and direction, there should be no sign of the screw positions in the final work. The edges may already have been dealt with in the studio but, if not, a band of cement or a hard-

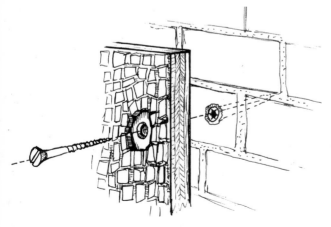

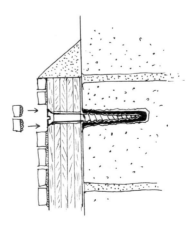

42 *Fixing a panel to a wall for permanent siting*

setting plaster filler can be trowelled on. This will make the panel a feature of the wall. The surrounding finish will depend very much on circumstances. For example, on a new unplastered wall, the mosaic could be placed first and plastering done around it by the builders. Alternatively, plastering could be done and an area left uncovered for the reception of the mosaic. In these ways a level wall surface can result, truly integrating the mosaic feature with the wall.

Portland cement on a wood base

You can carry out a panel, more or less as described above, using a sand and Portland cement mixture instead of the PVA adhesive cement, but you will need to incorporate metal reinforcement. Using a Portland cement, and basing it on marine ply, the work can be placed outside or in places of damp exposure (e.g. bathroom or swimming pool walls).

Having decided upon the board to be used, cut a sheet of expanded metal to the same size with metal sheers, then firmly tack it to the board with staples placed at about 15cm (6in) intervals.

Preliminary drawing is less easily done for this method as we have a very rugged working surface. However, one way of overcoming this difficulty is by drawing on the board before attaching the expanded metal. You will be able to see through the gaps in the metal sufficiently to follow your drawing in spreading mortar (i.e. cement/sand mixture) and laying tesserae. To help this visibility, make the drawing extra bold, for example using just a broad black outline and no detail – a characteristic very suitable for mosaic interpretation anyway. A separate cartoon on paper will also be useful for following during execution.

An alternative to expanded metal can be wire mesh stapled down at rather closer intervals. It is easier to draw on top of this by marking out your bold outlines with a brush and ink. Do not use any paint which may interfere with adhesion; black watercolour would serve well.

You can start working in any convenient way, perhaps methodically over the surface from, say, top to bottom. This can be suitable for a very well worked out design with shapes, colours and as many details as possible decided in advance and with a minimum of improvisations. This would be a sensible craft-like way of working. Or you may prefer to start from some visually important point in the design, perhaps centrally placed, and work away from it. For example, in doing a face, the eyes might be an obvious centre of interest to start with, building the face around them and subsequently adding the background. This is a more painter-like approach in which you are watching what you do as you do it and responding with possible adjustments. Either way, you should, of course, watch for all the visual effects as you proceed and be prepared to make adjustments and corrections. The important point is that the work must look right.

Spread enough mortar for each working period. This will be the usual sand/cement, three to one mixture. In applying it, work it well into the gaps of the expanded metal and leave enough above the metal to receive the tesserae – say about 6mm ($\frac{1}{4}$in). Clean off any surplus at the end of each session. Do not mix up with water or spread more than enough for about a predictable one hour working period. This gives the strongest setting time.

Panels carried out in this method will be much heavier than with resin glue and consequently less portable or suitable to be hung temporarily as a picture. For a permanent siting, the method is good and you can have concealed screw fixing as previously described.

Working with sections

For any large-scale projects, the work must be broken down into sections – because of weight and handling and because boards are not normally supplied more than 1.22m (4ft) in width. Maximum units will be around 1.5m² (16sq.ft) in area.

To get the best unity in the finished mosaic, you must have irregular shapes which will fit together tightly. Curving sections help to conceal junction lines better than straight ones.

A large sectional mural
Take 12mm ($\frac{1}{2}$in) plywood boards to cover an area larger than the proposed final work. These must be overlapped at the joints and clamped together. Mark out a wavy junction line, making sure that your line is well within the area of overlap. Then, with a portable jig saw, cut along the line through the two pieces together. Unclamp and remove the waste pieces and you will have two boards which fit together in the manner of a jigsaw puzzle. Plan out and make up your whole area of mural

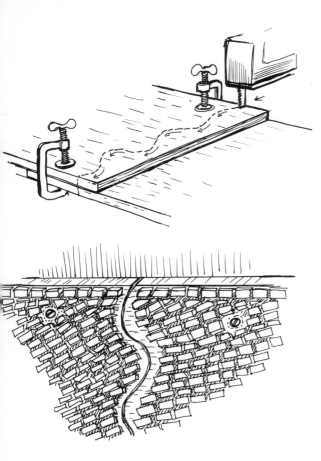

43 *Cutting and joining wood bases: a curving line makes for better linkage*

surface in this way. The pieces can be assembled on a floor as a trial of exact size and fitting.

Decide on suitable places for screw holes in each section; drill and countersink these.

The work itself may be carried out on the floor if you find it convenient to work sitting or kneeling. If you want to work vertically and have the whole assembly visible, you will have to make up a temporary frame to hold the sections together. This requires plenty of studio space and, if this is unavailable, the sections can be worked separately one by one on your work table. Careful planning and following of the design will be needed to make sure that unity is achieved when the pieces are put together. If possible, a trial assembly of the sections is desirable before transference to the site – perhaps on the ground in the open air, with viewing from an upper window to get a long view.

The mosaic is applied as for a single panel, either with a resin glue and sand mixture, or with the cement mortar and metal reinforcement. You should not work right up to the edges of each section, however, but leave a small area uncovered (about 2.5cm (1in) all round). This is done on site after assembly and will unite one section with another. You will be able to carry the lines of tesserae over the cracks and thus conceal all the joints from view.

In planning and working the sections, take care to make the flow of tesserae continuous over the crack. This is where it is advantageous to be able to put at least the adjacent panels together while working on them.

You should also leave small areas round the screw holes. After each section has been firmly screwed into a well-plugged wall, you can work over the screws, carrying on the directions of the tesserae.

In this way it is possible to carry out a large-scale mural conveniently in sections and without any of the joints or fixing points being apparent in the final result.

Frontal direct method

This is a modern method developed originally for commercial use in ready-made mosaic patterns used for wall cladding. The tesserae are attached to a glass fibre or nylon fabric which enables them to be carried to the site and pressed into a wet cement. It has similarities with the indirect papered mosaics except that the assembly remains the right way round throughout and the supporting fabric does not have to be removed but is incorporated into the cement. The following is an adaptation of this technique for use in creative work.

To do a small single unit – for example a square or circle – you will need a piece of nylon or glass fibre open mesh equal in size to the work, and a piece of silicone treated paper at least equal in size. The paper must be water repellent and unable to adhere to water based glue.

Draw your design boldly on this paper, and lay the canvas mesh over it. The strong lines of the drawing will be visible through the mesh so you can easily follow them and overlay them with the tesserae. Each tessera first has a small blob of a strong resin glue placed on its back. It is then put in the appropriate position on the mesh. The glue should make a firm bond between tesserae and

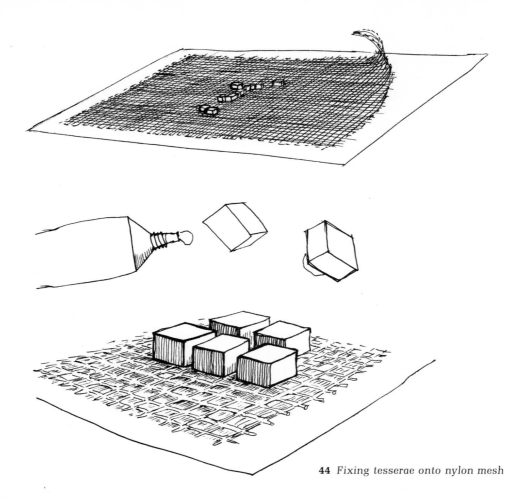

44 *Fixing tesserae onto nylon mesh*

mesh, and the surplus glue which passes through the gaps in the mesh will be stopped by the silicone paper but should not stick to it.

Carry out your work in this way, rather as though doing a direct method piece on a plywood base. When the work is finished it must be left standing until all the glue has completely hardened – 24 hours is advisable. Then it should be possible to lift up the fabric mesh with all the tesserae firmly adhering to it but leaving the silicone paper behind. A blob in the centre of each piece is enough to hold it – pieces do not need to be completely covered with glue. The prepared sheet can be moved any distance or stored any length of time until the bed is ready.

To prepare an area of wall, clean it down to the bricks (if an old wall). Some short masonry nails knocked in just short of the heads will give an extra grip for rendering. The latter should be done in two coats: first a coarse layer, criss-crossed and left for at least 24 hours, then a finer setting layer trowelled on. As soon as the second layer is complete, you can place the mosaic sheet on to it. Extra helping hands are useful for getting an exact placing before pressing. When correctly placed, press it firmly into the wet cement. This can be done evenly by means of a board or wood block. The mortar should penetrate the mesh between the tesserae and make a good bond with the whole unit sheet. It will not, however, fill these gaps and after setting – again at least 24 hours – a fine grouting can be spread, wiped off and the whole finally cleaned up with rags and a rub over with fine sand. If necessary, after completely drying out, it could be cleaned with acid as in other examples.

This method can be a very convenient way of doing work in the studio for siting elsewhere. You do not lose sight of your design and, except for the effects of grouting, you will know just

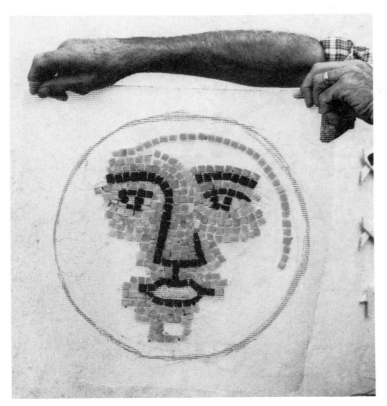

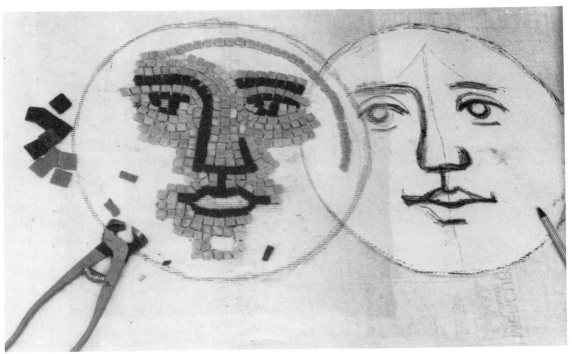

how it will look at all times. However, corrections after the glue has dried out are difficult, if not impossible, without cutting out a piece of the mesh support, so care should be taken to avoid the need for alterations.

It is best to try a small single piece first, but there is no reason why the method should not be used for large-scale work in which a scheme would be broken down into manageable sections. Great care is needed in assembling separate units as there is little possibility for adjustment once they have been bedded into the cement. For special projects and large areas, the assistance of a professional tile setter would be desirable.

Varied kinds of tesserae can be used. They do not have to be exactly equal in thickness and so textural qualities in the final result are possible – an effect eliminated in the reverse method. Very large variations in thickness may make for difficulties in transporting, and excessive weight will strain the mesh support. Fairly thin tile-like tesserae are the best material to use. The final work is thoroughly integrated and inseparable from the wall, the fibre thread becoming a kind of reinforcement in the cement.

Floors and the fabric support

The same method can be used for floors, providing that the tesserae are all of equal thickness, thus producing a level surface. It will give an alternative to the more usual reverse method – chosen for its resulting level surface. Again, being able to see the work the correct way round at all times is useful, and a final layout on a floor allows a visual check before setting.

For floors or walls the method means a single consistent mix of the cement and a single occasion application.

Mosaic as collage

Ancient and modern

The most obvious connections of mosaic are with ancient techniques, and a clear comparison is with the art of painting; yet it can have new similarities with modern techniques. Collage, now an accepted art medium, is the sticking down of material which is generally flat and often light and flimsy (paper, fabric, etc.). Mosaic might be seen as a kind of heavy collage using cement instead of paste.

There is a strange precedent for the inclusion of a different material in an example from early history: the pebble mosaic at Pella in Greece. Metal strips are used to differentiate areas of colour and so become a kind of drawing line. They are unobtrusive and scarcely noticeable in photographs of these works.

The all-important directional values of tesserae will diminish if we think of the mosaic more as an assemblage of formed pieces rather than a tight structure of cut or made tesserae. Horizons widen in a series of totally different possibilities. I want now to consider these relative to the art of collage and as a different source of mosaic material and technique.

The value of scrap

Crockery, tiles, broken pots — all manner of ceramic objects can be a vast source of material. These are not so much cheap substitutes for the more traditional forms of mosaic tesserae but alternative materials with their own particular values. Of course, ordinary ceramic tiles can be cut down with nippers quite easily to become regular tesserae, and this may result in just an alternative supply for use in any of the previously described techniques. But we must note that irregularities in anything but flat tiles will render them unsuitable for indirect or reversal techniques. In fact, curvature on such things as cups, saucers and dishes, even when cut down to small fragments, means that they are really only suitable for direct pressing into a cement bed. We should also note that, in many cases, colour will be surface glazed, and cut edges will usually display a different colour — the colour of the ceramic body. None the less, accepting such limitations and conditions, a big supply of cheap useful material can be built up. It can, of course, also be a consoling, redemptive process for household breakages.

You can gather up likely material whenever and wherever it may be found, sort it out and store it until a use occurs. Sometimes china shops, if alerted to your activities, will let you have their breakages or unsold stock at clearance times. Friends may present you with broken pots. Once you become watchful for this kind of thing, it will be found. You will develop a discriminating eye for all manner of scrap 'treasures'.

Many of your scraps will have unique appeal in themselves — perhaps fragments of an old pot, a decorative feature, a trade mark, a bit of pattern — these are pieces in their own right for use as collage-like components, not just raw material for breaking down. The putting together of such features into an organized scheme is very much the same as composing a collage picture with scraps of printed paper. It is an art of selection depending much on a purely intuitive response to available material. Some conspicuous feature might start it all off and around this you will assemble other pieces — perhaps because of some association, perhaps because of a simple visual correspondence of colour, shape or pattern. The process is not a logical one. It depends so much on what is found and cannot, therefore, be planned out in advance. It is much less dependent on preliminary drawings and more a spontaneous unpredictable effect. Accepting all these possibilities and limitations, scrap mosaics can be fascinating to carry out and nearly always result in a rich and enjoyable visual effect.

46 *Mosaic from scrap*

A scrap mosaic

Scrap mosaics are ideal for garden features. A good trial piece might be done on a spare bit of garden wall. You will find that it is generally possible to manage a much larger area than with a structured pattern of small tesserae. In fact, it is more difficult to make this technique effective on small areas, since it is essentially bold in character.

Having chosen your area of wall, say a few square metres (yards) in area, render it with the usual sand and cement, three to one mixture. Leave it to set with the surface roughened by criss-cross scratchings. This is the basic layer. On to this apply a second layer for receiving your scrap pieces, but this must, of course, be applied only in sufficient areas for immediate work, i.e. up to one hour's work. Before stopping for breaks, clean off any surplus cement. The technique is simply one of pressing in the fragments of tile, pottery or whatever, until they are well bedded. The vibratory touch will help this, especially with large pieces where even a few taps from the trowel will help the tile to sink and the mortar to rise up its sides. There are no strict rules, just experiment and find the best way of applying your pieces. However, continuity makes things easier to do and the design more coherent. Follow on one piece from the previous one and try to achieve some directional order.

When finished, no grouting is needed but smudges of mortar will often have marred tile surfaces and, if these have not been thoroughly cleaned off when wet, some vigorous cleaning may be necessary, perhaps even with acid.

Possibilities for this kind of work are very great and varied: they might derive from folk art decoration; they might be a kind of naïve art done without any art experience or training, or they might be part of sophisticated architectural planning. There is little to be said about technique. The best way to indicate possibilities and maybe stimulate activity is to look at a few major examples.

Gaudí and architectural decoration

The Spanish architect Antonio Gaudí was an innovator in the use of mosaics made of scrap material. His architectural design itself is notable for its organic qualities, seeming at times to be an extension of nature; his built environments emerge harmoniously out of surrounding land forms. It has been called biological architecture.

His outstanding early example is the Guell Park in Barcelona, completed before 1914. The whole scheme incorporates a church, constructed terraces and an extensive garden development stretching over a hillside. The constructions are like large organic sculptures, but in certain parts, notably on the upper terrace, they are covered with broken tile mosaics. The extensive surface decoration in Gaudí's work comes partly from Islamic influence, but his use of the material is original – perhaps anticipating Dada and surreal collage. Some bizarre effects are achieved by juxtapositions of recognizable bits of domestic crockery embedded in concrete.

The technique raises interesting questions. Was it simply economy? The vast undertaking and the lavish support given to Gaudí by his sponsor Guell, after whom the park is named, would suggest that the use of broken scrap material instead of perfect new material was hardly an economic necessity. Surely he wanted it the way it is. Would it be better with perfect tiles? Some tiles, in fact, were deliberately broken. The technique points to the fascination of fragmentation. Even if all the pieces of a complete tile are visible (as in some cases they are), the cracks between pieces add a new interest to the pattern. Perhaps it is the old attraction of losing and finding – we see what should be the completed object but we also see that something has happened to it. The cracking gives a dynamic life – a secondary level of meaning – to what otherwise would be conventional tiling. The evidence of the success of a work of this kind is to be seen in the great popularity of the park. It is much used by the community as well as being visited by many foreign admirers.

Another use of broken tile work is to be found on Gaudí's unfinished masterpiece, the enormous Church of the Sagrada Familia in Barcelona (constructed 1883–1926). Here it is used to cover the high pinnacles in exotic patterns reminiscent of Islamic art. The pinnacles themselves are like enormous fungoid growths. The combination of the tile surface with such structural invention puts these pinnacles among the most remarkable features in modern architecture. From street level the colour and texture are not conspicuous, but for those who ascend the towers, a closer view turns them into pure sculptural fantasy.

The work of Gaudí introduces possibilities for

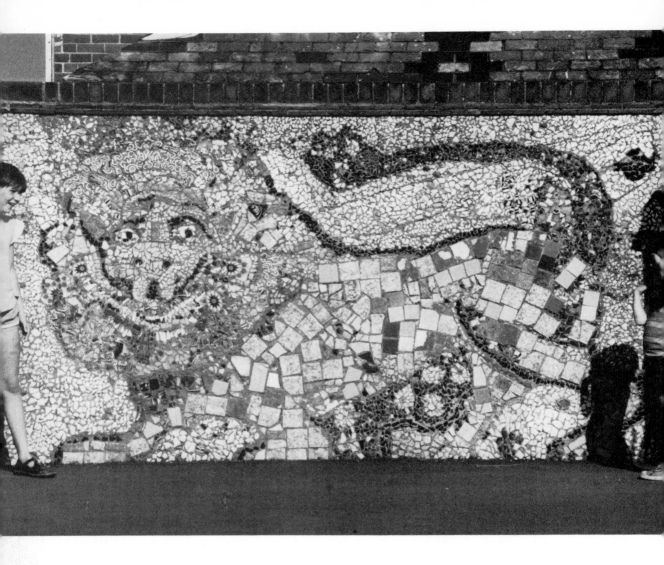

47a *Playground mosaic mural. A group mosaic carried out by children using scrap material – mainly broken crockery and ceramic tiles – at Bradley Road School, Exeter*

combining mosaic with sculpture. There is no reason why mosaic should not follow the spatial undulations of surface. Technique need not be different from any of the direct method procedures, it being necessary simply to follow the surfaces. Peculiarities of surface will call for invention and improvisation. A more naturalistic work by Gaudí is a giant lizard which is covered with mosaic and becomes a polychrome sculpture.

An extended repertoire for scrap

If we accept the idea that anything that can reasonably be bedded in cement is usable material, the scope widens greatly. If broken ceramics and glass – why not metal? Metal may not be susceptible to cutting in the same way as tiles but it is often found in small manufactured units – nails, screws, nuts and bolts or components of machines. Many of these things in quantity have visual similarity with an assembly of tesserae.

47b *Playground mosaic (detail)*

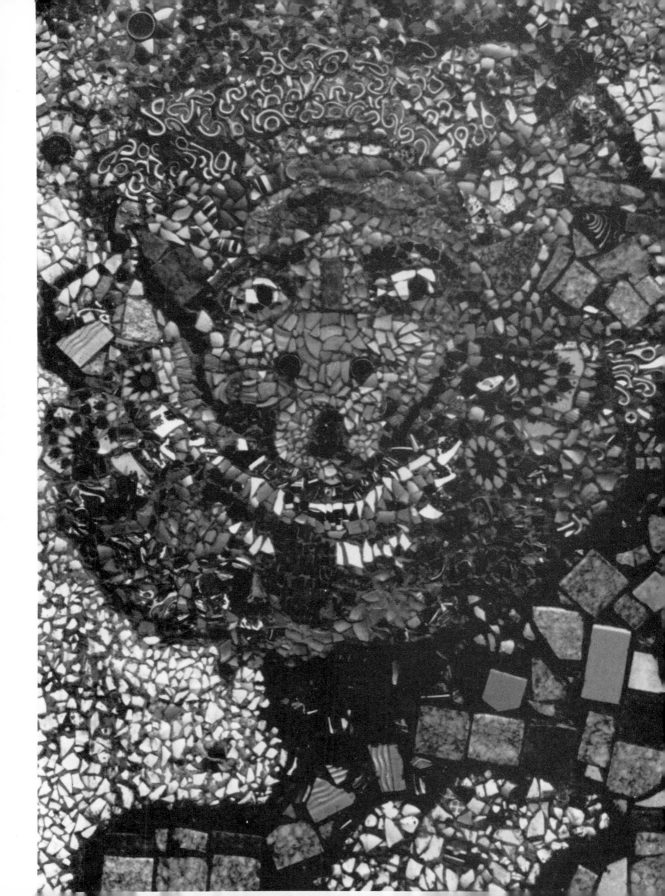

48 *Composition from old ceramic insulators, Nek Chand, Chandigarh, India*

It is from collage as an art medium that much stimulus is to be derived. Inventive artists in this field may find a back way into mosaics. It will be via principles of assembly and repetition of units more than by craft rules that visual excitement will be achieved. Painters or sculptors already competent with many materials may adopt multimedia collage as a form of mosaic; or, without any artistic training, adventurous do-it-yourself crazy paving makers may find a poetic expansion through collage mosaics.

Around the world are several great classics of this genre – some on an enormous scale. Watts Towers in California incorporates areas of broken tile mosaic and, is, in its entirety, a most wonderful example of re-cycled scrap. In central France, the huge construction of Facteur Cheval, a postman who collected found objects on his delivery rounds and, over the years, built a palace, is another major example of the untrained amateur applying himself with dedication to the building of something big from tiny fragments – surely in spirit a true mosaic, if three-dimensional and even architectural in scale.

Examples like these range from garden fantasies – the whimsical and the bizarre – to lifelong dedications and constructions which become a kind of parallel dimension to daily living. Most are carried out not for profit but by people earning a livelihood in other ways – in the best

sense 'amateurs' – but the scale of work, the energy required and the years of concentrated effort mean that they are in no way a trivial part of life. Kurt Schwitters, a German Dada artist, characterized much of this poetic aspect of life with his merz assemblies; these were collages, in some cases three-dimensional, but all built out of the bric-a-brac of daily life – unwanted, dispossessed objects. The name he used is interesting in its implied relationship of this fantasy activity to the more mundane part of living. It is the tail end of the German word Kommerz (commerce) and arose from an accidental break up of the word in a printed paper collage – merz seemed to reveal the poetic as distinct from the commercial (Kom) aspect of life. Perhaps this is a lesson for balanced living: we need the merz, the illogical, the artistic – in our terms mosaic – as a balancing component in a complete life.

Nek Chand and the Rock Garden

From India, and more recently – in fact still in progress – is a further and extraordinary piece of fantasy construction. This is the Rock Garden built by Nek Chand Saini, a one-time road inspector who made the bulk of this garden kingdom while working in his full-time job.

Nek Chand is another collector of discarded material. Much of his early assemblage is natural – the bizarre sculptural forms of rocks familiar to many as formal objects and often ornamenting a stylish interior. His versions are often large and have been built up into a kind of open-air gallery of formal rocks. Other components of the collection are manufactured – countless wastage and breakages of modern industrial life – indeed anything, particularly if available in quantity, becomes re-cyclable material for Nek Chand. The basic element is cement, which is handled with great virtuosity as a sculptural material. The cement is the support for the formal material. Parts of the work are, in fact, crazy paving mosaics of broken crockery reminiscent of Gaudí, whilst others are patterns derived from the objects as units. A richly texured wall is composed of old electric insulators. The plentiful supply of glass bangles used in Indian festivals and afterwards discarded is a regular source of colourful material clothing many figure sculptures. Old bicycle frames are used as armatures and reinforcement for concrete.

The inventive approach to the use of scrap material by Nek Chand, even if much of the work is not strictly mosaic, is an inspiration to the mosaicist – indeed to any artist. It is particularly interesting because of its location. It is sited in Chandigarh, the city of Le Corbusier, which is to a great extent the culmination of the rationalist approach to modern city planning. Decoration on modern architecture was to be superfluous: architecture itself, by its honesty in reflecting function, was of sufficient aesthetic appeal. Such ran the argument which had conceived the house as 'a machine for living in'. At Chandigarh it is tempting to see Nek Chand's Rock Garden as a necessary intrusion of the illogical, the organic, into the excessively planned. Whether this is the case or not, it is a delightful contrast to the brutalist mass of concrete blocks and grid-plan streets which form the body of Chandigarh. It is an invitation to us all to make fanciful constructions, even if they do not achieve the same acreage. Perhaps it is the outlet of creative construction of some kind or other that is much needed on the domestic front, and mosaic does allow us to expand from the house itself and enter the garden.

The personal and the anonymous

Individuals and groups

Because of their sheer size, the examples cited above raise questions about labour. One person alone can accomplish remarkable things, but collaborative work can go further. In terms of modern art, we so often think of the entirely individual product – one's 'own thing' – and this is valued as much for who did it as for what it is. At times, buying famous works is almost like buying signatures; but if the work is truly valued for itself alone, the product takes over from the maker. Group production can be a good way to produce more or bigger work; it can also be a way to communicate. We can work together with others and discover our own roles in making something probably bigger than that which any one of us could make alone. This experience has, unfortunately, become rare in the visual arts, although in the past this was not so, viz. the Middle Ages, the Renaissance work shops, the old master studios, and the Roman and Byzantine mosaic workshops.

Group work in mosaic has much to recommend it, psychologically and socially as well as artistically. It lends itself to division of labour more easily than some techniques, and a group

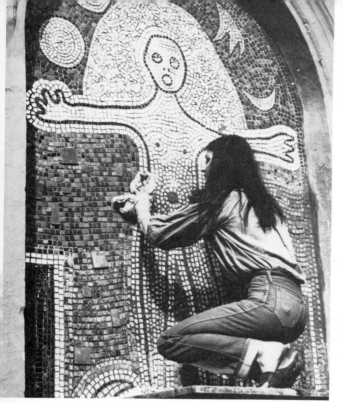

a

49a *'Protest': finishing touches to tile mosaic mural, College of Art, New Delhi, India*

49b *'Homage to Nek Chand': mosaic in tiles and natural stones, The Rock Garden, Chandigarh, India*

b

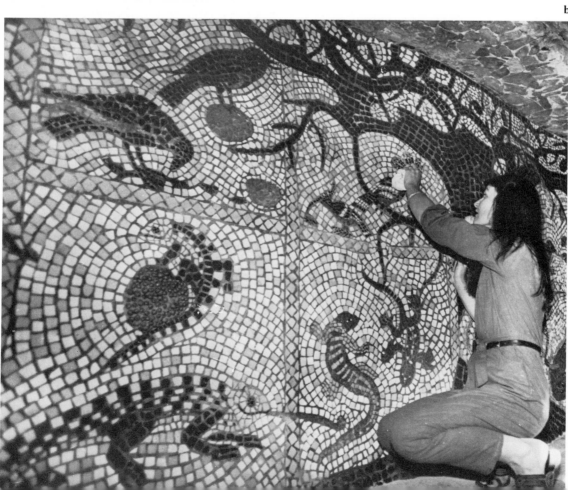

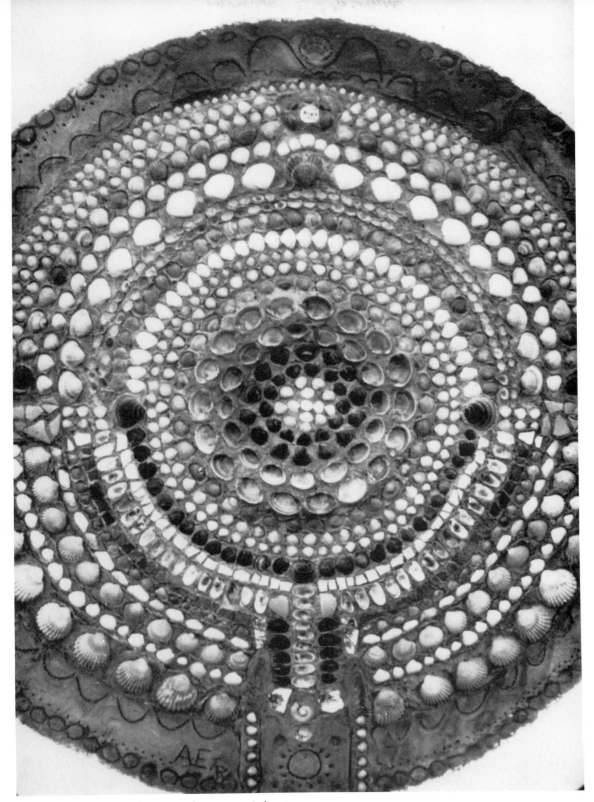

50 *Marine Mandala: a decorative feature carried out with available materials (shells and pebbles) on the outside of a house in the Algarve, Portugal*

project can involve people at various levels of interest and skill. There is plenty of work gathering and sorting, mixing mortar, rendering the wall and even discussing the intention and the results of the labour as pieces are completed. A team project can be a rewarding experience for all concerned – perhaps a little like drama or musical performances where we accept collaboration as the norm for any production.

The essential for satisfactory group work is good organization. There should be a director or designer of the scheme whose job it is to devise a project. This need not mean producing a finalized cartoon simply for copying by the team – the design may be a broad theme capable of being developed and, as such, it can be improvised upon by the team. For example, decisions about colour and precise shape, choice and cutting of tesserae will be the responsibility of various workers. My experience of such schemes shows that participants become deeply involved, and the working practice is captivating. The project grows inevitably, if slowly. The group director might draw the main outlines on the wall, leaving areas of infilling to be decided as things proceed. The usual technique will be the application of suitable areas of cement (a three to one sand/cement mixture) to a rendered wall with the main outlines of the drawing (in water based paint)

upon it. Care must be taken to clean off any surplus cement at the end of each work session. It is difficult to keep the pieces clean while handling, so a final clean up with acid is usually necessary. The finished result is often a delightful visual effect.

At a time when many are seeking spare time occupation due to increased leisure or unemployment, a mosaic project such as the one outlined can give a sense of purpose and direction. It can, for a modest cost, enrich an environment and be enjoyed by many. Collaborative effort holds people together as the cement holds the tesserae. It may be a compact group already – a family for example, or class of school children or perhaps a society or club. Many art societies, so often heavily concerned with painting, would find such group activity an ideal relief from totally self-based activity. Much discussion will take place before, during, and after the work and many points relevant to art in general, as well as to the mosaic project in particular, will arise.

Any of the techniques already considered could be adapted to circumstances. You must make a start and continue with confidence. Energy is generated and the group becomes a real creative unit – the result is a decorative delight for others to enjoy.

CHAPTER IX

Drawing, pattern and colour

Unique characteristics of mosaics

Mosaics can copy many things that can be made with other materials – pictures which are usually made with paint, patterns associated with other craft techniques like weaving and embroidery. What then are the special characteristics of mosaic?

The break up into fragments is an essential of the true mosaic, but this too occurs in tapestry, for example – in fact tapestries in photographs can look very similar to mosaics. For me the unique character of mosaic lies in the structuring of the tesserae – the opus styles. This is dictated by the nature of the material. The hard lumps of stone or glass cannot be overlapped and must be fitted side by side. This is not always the case with paper, for example, so cut paper mosaics do not have the stringency of those made with solids. The use of paint in small touches of colour, as in the styles derived from impressionism – the so-called 'pointillism' or divisionism – is only a loose analogy with mosaic, though the comparison is interesting in both directions. It is the composition of design into small components, plus the craft of assembling small solid pieces into a whole, that is the true mosaic. The word tessera – a cube – does imply solidity.

Fabrics, paper or paint may be used in mosaic-like ways but they do not enforce the same decisive cutting and placing of stones, nor the limited selectivity of a few colours. These essentials of mosaic are very apparent. They were thoroughly enunciated and exploited in the Roman and the Byzantine eras – perhaps seeming to leave little new ground to explore today. But the same could be said of other arts and their great epochs. As we have seen, inclusion of modern approaches can bring an extension to the technical repertoire but we are still left with the placing of small fragments in harmony with one another. However much this may be influenced by other pictorial arts, it entails certain peculiar-

ities of execution, both in drawing and the use of colour. The similarities and the differences relative to painting are worth investigating.

Drawing for mosaic

It has been stressed earlier that mosaic drawing is essentially drawing by placing pieces side by side, a line being, in fact, a row. This is true as we work with the tesserae but, as mosaic is not an easily alterable medium, we may well want to make preliminary drawings – both on paper as sketches or cartoons and almost certainly on the wall or base itself as an under layer or sinopia. Drawings such as these demand simplicity and boldness, and we have seen how preliminary paper mosaics are useful to this end. In addition, we can make separate drawings as ideas for mosaics. Sketch books are useful as places for documenting images. When not actually working with the tesserae, we can be building up our repertoire of imagery, and such drawing will be influenced by our ways of thinking and seeing as developed through mosaics.

Certain characteristics will be particularly suited to our purposes. For example, strong thick outlines and an absence of detail. This means thinking with and about materials as much as, or more than, realistic likeness to the subject. The drawing of a bird will tell us as much about lines and structures as about a real bird. Likeness to nature is more reference to nature than exact representation.

The use of ink markers will be most suitable for preliminary sketches – particularly the broad-ended ones. Improvised material is sometimes very useful, as it encourages new and creative thinking. A rolled piece of paper dipped in ink will provide a stimulating challenge. Similarly, a fragment of cotton waste tied or wired to the end of thin sticks can be inked and used to give broad robust lines, well suited as a preliminary to composing with stone fragments.

85

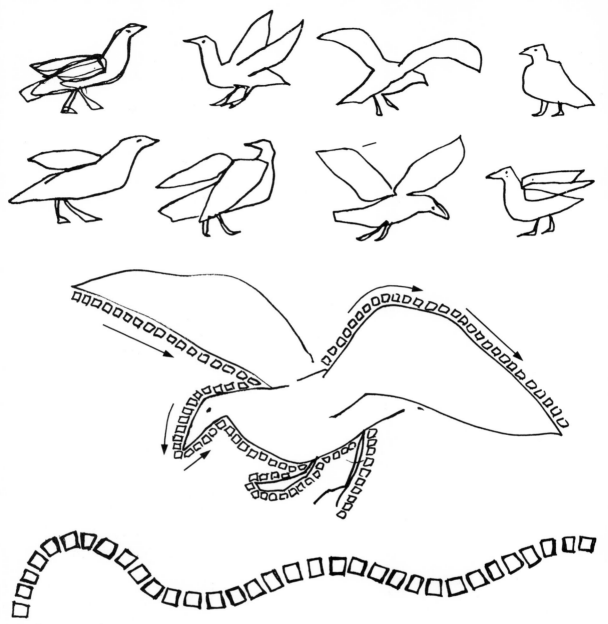

51 *Drawing with tesserae: freely drawn images translated into directional lines for tesserae*

'Fit the technique to the purpose' is a good maxim to follow and will result in a whole range of interesting imagery on paper alongside our mosaic output.

This linkage of drawing to the mosaic work is an important aspect of our work: it expands technique and craft into vision, joining ways of working to ways of seeing and thinking. Craft becomes art. The observation of natural forms, birds, fishes, flowers, etc., may have been played down in favour of invention via materials, but this is not to say that observation is non-existent. Keen observation of nature will stimulate us not just to make likenesses, but to re-build nature in terms of our own materials. It will be, to use Cézanne's word, a 'parallel' with nature.

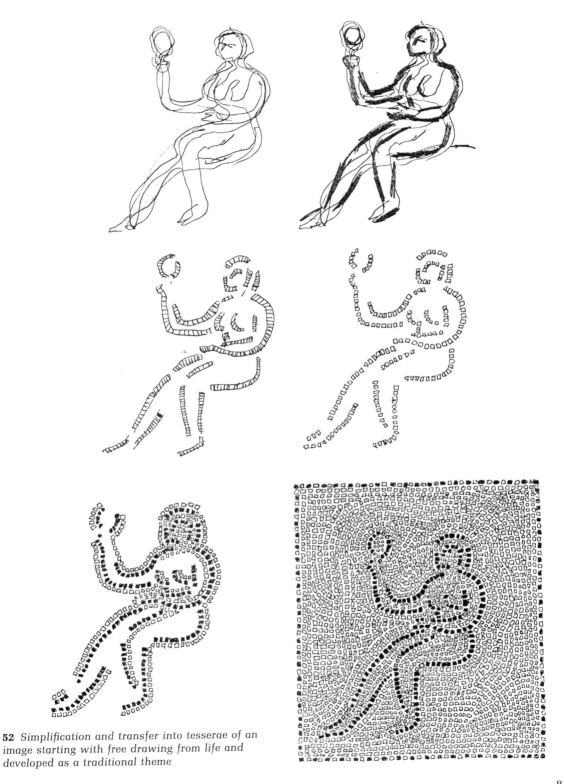

52 *Simplification and transfer into tesserae of an
image starting with free drawing from life and
developed as a traditional theme*

53 'Toilet of Venus': a bathroom piece based on a
traditional theme from classical art and recurring in
Renaissance and Baroque art

54 *Portrait*

55 *Portrait*

Portraits in mosaic

The medium may not seem suited to portraits. A sitter is usually present with the artist while a likeness is made. The tempo of mosaic, if nothing else, would argue against sittings as for paintings. Yet, if done via drawing, there is no reason why the image cannot be used for a mosaic, though the simplification needed to make a drawing suitable for mosaic is drastic.

This is a good exercise in making a few simple shapes convey the character of a person. The finished result, too, can be an embodiment of character which is a wide summary of collected impressions rather than an instantaneous snapshot likeness.

Try doing a number of drawings with your sitter present, then, on your own with your drawings around you, redraw the person in bold lines with a marker or thick charcoal stick, only including the really essential marks. Use this drawing as a direct method basis for interpretation into lines of tesserae. The finished result, even if lacking the momentary expression, may be an iconic lasting equivalent for the person of your sitter.

Mosaic and pattern

Pattern is generated by the use of the tesserae. The various opus styles might be considered as a series of patterns, and they can indicate great possibilities for pure abstract pattern. In Roman work this was used in borders. Many borders have become classics of ornament. The 'key pattern' is a piece of visual logic bringing an intimate interlock of two components. Patterns based on rope or ribbon weaving are intriguing routines of construction and delights for the eye. The knot is another analogy for intertwined lines of tesserae. A study of the Roman examples will enrich ideas and may encourage our own inventions along similar lines. The work may, of course, be carried out in any of the previously discussed techniques.

The spiral and creative pattern making

As well as emulating the rich store of Roman patterns, we can develop patterns out of the ways in which we actually place the tesserae.

The spiral is an ideal form for development in mosaics. It is totally organic, beginning at a point and proceeding outwards indefinitely. You can place a single piece as a control point – perhaps a

56 *Some border patterns and ornaments*

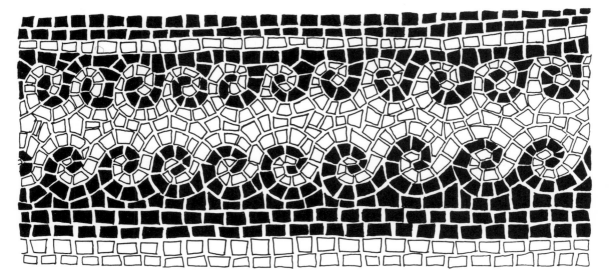

91

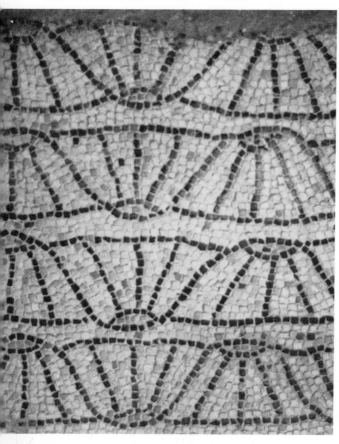

larger one than usual – from which to start, then cut smaller ones to circulate round the centre, keeping them fairly tightly packed and wrapping them around and around. After several circulations the tesserae can become a steady line of squares. A growing cluster has been started which has no limit. Using one colour only, you will have a purely structural pattern – another opus style. The structure is strong and will hold the work together in good bonding. Into this structure you can introduce colour – perhaps alternating two colours along the line as you lay it down, perhaps grouping tesserae in irregular numbers, or evolving sequences of greater and lesser numbers of the two colours.

The double spiral

If two lines of tesserae can be started out from the centre, there will be a sense of a background. In the extreme contrast of one being black and one being white, the tendency is to read the black as a line on a white background. When the required extent of development is reached, you have two lines of tesserae to be dealt with. They can be terminated or wrapped around in some way, or perhaps interlinked with another unit to become part of a series. A simple and obvious linkage of this kind would be a left-handed spiral flowing into a right-handed one – an ancient form to be found in a number of arts from early and prehistoric times, and prevalent in the Celtic world.

Methods of structuring such as the above become processes comparable with processes of nature. They are designs carried through not according to a pre-conceived plan but according to an initiated system; consequently there is an element of growth and some unpredictability in the process. Improvisations can occur within the system structure. In a sense, one is growing a mosaic like a gardener grows a plant, perhaps feeling the same responsibility for results yet acknowledging the power of an impersonal energy.

The spiral is perhaps the most organic and dynamic system of growth in mosaic. It is also basic to many living forms.

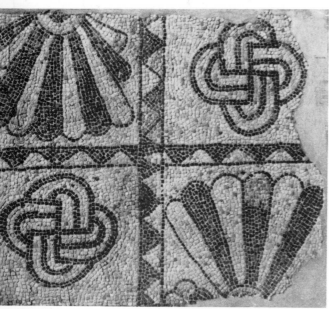

56 (cont.) Patterns and ornaments; panels in the church of San Giovanni, Ravenna

57 Spiral: detail from marine panel

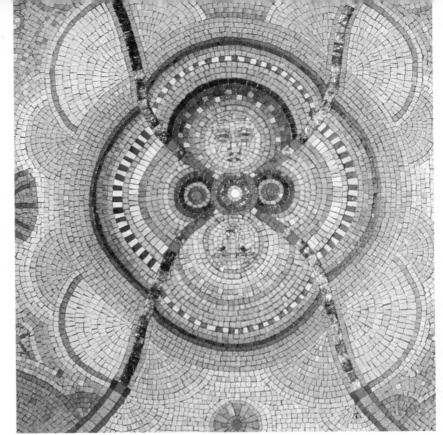

'Sun and moon' (detail) —
ceramic and glass —
1.5m (5ft) x 1.2m (4ft)

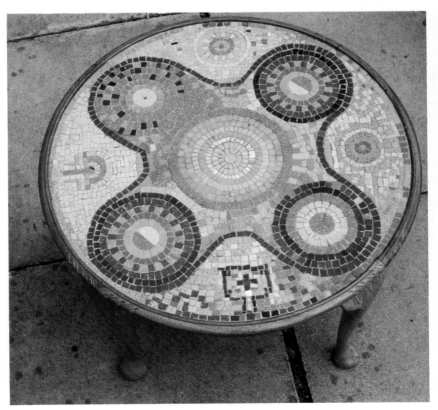

Four seasons table — mixed media

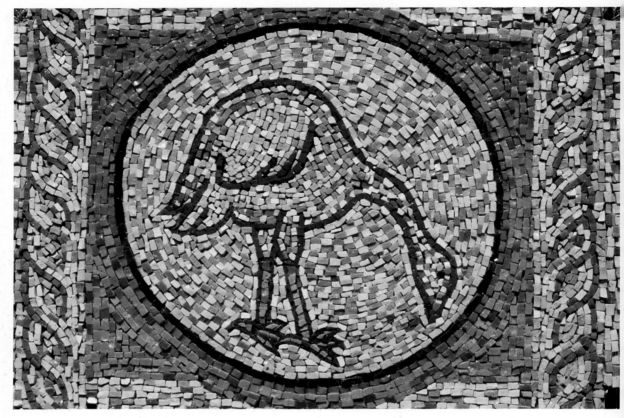

'Stooping bird' — smalti —
60cm (2ft) x 91cm (3ft)

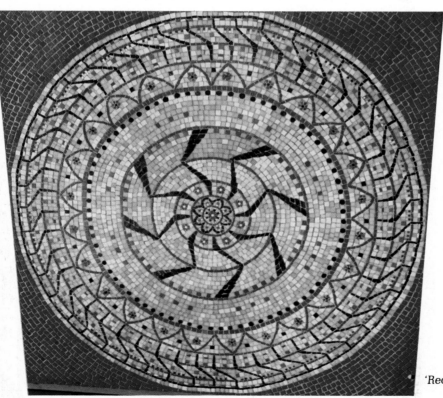

'Red Chakra' — vitreous glass —
91cm (3ft) x 91cm (3ft)

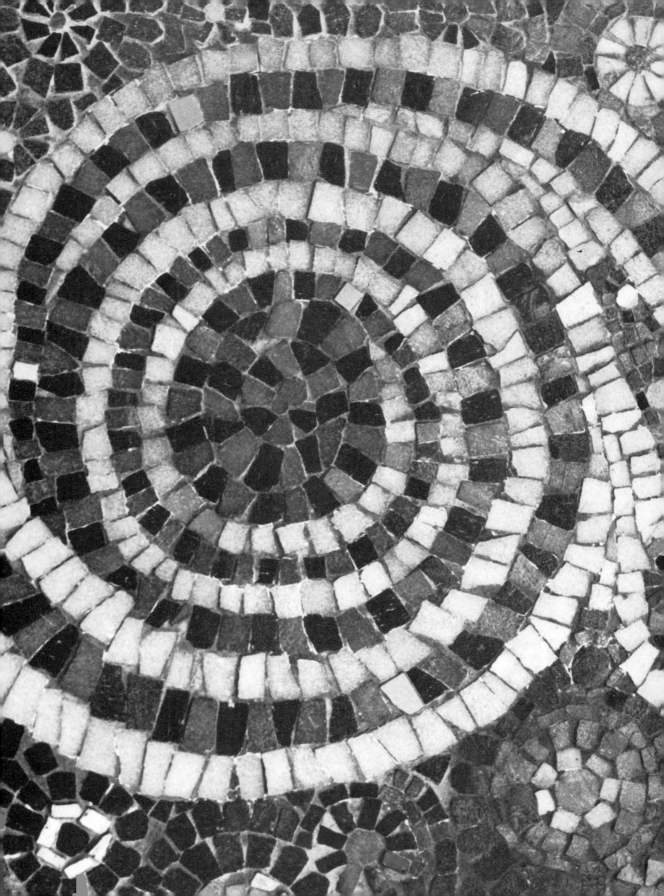

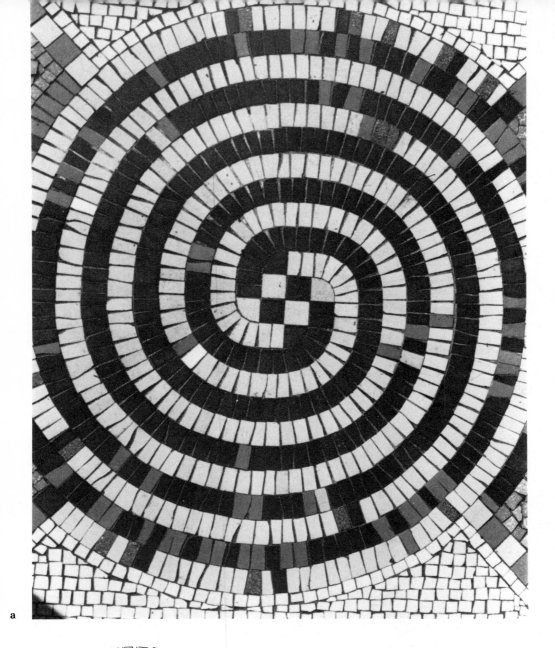

a

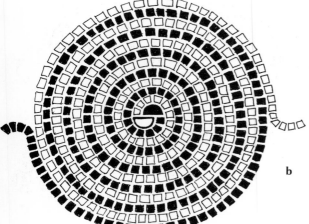

b

58a *Starting a spiral*
58b *Starting a spiral: centre for a spiral system. An alternating of two colours at a centre gives rise to a spiral growth which can extend as far as required for any scheme. Slight colour variations ('accidentals') are introduced to avoid monotony.*

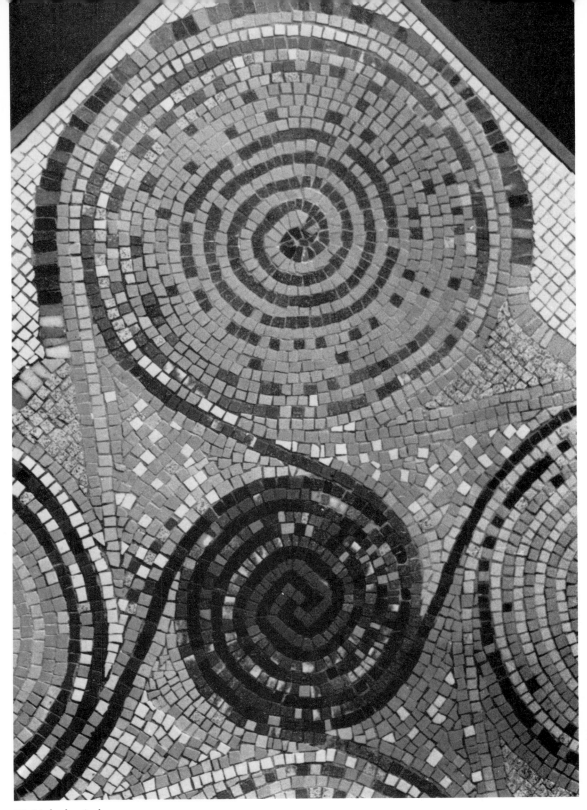

59 *Linked spirals*

Abstract pattern

Using shaped tesserae instead of squares, it is possible to build up patterns deriving from the shapes themselves. The triangle has an obvious potential for composition: the simplest arrangement would be lines of upright and inverted triangles – the chevron motif of traditional ornament.

Centres of structure can also be made by grouping. Four equilateral triangles put together will take us back to the square. Six triangles pointed together will give a hexagonal 'cell' to start from, around which other pieces can be arranged, thus allowing growth to take place. The central cluster can be ringed round again and again until a sufficient size is reached. The formation will be approximately circular. If there is only one such formation in the design, it may have to be accommodated to a containing square of the total design. A roughly triangular area in each corner will have to be filled when we attempt to place a circle within a square. Here invention of pattern is needed to fill four minor centres. Adapting shapes and sizes will give fascinating exercise in creating pattern.

If there are two or more centres to start from, a

60 *'Night and Day': interlocking spirals in smalti and mirror glass, the Post Office, Chard, Somerset*
61 *Double spiral*

62 Mixed structures: student exercise

63 *Panel suggested by Islamic pattern*

number of minor secondary centres will be formed. The design will grow from basic principles. It is not a case of working out the result through preliminary drawing or by copying some previously planned result, but determining the arrangements as you go along. Most probably you will want consistent symmetry – what happens on one side will most likely be expected to be repeated at the corresponding point on the other side. The system should be well considered in advance but not worked out in every detail. This method is a combination of control and free development. It can be an ideal balance of psychological energies – the orderly and rational with the intuitive – and for this reason it is a most satisfying working procedure.

The method is clear in general principle and it would be tedious to go into detailed description. The important thing is to grasp the method and then to experiment. Several examples are shown but unlimited variations can be made upon a limited range of themes. Other examples shown should be self-explanatory.

Cutting will take longer than when using

simple square or rectangular pieces as there is a greater variety of shapes to follow. Fitting the pieces together, too, may be a slightly longer job than laying down continuous lines of tesserae in opus vermiculatum.

Islamic pattern – an example of method
Islamic pattern can provide a prototype for mosaic work. It is, of necessity, abstract – the religion discouraging use of imagery. Geometry is the basis of Islamic pattern. If its results look like flowers or crystals, these resemblances are metaphors drawn from the mathematical forms.

The reduction of pattern to elementary units of abstract form is ideally suited to the structuring of tesserae. The pattern is completely rationalized into clear and repeatable elements. The method dictates the cutting of each tessera and all vague or impressionistic effects are removed.

Some of the finest work of Islamic art is geometric tile mosaic. Examples are to be found in the mosques of Isfahan. Later work shows similar patterns but using painted designs on larger tiles instead of making the pattern by building them out of tile units. The painted versions lack the strength of the constructed ones. In the former, the actual lines of grout become pattern elements in the whole ensemble. This is truly in the spirit of mosaic. In the painted versions the lines of tiling are just a regular square grid. Structuring according to geometric principles can become another opus style with its own peculiarities and possibilities and Islamic work will certainly be an important source of inspiration for anyone interested in this possibility.

Letters in mosaic

The Roman world, the source of our western alphabet and the origin of so many mosaics, produced very few mosaic letters, yet letter forms are a rich source of shapes very suited to mosaic. Tesserae can easily be cut to make letter shapes, and the surrounding ground can echo the letters with an appropriate opus. Letters and ground integrate as in any good mosaic. Whatever has been said for other images can be said for letters.

But there is another reason for this combination – a more commercial one: letters in mosaic are suitable as signs. They are robust and weatherproof and, as such, ideal for public notices. In Victorian times this potential was frequently used in shop entrances. Cost is often claimed to be the reason for their disappearance but, whilst this may be so for floors, wall signs or plaques could be carried out at prices competitive with other materials.

As a design feature, the mosaic letter has a strong graphic appeal and could well be a part of the design studio repertoire.

Colour and mosaic

Colour in mosaic can vary from the simplicity of black and white (which is colour of a kind) to a multi-coloured spectrum of tesserae in smalti.

Given an unlimited range of colours in the tesserae, colour in mosaic should be a simple matter of matching the colour of the design with the nearest equivalent of tessera. In this way the tesserae are like a painter's palette – you just choose the colour you want and use it. There are two disadvantages: one, you need a very large number of different tesserae, and two, the all over colour of large unvarying areas can make for dullness – there may seem to be little point in rendering the colour into little squares. On the contrary – with a limited number of colours you will have to suggest your colour effects by mingling differing colours. Though you cannot mix colours in mosaic as you can with paint, you can achieve optical effects, that is to say different colours grouped together and seen as one area will, in a distant view, mix in the eye; hence the colour effect experienced by the viewer is an optical effect. Used in this way, mosaic can have similarity with certain aspects of impressionist painting where separate brush strokes of unmixed colour are jumbled together on the canvas rather than mixed on the palette. A mingling of blue and yellow tesserae can produce the effect of green for the viewer – an effect which will increase with distance as the individual tesserae become indistinguishable from one another. The result is, in fact, a kind of mixing, though the components do remain inviolate. It is the same in principle as colour printing, in which very small separate dots of unmixed coloured inks produce the effect of wide colour variety – even from only three pure colours. Look at a colour photograph in a magazine through a magnifying glass and you will see that it is a mosaic of tiny dots of colour.

64a *Letter forms, some graphic possibilities*

64b *Two mosaic signs*

Accidentals

Effects such as the above add much visual excitement to the surface of a mosaic. Even if a large area is more or less uniform in colour, it is good to introduce occasional deviations from uniformity. I call these accidentals, like the notes in music which depart from those expected in the overall key signature. For example, an area of white might have occasional off-whites, greys, even pale blues or yellows. They can be dropped into the tesserae structure in a random way, hence apparently 'accidental'. There are no set rules for this kind of thing – it is a matter of experimenting. Painters will appreciate the possibilities here. Along with the colour of grouting, accidental colours will contribute much to the visual impression.

Finally, what is important is what we see. What looks right is right. This is to take an artist's view. It is a view which transcends the simple craft view of working according to the correct rule.

The special quality of colour in mosaic

The inescapable and obvious character of mosaic is that it is additive, though, like the obvious, often unnoticed. The work is made by adding tiny piece to tiny piece. It is built like a wall, brick by brick. This essential quality influences every aspect of mosaic because it makes us conscious of every piece of the whole as we work. A line can only be drawn point by point. Similarly an area of colour can only be made fragment by fragment. This gives very precise control over what we do.

In the case of colour, it means we can be continually building a harmony of colour with each piece we add. On the basis that every piece optically affects the whole area of vision, we are constructing a colour harmony with each addition. The slowness and precision with which this happens gives a control unlike that of any other art – certainly unlike the mixing together of separate pigments in paint and even different from the fragmented brushwork of impressionistic or pointillistic painting with which it does have similarities. This is because the looseness and freedom of application of paint allows it to be placed anywhere and for layer to succeed layer. One can obliterate and go back with paint. It, too, can be additive but rarely in the progressive point by point way of mosaic. The restriction of inch by inch working across the surface like an advancing tide of colour with the slowness and

deliberation which this demands is a new and unique quality. Our 'limitation', therefore, is not an inhibition but a possibility with a new creative power.

Working on a multi-coloured mosaic will make you feel the importance of every tessera – even among many thousands. Each one contributes to the final harmony and is as important as any single note in a symphony. You can, of course, go back and make changes if you feel it necessary; you can, at the end, review the whole and make any adjustments required – but this is not in the character of the working process and should, for technical reasons, be kept to a minimum. A dab of the brush can change a painting; to do the same with a finished mosaic is at least a hammer and chisel job. The progressive build-up is the essential quality, therefore, with later changes or alterations used only in cases of real need.

Colour and colours

Multi-coloured work, as described above, implies a large range of separate colours – a kind of mosaic palette from which you may choose odd pieces and add them as the effect demands. This method is sometimes used, and enormously rich surfaces can result containing innumerable accidentals. (The comparison with musical symphonic composition or with impressionistic painting was not just rhetorical.) It is, however, more usual to select a short series of colours and to stick to these. With four or five colours, numerous variations can be made. The optical effect of colours against one another is often quite astonishing.

For example, with only two colours the effect of surrounding one with the other can vary enormously according to which is in the centre and which forms the surrounding ring. Such effects are demonstrated in an extraordinary way by Joseph Albers in 'The Interaction of Color' – an important modern work on colour showing how colours must always be taken in their context. The way in which colours are assembled is as important as the individual colours themselves. Central or encircling, large or small areas, simple or intricate patterns – these are among many things influencing our reaction to colour.

If the word 'colour' is used, we generally mean the total assembly of all separate colours seen together – sometimes called harmony. 'Colours' refers to the individual and separate parts,

65 *Mosaic 'translation' from Coptic fabric*

whether tesserae or tubes of paint.

Practising different ways of using a few colours can produce numerous different effects and these can often be more revealing than attempts to handle a great number at once. The same can be said of paint or many other art materials. A closer look at some examples from history will substantiate ideas.

Roman mosaics rarely have more than three or four colours in them, colours which were determined by available natural material. In Italy it was often marble, and the range of colours would be the range of possible marbles – black, white, grey, pink, golden yellow, green – a wonderful span including minor variations within a colour group. In other parts of the Roman Empire, local stones might be used – limestones, for example, and sometimes burnt clays for reds and browns. It was only late in their history that the Roman mosaicists began to include coloured glass, and then only rarely.

Material limitations are not detrimental to colour as a whole. Schemes can derive more benefit from limitation than from unrestricted availability of materials.

Mosaic as translation from other media

The idea of mosaic being a medium for copying other works, such as paintings, has been played down in favour of mosaic as a creative medium.

There are, however, occasions when compositions in one medium can be completely rethought in terms of mosaics. This I call 'translation', and similarities with language translations could be upheld with some precision. The resulting mosaic must be convincing as mosaic and have left behind any connection with the original. This approach is best used after you have some experience with more direct working methods.

Woven fabric designs may lend themselves easily to this kind of treatment because the reduction of colours to a series of threads is similar to the selection of tesserae. Do not attempt to copy thread by thread, however, but see the pattern as bold blocks of tesserae. The example shown was taken from a Coptic fabric contemporary with late Roman times (figure 65). It is, perhaps, the kind of thing that a Roman mosaicist might have made using the imagery of Coptic weaving.

This transference of themes from medium to medium and the sharing among artists of a commonwealth of ideas is prevalent in history and need not conflict with personal creativity as emphasized in recent art education.

Mosaic and the photograph

The photograph as a record of a passing moment is at an opposite pole from the mosaic, which is a carefully considered arrangement to form a permanent image. There may seem to be no connection between the two, yet in the spirit of modern experiments it could be interesting to take the imagery of a photograph and translate it into tesserae – an attempt to reconcile the ephemeral with the permanent.

The image of, for example, a head in a photograph, is simply a pattern of light and shade (or colours). This can be interpreted quite easily into a flat pattern of tesserae, but simplification should take place. At its most extreme this could be into just black and white. It can also be into a limited range of tones or colours – four or five at most is recommended, like a Roman scheme.

There is a certain fascination in the momentary impression being rendered with slow deliberation. The result can look incongruous, but on the other hand it may appeal to some tastes because

66 *Photograph reduced to grid for mosaic treatment*

of its oddity. A smile, caught by the camera, difficult to record in drawing or to be held by a sitter, can be fixed or frozen into permanence.

If you really want to carry this through systematically, you can first transfer the photograph to graph paper by tracing. Then identify each of the squares on the graph paper with a single tone of the available tesserae. Later, cut the actual tesserae to correspond – the size can be scaled up as required. The pattern on the graph will be totally regular – opus regulatum – but this could be scrambled into different styles. Even opus vermiculatum could be used, but this will bring more personal interpretation to the photo image and depart from the effect of fixation already described.

A project such as this one, carried out in the spirit of an experiment, can enlarge ideas and certainly link contemporary ways of thinking and seeing with the ancient techniques.

Some projects

The projects in this chapter offer some applications of mosaic to specific purposes. Their presence is intended not only as a source of instruction, but also as one of inspiration for future, and developing, ideas.

Mosaics for tables

After floors, the table top is the most obvious horizontal use for mosaic.

Sizes of up to about 1m² (10¾sq.ft) are manageable from the point of view of weight and portability. Reasonable smoothness is obviously necessary, so either tessera of equal thickness or an indirect method must be used. With standard thickness, some irregularities of surface may still result from variations in the adhesive film. This may be acceptable but, if you want a really level surface, the indirect method is preferable. The slab should be made on a piece of plywood according to methods already described.

This project is concerned with the production of suitable mosaic slabs, not with the making of the table itself. Metal as well as wood is suitable for a table. The example chosen is, in fact, metal and is a garden piece, but the mosaic slab could equally be mounted on wooden legs and perhaps framed in wood.

Table legs

The mosaic slab is really the table; the legs are a convenient addition and can be of any kind. Kits of legs can be bought and fixed according to instructions, but care must be taken to check that any screws entering the base board of the mosaic do not exceed or approach too closely the thickness of the board, as tesserae could be weakened or moved.

A very convenient table base might be an already existing old table – perhaps acquired from a second-hand sale. Such a table could be restored and a mosaic surface applied to its top – the design of the original furniture can sometimes influence the mosaic you produce. To a small extent, it is like doing a commissioned piece for an architectural site.

With a metal frame, the mosaic can be a loose slab resting in the frame by its own weight (see

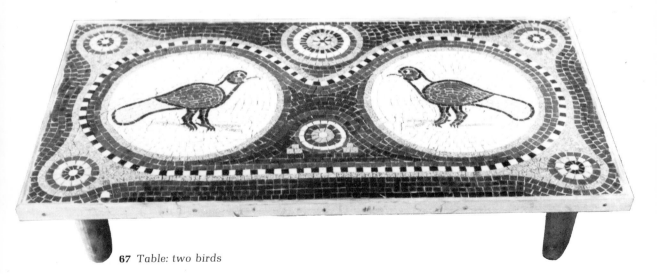

67 *Table: two birds*

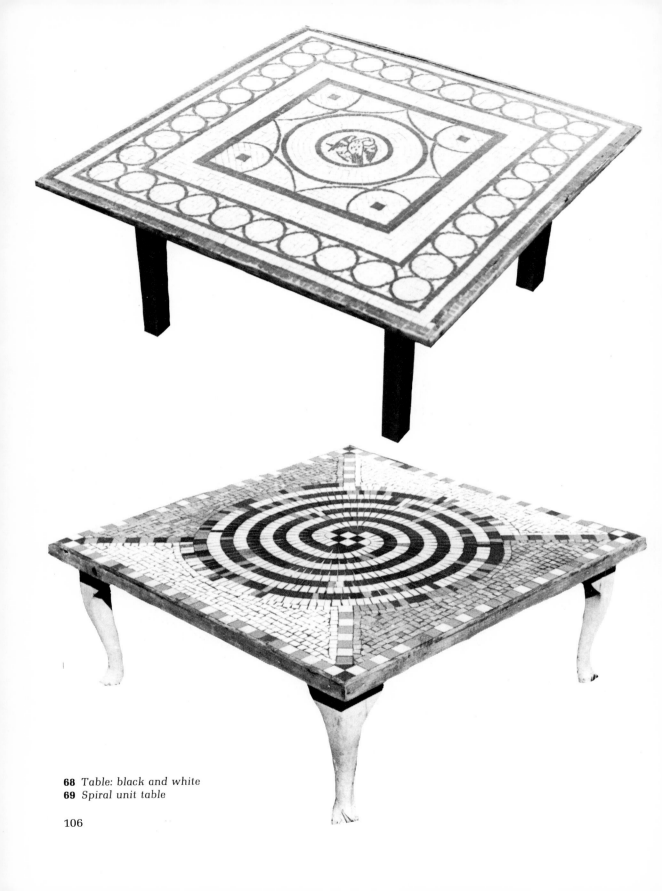

68 *Table: black and white*
69 *Spiral unit table*

figure 71). You could make several slabs to the same dimensions and change them from time to time, perhaps according to the seasons; this idea would be particularly appropriate for a garden or patio table.

A house name or number plaque

Letters and numbers are interesting forms for mosaic interpretation. In its simplest form, the letter or number gives us a positive shape against a containing background, and all that has been said about drawing and opus styles can be applied.

House identification by a name, number, or even an emblem or logo is functional but also gives a unique personalization among so many standard mass-produced products.

A small plaque can be made with drill holes for screwing into a plugged wall, the screws afterwards to be covered by tesserae for permanent concealed fixing (see figure 42).

Edges and finishing

Slabs will need a finishing edge. Here are some suggestions.

1 When the thickness is approximately equal to the length of a square tessera, a line of these tesserae can be stuck to the edge. This is a handy

70 *Simple table from mosaic slab with legs attached*

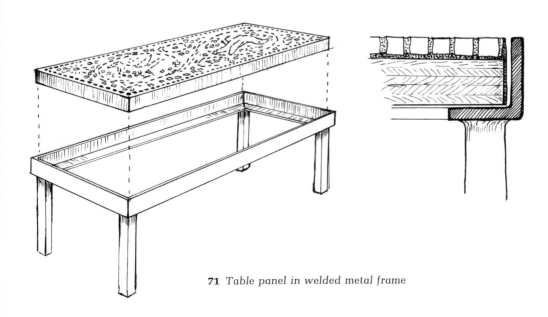

71 *Table panel in welded metal frame*

72 *Mosaic number from a children's class*

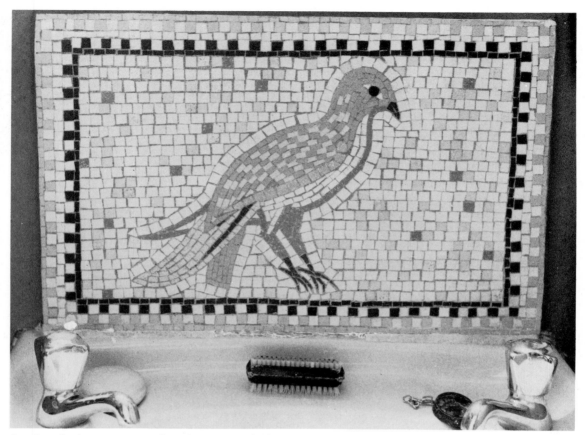

finish which preserves the character of the mosaic across the whole surface. The edges of the surrounding tesserae will provide a thin line frame from the front.

2 Wooden edge strips, like ordinary picture framing, can be quite effective in appearance and efficient for hanging screws. Four mitred pieces of square section equal to the thickness of the slab are good – preferably of hard wood. They can be screwed or tacked to the mosaic base.

3 A layer of epoxy resin with inert filler can be built up along the edges and, when set, filed and sanded down to a smooth surface.

Bathroom or kitchen splash panels

Another useful function of mosaic is to provide washable decorative surfaces for wet places. Many situations in a kitchen are suitable, and bathrooms, shower or sauna rooms are ideal. The pleasure of bathing combines easily with aesthetic contemplation.

73 *Wash room splash-back: a student's exercise*

A panel may be fixed to the wall with screws and plugs as for any of the permanent fixings.

Pots and three-dimensional objects

Mosaic has the possibility of following round curved surfaces, such as a large pot or bottle. Here are two examples: one from a ready-made ceramic flower pot, the other using a purpose-made concrete receptacle (figures 74 and 76).

Flower pot

A large, ordinary, earthenware flower pot was bought for this from a garden suppliers. The tesserae were fixed with a damp-resistant resin adhesive, and the finished work was then grouted with cement in the usual way. The bird design used here aimed at all round continuity – the design inviting circulation around the pot.

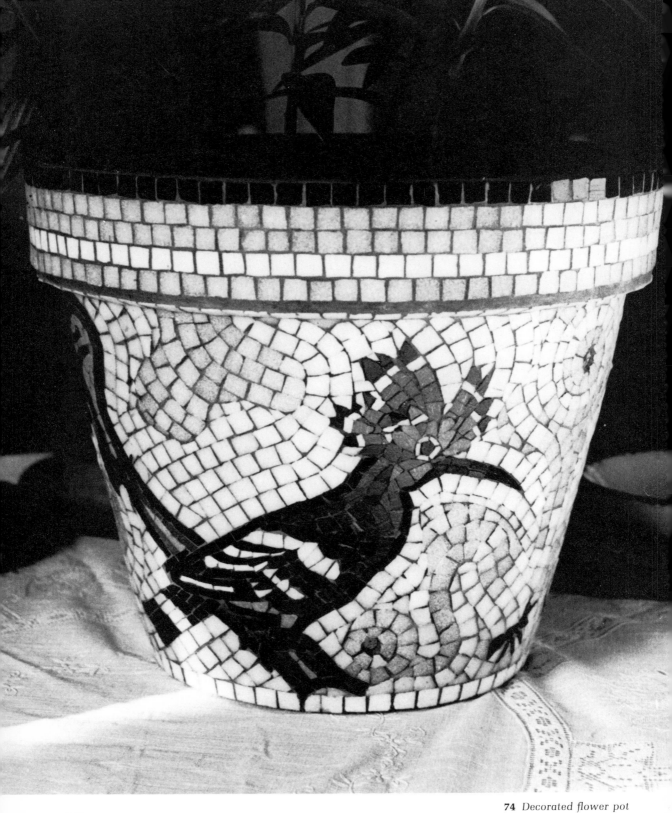

74 Decorated flower pot

75 *Casting a concrete container for mosaic covering*

Casting objects in concrete

Garden objects such as plant containers can be made in concrete and covered with mosaic. Only a simple one will be described, since greater complexity would take us into sculptural constructions.

An open container can be made inside a wooden shuttering, with a core of some easily removable material, such as clay. The easiest way is to make it upside down. Model the core on a board first, leaving plenty of overlap, then place your shuttering around it. It will form a simple wooden box without top or bottom. Prepare a three to one concrete mix of coarse sand (a little fine gravel can be added for strength) and cement. Do not add more water than is needed to make it just manageable. Tamp the mixture down in the space between the clay core and wooden box shuttering and spread it over the clay core to a thickness at least equal to the space filled at the sides. This thickness should be about 5cm (2in) for a container of about 30cm (12in) in height. Bent pieces of iron rod, or bolts, might be

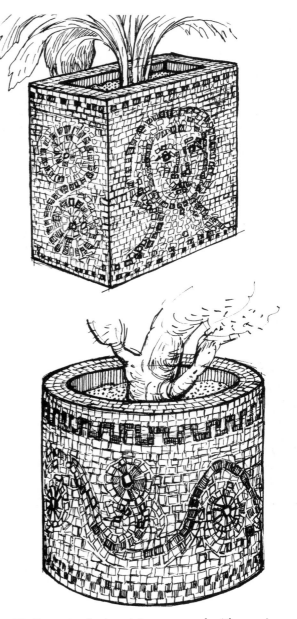

76 *Concrete plant containers covered with mosaic*

placed in the concrete for reinforcement. For real strength, 6mm ($\frac{1}{4}$in) metal rod bent into U-shapes can be incorporated (see figure 75).

Allow at least two days for setting and then turn the whole over, remove the board, and dig out the clay from the core. Your object is now complete and can be worked on with mosaics,

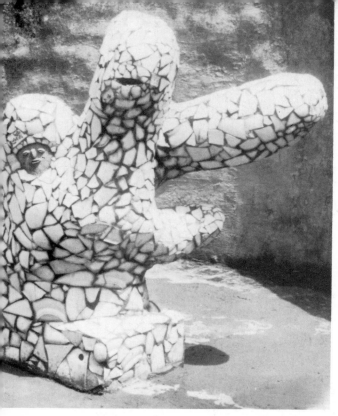

77 *Sculptural mosaic, Nek Chand, Chandigarh, India*

which can completely cover the sides and top edges. If you use glass tesserae, the bevelled edges of these are made to accommodate the right-angle corners. Direct method with cement is a suitable method. If tesserae are attached with adhesive, it should be a water resistant variety.

Objects such as these make attractive garden containers for plants – perhaps a miniature cactus garden. If water drainage is needed, a hole, like a flower pot hole, should be made in the concrete at the filling stage. The container might be round, square or oblong and of varying heights. Just remember that they will be very heavy and not easily portable, but can be more or less fixed features in a garden.

Concrete sculpture mosaics

In the same way as we have made the object described above, three-dimensional forms can be invented. Concrete is more manageable as a sculpture material than is often imagined. The making of the forms is beyond present scope, but, depending on the ingenuity, skill and taste of the individual, possibilities for polychrome sculp-

ture open up. I would stress that the making of the form is essentially a sculptural matter – the mosaic is necessarily a later application and experience with any of the techniques described could be relevant. However, if the work is planned from the beginning as a mosaic piece, the mosaic can be an integral part of the whole concept and not just a cosmetic application.

Excellent examples are, Gaudí's 'Lizard' in Parc Guell in Barcelona, some of Nek Chand's collaged figures in the Rock Garden at Chandigarh and O'Gorman's sculptural and architectural mosaics in Mexico City.

Transparent mosaics

Here we encroach on stained glass, but the possibility of transparency in mosaic is worth considering as it is the same technique but using glass tesserae applied to transparent surfaces. The lighter colours of glass tesserae are at least translucent. If applied with a transparent adhesive to a glass base, they can then be viewed against the light.

To make a small panel, take a piece of plate glass (6mm [$\frac{1}{4}$in] thick). Draw your design on paper to actual size; it is then convenient to lay the glass over the design and work on the glass. Make sure the tesserae chosen are all reasonably transparent. Cut them in the usual way and stick them on to the plate glass using a clear adhesive – any of the resins will do. Single component adhesives taken straight from the one tube are easier to handle and do not involve mixing and estimating quantities for work periods. Leave narrow spaces around each tessera for grouting. The best grout is the black cement fondu obtainable as a sculpture material.

The finished panel should be framed in wood and can then be hung against the light in a window. The grouting takes on a similar function to the leading in stained glass and contributes a strong black line element to the design. The differentiating quality from stained glass will be the break-down into small units of the colour areas and the constructive use of these as in other mosaic techniques. If you want greater transparency you can use actual coloured transparent glass, but this will come in larger sheets and must first be cut down into manageable squares with a glass cutter before you can reduce it further with the usual mosaic nippers. If you choose to work in this way to a great extent, then manuals on

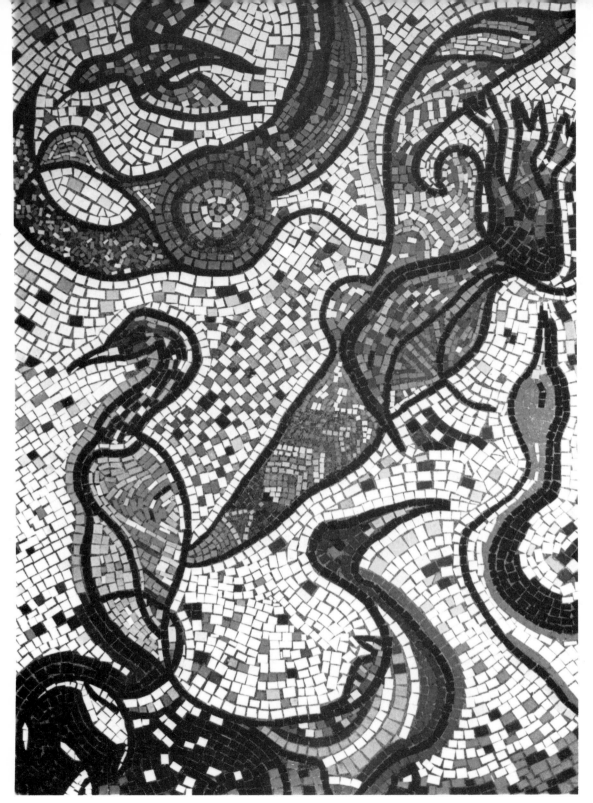

78 *'Flight and Birds': card and paper mosaic as group project with students*

stained glass should be consulted for techniques of special relevance.

Mirror mosaics

Some brilliant decorative effects can be achieved by using small fragments of mirror glass as tesserae. They can be introduced among coloured pieces to give special effects or sparkle (as with gold or silver), but an interesting experiment can be done by making up an entire surface with mirror fragments. Changes in size give variety, various opus styles can be used, and irregularities of angles in setting in direct method will give different lines of reflection. The scene in front of such a mosaic will appear much fragmented with the grouting lines permanently asserted showing the changing colour patterns of passing events.

Remarkable examples of this style are found in some of the Indian Moghul architecture. In fact, the technique has affinities with Islamic art and would be difficult to relate to anything except abstract patterning. The brilliance of effects can be seductive but there is scope for serious experiments.

Community mosaic

Not only can mosaic bring pieces of stone together, but it can also bring people together. It is possible in mosaic to divide labour and to work together in groups in ways which are much more difficult in other arts. From a two-person collaboration, a family mosaic, a school class mosaic, even a community mosaic – there are many ways of coming together and of dividing the work. For more details, refer back to pp.81–4.

Mosaics and education

There is a clear possibility for mosaic in the school art class, either as a collective project, as outlined above, or as separate pieces for children to complete in the same way as they might drawings or paintings. The manipulative qualities encouraged are excellent, and the sense of design in making decisions about colour, shape and texture can supplement other art work. The feeling of accomplishment in finishing the work by actually placing the last piece in the last gap has something of the satisfaction of the jigsaw puzzle. Care must be taken, however, to relate mosaic to the abilities of age groups or individuals. The process is slow. Sufficient concentration cannot always be maintained by young children for long periods. The nature of the work, size of tesserae, area to be covered and time available are all questions that must be considered before launching into the pleasure of handling the materials.

Given careful supervision and encouragement, school children of all ages can produce splendid mosaics.

Some varied themes

The maze

The systematic construction of maze design is ideal for mosaic. The making of the tracks to be followed by finger or by eye allows them to grow piece by piece. The mosaic spreads from the centre – the point of solution of the maze – so the making of it will be something of a puzzle in its own right. Figures 80–84 show some examples which present optical problems for solution. Apart from inviting us to 'do' the maze with the eye or the finger, the overall appearance is visually satisfying as a piece of ordered design. Even without being a puzzle to solve, a maze design can be an instantly satisfying assembly.

Traditionally, mazes were more than games; they had a spiritual significance, and testified to the mind penetrating into mysteries. In Roman mosaic they often referred to the archetypal labyrinth of King Minos, the centre having an image of the monster. Throughout history they have been made in various sizes – large ones to enter, walk about in and perhaps be bodily lost in, and small ones to gaze on and there experience the contemplative state. The structures have meaning and it is because of this that they have an arresting visual appeal. Like mosaic itself, they are essentially structures, so it is hardly surprising that maze design, conveniently executed in mosaic, will doubly appeal, satisfying eye and mind together.

79 *Classes in mosaics: children's class and Adult Education*

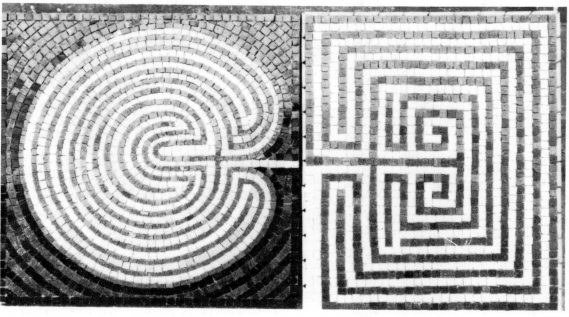

80 Patterns and mazes

81 *'Elephant and Mouse Maze': black and white ceramics*

82 'Maze Man'

83 *'The Chase and the Human Maze'*

84 *Maze based on floor maze from San Vitale, Ravenna*

The mandala

The mandala is a visual aid towards a contemplative state of mind. Its origin is generally taken to be in Eastern religions, but its occurrence as design and as a form in nature is universal. It is often regarded as a circular form but the essential character is one of having a single centre; squares and triangles can equally be utilised if constructed around a centre.

Apart from any mystical or psychological interpretations which such forms may have, they can provide a system of creative development for the designer and are especially suited to mosaic interpretation.

A single centre (in mosaic terms — one tessera) can be the start of a whole system of design. The size of the final piece is not limited except by the size of surface available. In its simplest terms,

85 *Mandala*
86 *Mandala*

87 *Mandala utilizing optical patterns*

you can place a round tessera at the centre of a square board. (The precise centre is easily located from the crossing of the diagonals.) Around this central pivot you can place an encircling ring of small oblong tesserae, and around the resulting circle another and another, and so on. You will have an area of growth which rapidly increases. You can introduce different colours – maybe concentric circles of alternate colours – even black and white.

Something resembling a target will soon result – visually arresting but perhaps too simple to sustain interest. However, this is only the start to what can become an involved process. Many variations in the rings can be accomplished by alternating and juxtaposing colours, and eventually you will arrive at a design 'problem' – that of accommodating your circular formation to the containing square. Four approximately triangular spaces will be left to be filled and here improvisation takes over. Triangular shapes can be introduced, even minor circles. The great advantage of mosaic for this purpose is its physical, tactile presence. You are forced into invention: to complete the piece you must make decisions. The process is a kind of design logic growing quite naturally out of the nature of the materials, the process which we have devised and your own ways of thinking.

You can invent innumerable mandalas with mosaic, and they can be as simple or as complex as you care to make them. You have at your disposal a wonderfully flexible system of producing satisfying decorative units. They are satisfying to carry out and nearly always satisfying to see when complete. Perhaps the process so

88 *Optical mandala*

89 *Mandala geometric: three-dimensional effects*

parallels systems of natural growth that our working method has become a kind of secondary nature. Likeness to natural forms – flowers, crystals, cellular structures – even atomic structure – is almost inescapable and you can make such references in your mandalas to whatever extent you wish, or you can retain the work at a purely abstract constructional level, perhaps leaving your viewers to discover their own metaphors.

The mandala is a vast world of ideas and possibilities and the mosaic process can manifest these most wonderfully. Any of the methods already described can be adapted for carrying out a mandala.

The spiral
Like the mandala, the spiral has important growth potential. As we have already seen, beginning with a single tessera you can advance a continuous line around its central point. Again, one has a spreading growth. Taking two lines outward from a starting area – perhaps made

124

90 *Mandala – 'Alpha & Omega'*

from a split circular tessera – gives you a double spiral for which two colours can be used (or, at its most basic, black and white).

Starting in this way, you will have a very strong centre of growth which can proceed as far as surface or your intention allows. The question then arises of how to terminate the process. You can eventually take the two tracks to different sides of the square and simply fill in space (opus tesselatum perhaps). With a four tracked spiral,

each track can terminate at one corner of a containing square. For oblong shapes, another way is more suited: you can link one spiral system to another so that the expansive development of one system goes off at a tangent to become the outer circle of another system and to then wind down to another centre. The evolutionary process becomes convolutionary. In this way you have a double centred design. Very complex designs can be made by having further linked systems.

The spiral system is another ideal organic method with mosaic. It is fascinating to carry out

91 *'Flight Metaphor'*

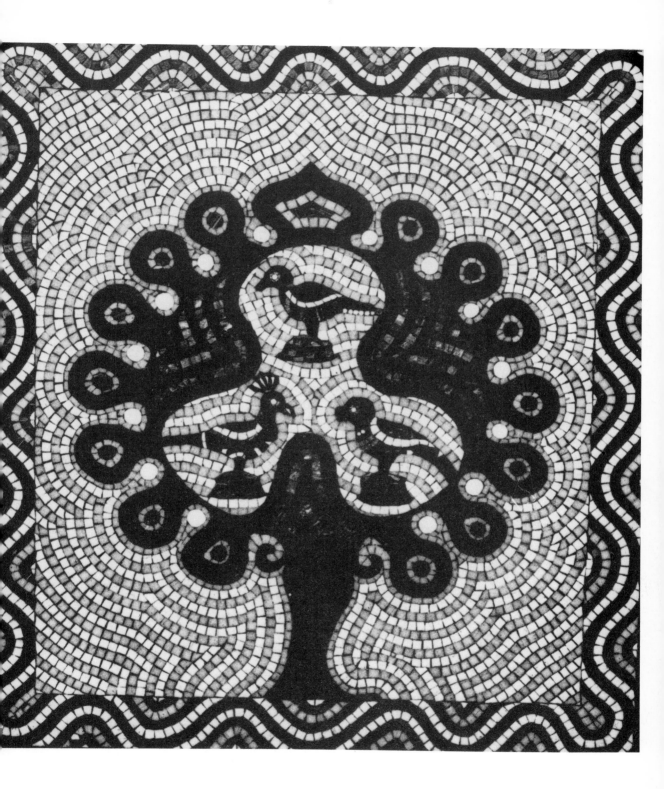

92 'Birds and Tree I'

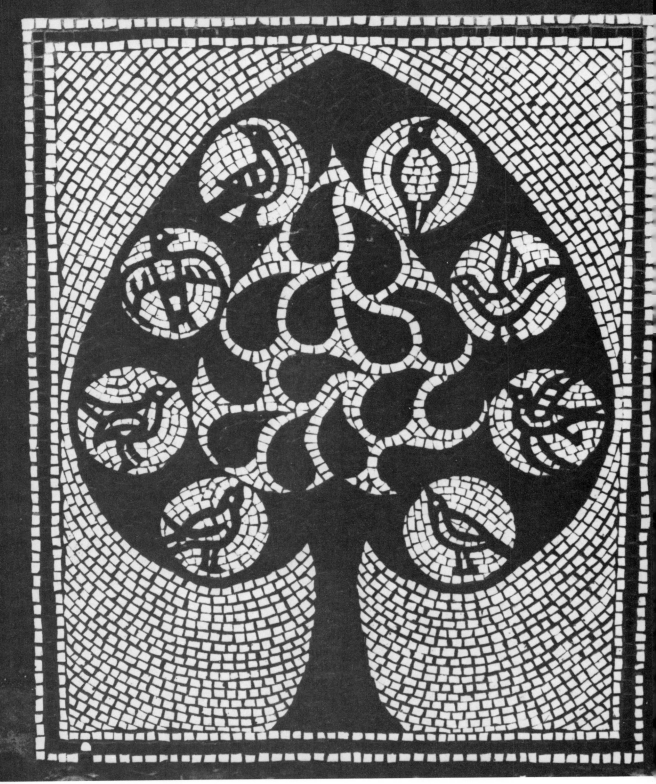

93 *'Birds and Tree II'*

and to view but is also structurally sound as a bonding means for tesserae. In fact, with it I have added to my own repertoire of opus styles: opus spiralatum.

Organic design and mosaic

The mandala and the spiral are two growth systems. Designs of these kinds can, of course, be done on paper and copied in mosaic, but they can also be methods of growth taking place through the handling of the material and through your own living developments as you work. In this way they become extremely satisfying and absorbing creative processes. While we may have a general idea of a result – we may have done paper work as a preliminary – the final result is determined by the process. Accidental effects may be incorporated in the form of slight colour variations of a random kind; improvisation can take place. There is a sense of freedom, yet this is within a system. These processes of mandala and spiral growth provide an ideal balance between a predetermined design and improvisation; the examples illustrated here will provide a better commentary than prolonged description.

94 *'Cat on Mat': hearth mosaic*

CHAPTER XI
Mosaics in history

A general outline

Europe and the Mediterranean

After practising mosaics, even to a small extent, you will develop a new eye for the work of others. The ancient examples come to life for you.

We began by considering historic examples as parallels with personal experiments in technique. We will return to history to examine some work more closely, but first let us survey the main periods of mosaic.

In the remote past, mosaic appears as a decorative art – the arranging of small pegs of clay on wall surfaces in Sumeria. In Egypt, fragments of coloured materials were incorporated into furniture and small objects, including jewellery. It is as pavements, however, that mosaics made their major contribution to architectural and decorative art. The Greeks were, perhaps, innovators, using pebbles and other natural stones and introducing, on occasions, metallic strips, but the Romans made mosaic a major form of architectural decoration. The Romans standardized methods and techniques and provided the basic terminology still in use today. In the main, Roman work was in natural stone but cut into regular cubes. Sometimes fired clay was used and, rarely, glass, for special effects. The use of cement mortars and concrete is also a Roman development. Though the basic technique was fairly standard throughout the Empire, some interesting vernacular variations occur where local materials and native skills interpret the prototypes from Rome. This happens in far out regions of the Empire like northern Britain and Morocco.

The Early Christian era saw a shift of mosaics from floors to walls, with the subjects becoming

95 *Sketch of black and white Roman mosaics:*
a) *head in the black and white (Ostia) style;* **b)** *dog from Pompeii incorporating letters* CAVE CANEM – *beware of the dog*

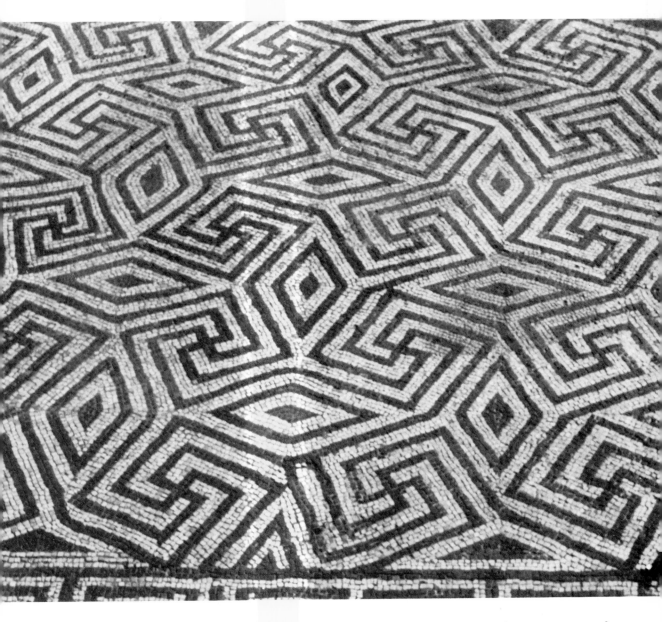

96 *Roman pavement: abstract interlacing patterns in black and white marble, in pavement at Ostia*

more humanized. The earliest known portrait of Christ is in mosaic. It is from a fourth-century Romano-British site and is now in the British Museum. The character of the Jesus of the Gospels infuses Roman gods in several examples, notably in the Galla Placidia Mausoleum at Ravenna. Roman formality relaxes into some of the finest examples of the art in early Christian times. Colours and techniques become almost impressionist.

In the fourth century, church interiors were extensively covered by mosaics. Domes became special features, often containing images of Christ in glory. The Byzantine Empire is the second great period for mosaics. They became conspicuous ecclesiastical features as icons. The

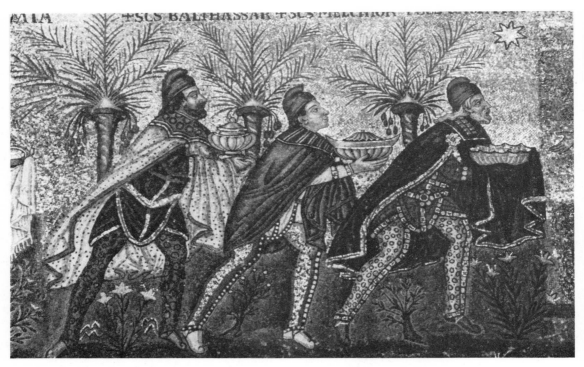

97 *The richly ornate mosaics of Ravenna from the church of S Apollinaire Nuovo:* **a)** *the Three Kings;* **b)** *procession of Holy Virgins, sixth century* AD

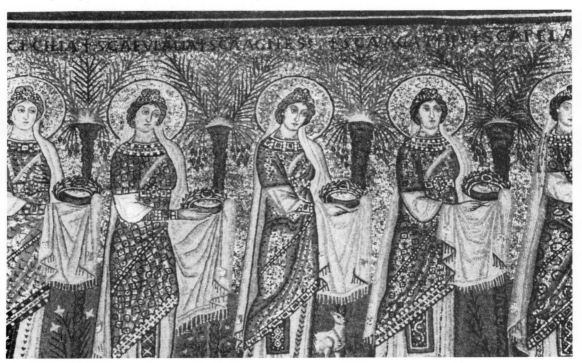

icon is a meditational aid, the viewer being actively involved in creating a state of adoration, not for the material object but for what the object represents.

In the Byzantine period, mosaic reflects a hierarchical system – both divine and human. The naturalism of late Roman work was replaced by symbolism, and the use of gold became a significant element in a transcendental spirituality. Colours were increasingly manufactured and used like pigments. This is a possible origin of the smalti, still uniquely made in the same region. Mosaics were almost all on walls or vaults, and they were executed *in situ*, being embedded in wall plaster, not cement. The direct method of hand placing, in what must often have been difficult positions in buildings' such as domes and vaulting, gave a ruggedness to surfaces causing the light to reflect in many directions – hence the sparkle of many Byzantine mosaics.

The advent of large-scale fresco painting in church decoration led to a decline in mosaic. Fresco was cheaper and easier to produce. Perhaps it was originally a cheap substitute for mosaic, but the ease and freedom of drawing which it brought is often viewed in broad surveys of art history as artistic liberation. It is seen as a great step in the direction of naturalism. The 'stiff', patterned figures of the Byzantine mosaics did loosen into life under the brush of Giotto, but today, in our age of liberation and experimentation, we may see the freedom of the brush, particularly in the service of realism, as a questionable gain.

The move from mosaic to fresco also brought the divorce of art from craft and a new hierarchy of artistic values. Again, with the hindsight of modernism, we may find the art/craft split false and be ready to accept all media as aids to expression, without wanting to give them labels of creditable approval. Our concept today of the artist embraces the use of all techniques. We are now in a time of rediscovery. The Renaissance liberated the artist from the status of a simple craftsman learning through apprenticeship to the role of originator; but the mosaicist was left behind with the status of workman copyist. Mosaic, in so far as it continued at all, was a medium for reproducing painters' work. This notion has persisted even into the twentieth century. Major modern artists, including Picasso, have had works copied in mosaic.

Recent interest in crafts and the rediscovery of

98 *Ancient Mexican mosaic: a human skull partly covered in turquoise mosaic (uncertain date), British Museum – Museum of Mankind*

their potential as creative media can reinstate the mosaicist as artist. The person who thinks out the design, who cuts and sets the pieces and who carries the whole work through from idea to finish can be one and the same person. The mosaicist is an artist in this special medium, as the sculptor is artist in clay, metal or wood.

Central American mosaics

A notable alternative tradition to the European is the Mexican. Mosaic technique in its broadest sense – the application of fragmentary units to a surface – is a part of Mexican art. It is not used to convey images, nor to express systematic ornamental patterns, but more to embellish three-dimensional forms. Unlike the tesserae of the Romans, the units are flat and plate-like, often of precious material like turquoise. Their main

function was to cover masks used in religious ceremonies, and so correspondence to the human face is important, but as literal following of surface rather than as representation. This involves intricate fitting of the pieces but not the systematic identities of opus styles.

Mosaics also occur in Peru, where they were used as decorative surfaces on secular jewellery.

A somewhat macabre sculptural base for mosaic is the human skull used in Mexico as a ritual object. The image of the skull often occurs in Mexican art and in modern times has been used by the mural painter Diego Rivera.

What do we learn from history?

The origins of mosaic being so ancient, we have much to look back to. The person who practises any art will look at masterly examples with a keen eye. Having done even a little mosaic, you will look at an ancient example and feel as though you were making it yourself. You will look through the images to the way they have been built, piece by piece. This will be an intimate reading of the work giving great enjoyment and satisfaction.

The result of this understanding is a feedback into practice. A careful scrutiny of, for example, a fine Roman piece will bring you to an understanding of the work and a rapport with anonymous hands some 2000 years ago. Two likely courses of action result. One is to make an actual measured copy from the original – usually by way of a good large photograph which will show each single tessera. The other is to do what is known as a pastiche. This means doing a work in a style which you have thoroughly understood and absorbed but doing it as if it were an original new piece – making a piece which a Roman mosaicist might have made but did not.

Copying is certainly a good discipline. You will really come to know the selected model, and you will have learnt care and accuracy in cutting tesserae to correspond with the original. Strictly speaking, the work should be the same size as the original, the materials the same (e.g. marble for marble) and the technique the same (e.g. hammer and hardie rather than nippers) and, as far as possible, similar mortars used. It should be possible, with care, to make a piece closely resembling an original model – a result which in itself may seem worthwhile, though for the artist it is a means to an end – the end of acquiring skill.

This way of learning is still basic to the Italian academies. On grounds of thoroughness it is hard to fault it, yet it is out of keeping with contemporary ways of art study in the Western world.

The way of the pastiche combines a deep observation and understanding of traditional methods with original design. It is demanding – you will have to think of 'typical' themes without reference to actual models. You will, in fact, be reviving the whole process of mosaic, the way of thinking as well as the way of using the tools. There need be no exact correspondence in size, and even materials and techniques can be used in a more interpretative way, bringing them into line with modern conditions. There will be no sharp line of demarcation between a passive learning process and your 'own' personal work. Your own themes and ideas will grow quite naturally from a background of tradition and personal attitudes. A style of your own will most likely establish itself from this situation.

The way of pastiche is not submission to ready-made processes, and it was the way of the major artists in their early years (Michelangelo, Rembrandt, Turner, Picasso – to name a few whose work has absorbed much from predecessors).

The way of the copyist is more the way of the craftsperson. Ideally one should try all ways. An actual copied piece will certainly help in acquiring skill. Pastiche will help ideas to grow and enable you to 'think' in mosaic, rather than simply to use it as a reproduction medium, and even to reproduce your own designs.

Why should we not ignore historic examples and simply reinvent the whole art in our own terms? This is, in fact, not so simple as it might seem. Most people are stimulated to do things by seeing existing examples, mosaic being no exception. It is better, therefore, to use experience constructively, to learn from examples, but also to develop from them.

Roman mosaic is the easiest to learn from since the technique is restrained, the colour range small and the various styles more or less consistent. Roman work, as we have seen, has established the basis of later mosaic practice. Surfaces approximate to a flat plane, and there are no textural variations in surface to be concerned with, as in Byzantine work.

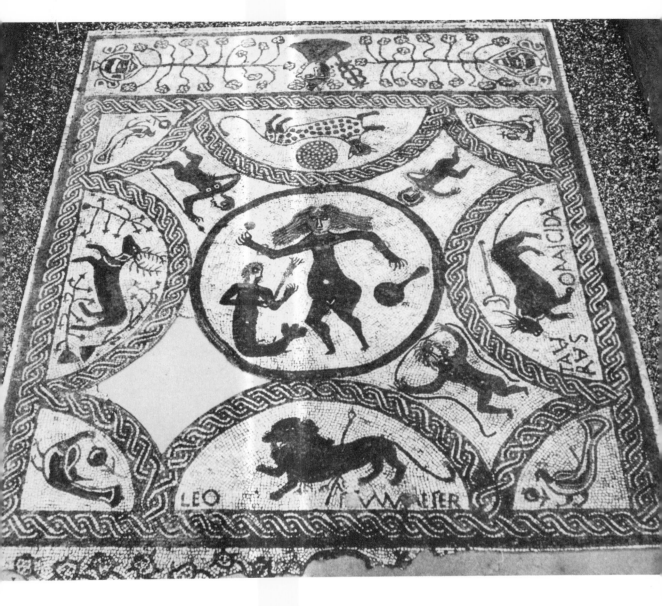

99 *The 'Venus' mosaic, Rudston Villa, Hull Archaeological Museum*

The image and the ornament

Roman mosaics frequently divide into sections: a central panel, called the emblema, and a surrounding framework of pattern. The emblema is usually an image, a head or animal or still-life; the surround is an abstract pattern sometimes involving complex systems for interlocking colours and shapes – the knot, the key pattern or other

regulating idea. The whole mosaic becomes an assembly of representation and invention.

Emblema often involve more intricate work and each conception was probably a unique creation; the borders tend to standardization, many being repeated, perhaps with local variations according to the skills of the workmen. The emblema were no doubt the work of masters

135

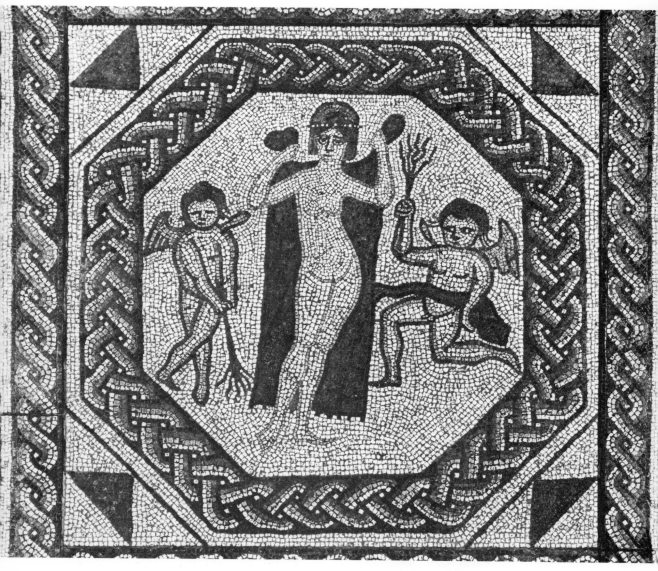

100 *'Venus' from the 'Dido and Aeneas Mosaic',*
Somerset County Museum, Taunton

working on pieces in the workshop and taking
them to the site where they were finished; the
borders were most likely done *in situ* in a more
routine craftsman-like way.

The composition of the total mosaic embraces
what in modern terms we might call the figura-
tive and the abstract. In this respect they still
have contemporary relevance and present an
ideally comprehensive art of assemblage.

Mosaics and realism

After much insistence on the pattern of tesserae
and the abstract qualities of structure and
colour, it may seem a big step to consider mosaic
as a medium of realism. None the less, there are
some early examples which demonstrate a re-
markable potential for realistic effects.

A Roman work of the second century AD, now
in the Capitolino Museum in Rome, could almost
be mistaken for an oil painting. To achieve the
painterly, or even photographic effect, the tes-
serae must be small and the range of colours and

shades considerable. Given these conditions, the tesserae can be matched to a design that was most likely produced first in sketch form with paint; the final result can be built up rather like a painting of the pointillist kind – point by point.

If the tesserae are marble, or other relatively soft materials, it is possible to grind and polish the surface to a smoothness that eliminates all textural qualities. One is left with a smooth dematerialized impression – just the characteristic admired by advocates of realism in painting.

This kind of mosaic is certainly impressive as an achievement but it is arguable that it is defeating the purpose of mosaic practice. In

Roman times it may have provided a resemblance to reality greater than was possible even by painting. Pictorial mosaic, as distinct from patterns for pavements, was probably the most representational art after sculpture. To make pictures of cherries so life-like that the birds would pick them was the criterion of some arts.

Today, when realism is available through sophisticated painting processes or photography, we set less store on achieving it laboriously through craft techniques. We prefer to see the nature of the material we use rather than to conceal it. Artists are more likely to use a medium or technique for its intrinsic qualities than as a means to an end. Perhaps more than ever before, the special and unique creative potential of any medium can be realized, and hence we can reinvestigate the ancient techniques without

101 *Roman mosaic in realist style: Museo Capitolino, Rome*

102 *'The Unswept Floor'. Detail from a Roman floor from the second century* AD *in the Vatican Museum. This detail shows a mouse with a walnut against a plain background. The surrounding line of tesserae has been emphasized to show how it goes around both the objects and their shadows – even the shadow of the mouse's tail*

feeling bound by historicism. Birds pecking at the cherries of art is no longer the ultimate in critical acclaim.

The possibility of realism, then, is something which we can freely accept or reject without attaching special virtues to it.

Realism and the trompe l'oeil

An extreme example of realism is the attempt to deceive the eye into actually registering as real the art image. This is not so much the province of mosaic, although there are examples of it which provide a fascinating reflection on life in Roman times. Notable examples are the pieces known as 'the unswept floors'. Here the kind of things that revellers at a feast might drop on the floor are actually depicted in mosaic to perpetuate the memory in a floor never to be swept clean. There are fish bones and nut shells and, in one notable example, a little mouse who has come out to nibble at a nut.

The micro-mosaic

Closely allied to realism is the so-called micro-mosaic – in fact the use of minute tesserae is a prerequisite of realist illusion.

The micro-mosaic is one which reduces the size of the tesserae – perhaps to the limits of hand-crafting. It will necessitate the use of tweezers for placing and perhaps a magnifying glass for seeing. The result, when viewed at a distance, will be one of overall colour effects, the structural patterns being hard to distinguish. In other ways it need not be different from any other mosaic.

Examples highlighting extremes of possibility raise interesting questions. To what extent is the admiration of mosaics based on recognition of the difficulties being overcome? To what extent are we admiring sheer skill? Every mosaicist is familiar with certain questions and exclamations: 'How long does it take?', 'What patience you must have!'. Most of us will treat these with amusement, since few of us know exactly how long we take over a piece and we are not usually aware of patience or of work as a kind of self-inflicted punishment. Even less are we likely to know how many tesserae a mosaic contains! Like all artists, the mosaicist becomes totally absorbed in the work and, perhaps more than most artists, finds obsessive attraction in working.

Mosaic, then, is not a display of endurance or a perverse fascination with difficulty. We must

differentiate between genuine aesthetic pleasure and a simple praise for skill as reward for hours of toil.

Mosaics and modernism

Mosaic method can be seen to have much similarity with certain painting techniques – the use of little dabs of colour in impressionism, the division of complex colours into components and their use in regular touches in pointillism. Paint

103 *'Community': detail from exterior mural. The grid pattern of opus regulatum has been utilized to suggest architectural forms in harmony with an urban environment; Community Centre, Hull, Humberside*

in such usage is often mosaic-like, but the reference to mosaic is only analogous.

Because of an early and very complete development, mosaic has been dogged through recent history by the heritage of antiquity; its contemporary practice is seen too often as mere revivalism. While similarities of paint application to mosaic have often been noted, painters have rarely turned to mosaic itself as a medium for original creation.

Victorian revivalism included mosaics in church decoration, sometimes incongruously in neo-Gothic architecture. Painters like Burne Jones used mosaics, but again as a medium for reproduction. Perhaps a certain richness resulted from the eclectic and expansive taste in Victorian mosaics (as with stained glass) as, for example, in the domes of St Paul's Cathedral.

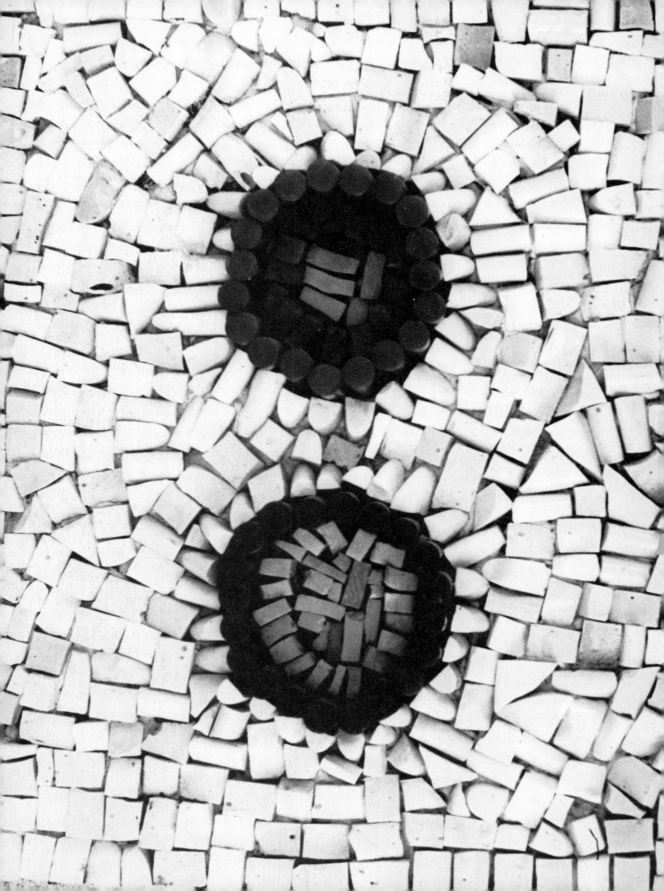

Geography, as well as history, limited mosaic, and it is seen as an Italian medium. Great traditions of mosaic have certainly been maintained in Italy, and families of Italian mosaicists have migrated across the world, frequently being employed in the execution of the designs of others.

Some eminent artists – Picasso, Braque, Leger – have contributed designs to mosaics. The modern artist who took mosaic most seriously as a creative medium was Gino Severini – another Italian. In an important lecture on mosaics, published in Ravenna in 1952, Severini attempted to link ancient and modern. Later conferences in Ravenna, notably in 1959, brought together many distinguished artists. Afro, Campigli and Capogrossi were among the modern painters whose work was rendered in mosaic. However, the work was still largely carried out by mosaic specialists according to the painters' designs; a direct use of the material by the artists was rare.

In spite of this European revival and an upsurge of interest in America in the 1950s and 1960s, the medium has remained largely one of reproduction, of folk-like decoration, or do-it-yourself home decor.

Juan O'Gorman in Mexico has produced perhaps the largest example of modern mosaic to stem from an individual creative talent linked to public service. His exterior for the library of University City, Mexico, is a *tour de force* of mosaic decoration. O'Gorman succeeds in using the creative energy of a modern artist to integrate divergent concerns of modernism – the individual talent, social demands, traditional iconography, and innovation – things which many modern movements have failed to connect.

The creative revolution in art, stemming from the post-First World War re-think of art with its social and educational obligation, did promise great possibilities. The new schools and academies of Russia in the early 'twenties, and the Bauhaus in Germany, had far-reaching effects in art and design. Mosaic, as such, was not a medium used by them, but many experimental constructions with widely varying materials were carried out; the technique of collage was much employed both to encourage new looking at materials and to stimulate ideas by unexpected 'accidentals' or unconscious juxtapositions. At first, mosaic seems too loaded with tradition to appeal to the experimenter or revolutionary, but in its simple principle of assembly from standard units it is basic to creative thinking. Mosaic procedure is, in fact, an ideal medium for educational use and one which can embody many notions of modern movements. It has now, as it had at other periods of history, an adaptability to prevailing styles. It is my belief that it can also be the origin of new thinking rather than just a convenient vehicle for ideas originating in painting or sculpture. Surprisingly, this has not yet happened to the extent which it might.

A modern experiment

A notable attempt to relate mosaic to modern movements was that of Jeanne Reynal in America in the 'fifties. Her work should be seen in the context of abstract expressionism and action painting – a time when the spontaneous act and the accident were much in use by painters. Reynal scattered tesserae into wet cement in a random way. Something of the free and direct expression of her contemporaries in painting was achieved – the scattered tesserae taking the place of the dripped, dribbled or thrown paint. With so much innovation in the arts, this technique was perfectly acceptable and was perhaps an almost inevitable experiment to make; but, while the free use of paint extended the possibilities of the painting – the liquid properties of the material were part of its nature anyway – the scattering of tesserae is quite foreign to the nature of mosaic technique and, consequently, experiments such as those of Reynal simply produced a terazzo-like decorative surface. Too much of the essential structuring of mosaic was lost for there to be a true advance in the use of the medium.

Mosaics in modern art

Mosaic as an art medium can respond to any style. Some of the masters of modern art movements have designed for mosaic or had paintings executed in mosaic. This, however, is not very different from the use of mosaic as a reproductive medium in post-Renaissance times. A mosaic version of a Picasso can be made just as a Raphael can be translated into mosaic. Can the medium originate style through its own innate characteristics?

104 *'Fleur du Mal' (detail) low relief formation in mixed material*

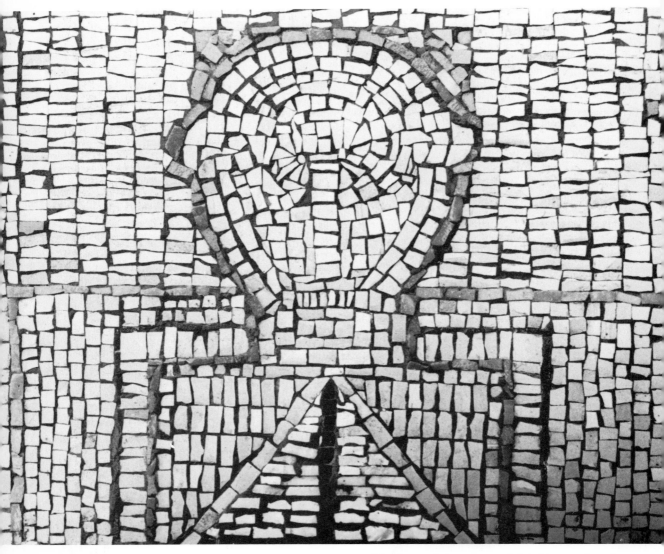

105 *Sanctuary 1*

An aim of this book has been a clarification of the processes of mosaic so that they can be used creatively by individuals. For this reason, a copyist approach has not been adopted, although it has been shown that much is to be learnt from the past. What is to be taken from the past is the spirit so that it can live again in the particular circumstances of our own time. The simple basic method has been stressed because, by understanding the method, one can develop ideas within this. The process itself will be instrumental in determining ways of thinking and seeing. In this way the handling of mosaic material is ideally suited to modern thinking in art. The medium and the image are intimately connected – indeed are one. The exploratory and experimental methods of modern art education can be projected into mosaic because it has a tactile simplicity and a direct effect on the imagination. It has a capacity for suggesting images while remaining so obviously itself.

The modern concern with the nature of the medium as well as the message it may encapsulate is nowhere better fulfilled than in mosaic, where process, abstract values, systems and

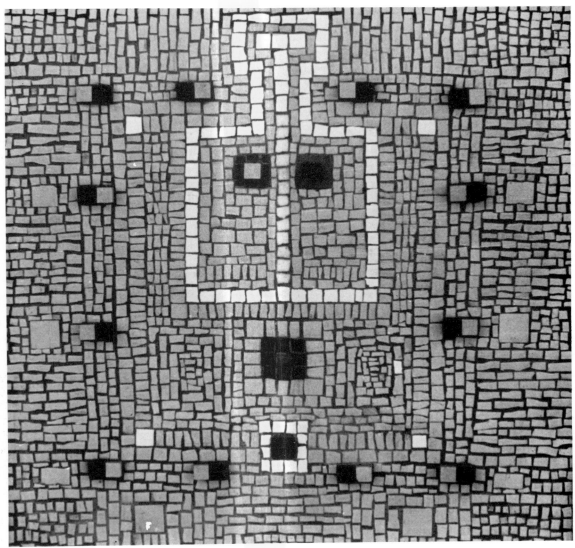

106 *Sanctuary 2: ceramic tesserae and low relief marble cubes*

possible imagery can all coalesce. Searching questions of modernism on the nature of illusion and the relationship of dimensions to flatness of surface, are highlighted by mosaic every bit as much as by brush marks on canvas. Perhaps a great bonus for mosaic is its social acceptance. Mosaic as a material is widely liked and therefore easily acceptable in public places. It is robust, stands up well to exposure and does not require the museum's warning of 'do not touch'.

Within modern art, with its current aesthetic, psychological and social considerations, mosaic can have an important place. To give it this place, and perhaps to go some way towards the universality it must have enjoyed in Roman times, we must work from within through understanding, not through imitation; we must release creative energy through using the process and making it a natural outlet.

Mosaic is a special medium uniquely suited to creative experiment. It is the basic additive structural process of nature. We make it in the way that many structures have been formed on the level of chemistry, biology, or human building – adding piece to piece to make something bigger

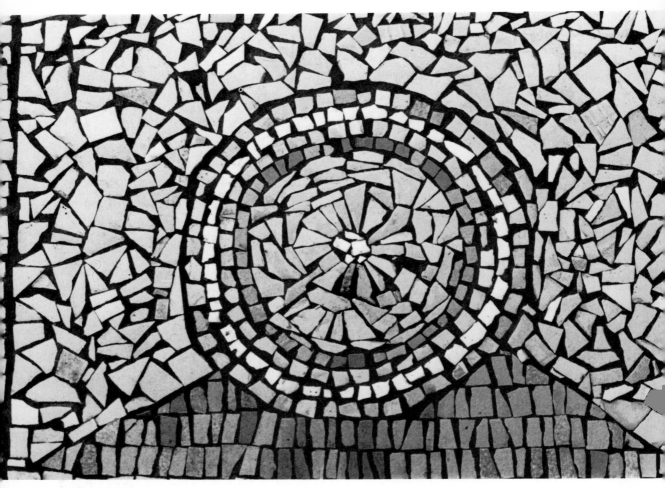

107 *Yantra*

than the parts. The opus styles are not just decorative preferences – they relate to primary creative processes. The use of the spiral and the linkage to the mandala are extensions for mosaic style which open vast territories of meaning. These are not esoteric, but are embodied in physical properties and simple skills.

An updating of the mosaic process can also be an updating of many unfulfilled ambitions of modern art.

Towards a philosophy of mosaic

Mosaic is a simple craft, predominantly involving processes of physical construction; yet, in its simplicity, it can become an all-involving way of life. It will take up much of your time, you will have to live through the process of making, and you and others will have to live with the results. It can become something of an obsession, and the time you give to it is likely to increase.

In the same way that many aspects of our world can be interpreted at two levels – one more superficial and generalized, the other more enquiring and philosophical – so mosaic can be regarded simply as an enjoyable method of creating designs, or as a creative art form with its own hidden meanings and effects on our lives.

Art and life – making and meaning

Mosaic, like painting, sculpting, writing poems, making music and many other activities, has a way of being a life parallel. It is more than a simple skill to be turned off when you walk away from it. You will develop a way of seeing things as mosaics, as painters might mentally interpret what they see into brush marks. You will become selective through understanding the process, and build up your own anthology of mosaic images. The process itself has a compelling fascination. Its additive nature, though slow, is sure and obvious. A piece in progress looks different after every day of work and, hour by hour, you will see growth. Something is growing

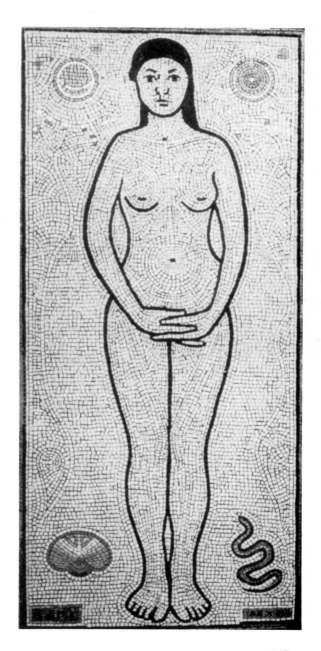

108 'Ella': black and white, life-size figure. Colour has been minimized to use directional lines fully. The lines within the body are closely based on anatomical structure; those in the background give spatial echoes of the silhouette. Poetic metaphors and symbols are also present in the structural patterns, e.g. the navel is a central structure point for the tesserae which takes on a mandala-like formation with its appropriately far-reaching symbolism

109 *'Ella' detail: the head*

110 *'Ella' detail: the body*

with your life, like a plant, like a child, like time itself. It is in this sense that I have called it a parallel life. Yet for all its poetic dimensions, it is physically real and solid.

During the periods of working, and particularly as your movements become automatic and unconscious through habit, you will have time to think. You will still have to concentrate on the work – mistakes are easily made – but the degree of concentration is such that it is also (paradoxically) relaxing. The rhythm of work is such as to promote a balance between focused concentration and mind expansion. Thus a condition of doing and mental awareness of a special kind

may make the activity particularly attractive within the daily routine of living. Perhaps certain times of the day can be set aside for mosaic work.

As you have seen already, activity will also stimulate interest in other works. You will have an eye for mosaics. Ancient work in the museums will be a new experience and maybe journeys to distant sites will add extra meaning to holidays.

In short, doing mosaics will not be confined within your working place or working time. You will be involved with it and, as with any art, it becomes an ingredient of life. Symbolically, mosaic is integration; it is literally a putting together of fragments to constitute a whole. The

146

word is often used metaphorically in this sense — 'the mosaic of history', 'the mosaic of society' etc. On a personal level we may consider life as a mosaic — not only the bits of stone we put together in the hope of making a whole, but the abundant stream of apparently isolated experiences must come into unity as a whole life. A philosophy of mosaic must see mosaic as a central meaning: it is a 'way' as all art is.

Warnings

If doing mosaics becomes as important for you as this, some warnings should also be noted.

Firstly, being obsessive, mosaic can be addictive. You may find you can hardly bear to leave it alone. This is fine if you are looking for all-consuming dedication; if you are not, you can still do mosaic but you will have to watch and control your time.

An unfinished piece in the house is always an invitation to add the next little piece (and the next, and the next . . .) until the last tessera is placed with both relief and regret, and the next work can be started.

The second warning follows from the first, but can be more acutely felt. Because of the temptation to do ever more, and because the activity confines you physically to certain postures, severe tension in parts of the body can result. You are holding positions for long periods and, because of obsessive interest in what you are doing, you are not aware of the strain. This happens particularly with horizontal work done on a table top where a leaning posture may be held continuously. The work is not physically demanding so you notice nothing at the time; the next day it may hit you with severe pains in the back or shoulders. At one time, after being smitten by such a condition and when a doctor was mystified by possible causes, I diagnosed a new ailment which I called 'mosaicist's back'. Its discovery is a painful experience but, once the cause is known, the result is easily avoidable.

You must work rhythmically in a way which incorporates relaxation as well as tension. The cracking of a tessera is a moment of tension. When it has occurred, allow the muscles to relax, if only briefly. In this way tension, relaxation and balance are built into a sequence. Anyone who does yoga will understand this need, and to relate mosaic practice to yoga, t'ai chi, or many other mind-body integrators currently being explored,

can have excellent all-round results. If mosaic is practised as a therapy, considerations of this kind are essential.

Not only must we learn the simple practical skills — we must learn to relate them to life. The sequence of cutting and placing tesserae has an interplay of tension and relaxation. A parallel body process is breathing, where inhalation and exhalation are essentially opposite but related components of a complete cycle. If we can match a working process to the ever-present, vital process of the breath, we can integrate action and thought. Breathing is the obvious rhythmic tempo to which to relate.

Inspiration

Inspiration is a word often avoided by professionals in art. It is either taken for granted or thought to be a vague romantic notion, the consideration of which takes attention from the real serious business of work.

None the less, we are sometimes aware of specially favourable periods of working and specially felicitous results. It may be worthwhile enquiring if there is any precise and practical meaning for this word.

The reason for its avoidance is its seeming sloppiness and possibly embarrassing suggestion of a dependence on factors beyond our control — on something coming to us from outside. To a professional and guarantor of excellence, such a suggestion may be unacceptable, but there are practitioners in all arts who will admit to a sense of the work seeming to take on a life of its own — a feeling that we are simply the vehicle through which things happen. Without this condition acquiring mystical connotations, we may simply be entering a state of very high and automatic efficiency where all things, mental and physical, are operating harmoniously — in fact a totally integrated experience from which the work is the by-product. A condition of this kind is generally considered to be highly desirable and the resulting work is said to be 'inspired'. Yet, paradoxically, it stems from a non-assertiveness on our part: other qualities have in some way flowed into the work by not being blocked, rather than by being deliberately put there.

Although the neglected psychology of inspiration is beyond my scope, it is certainly worth looking at ways in which the condition may come

111 *'Flight': a garden panel*

about. Today the idea of waiting for inspiration to come to us does not find favour. If the condition has distinct psychological identity, it is something that comes about more through work than by any passive waiting for wonderful ideas. Whatever inspiration may consist of, there is general agreement that it is only a part of one's processes – that work of a routine order constitutes most of what we do. Mosaic is an extreme case to consider because the slowness of the process makes us very much aware of what happens at every stage. Sudden spontaneous expressions, such as might happen with a paint brush, are impossible. We proceed in a conscious manner piece by piece – certainly the tortoise of art, not the hare.

This slowness allows design to mature as we carry it through. The selection and placing of every single tessera is a conscious act – any careless placing soon loses the structural flow. A kind of concentration is encouraged by mosaic but it is also a relaxed condition in which our thoughts are not wholly occupied. Music may be an ideal accompaniment to work, engaging some of our attention and leaving some free. Radio, tape and disc may find their way into studio equipment. I have enjoyed many musical performances while working on mosaics and sometimes, even long after, recall the actual music in looking at the finished piece. Certain states of mind become associated with the mosaic activity and it is perhaps these that constitute a psychological dimension to work – a dimension which is close to what is called inspiration. In my view inspiration is a genuine recognizable state but it

149

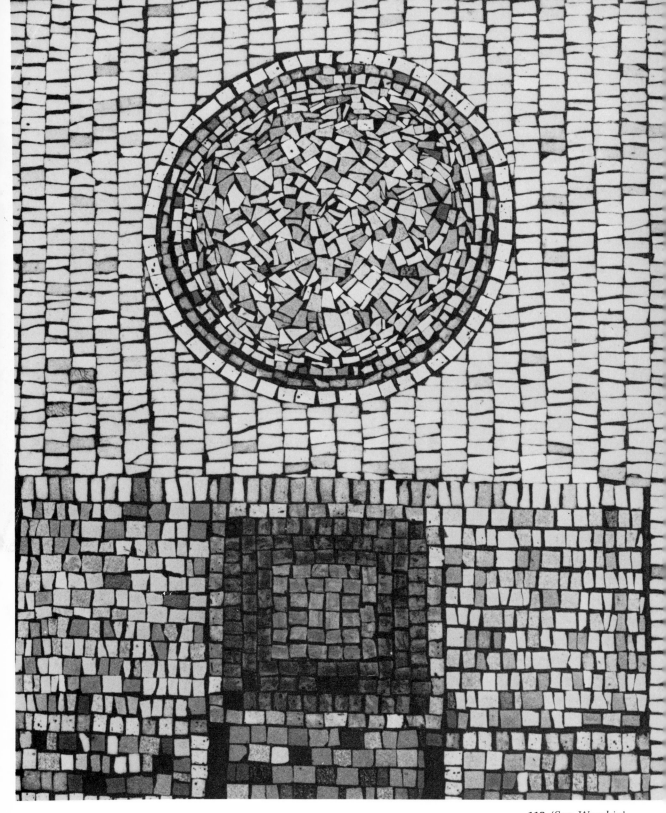

112 *'Sun Worship'*

113 *'Bodhisattva': a garden panel*

is generated through work and the conditions of work. It is not a detached immaterial vision which precedes the work.

And so the way to inspiration is through right conditions of working. This brings me to the only really important 'rules' in any art. They are to make a start, to persevere and be attentive. Do not wait for ideas; start work and ideas will grow through working.

Mosaic and the muses again

It seems we are back with the muses. We began seeing a possible origin of the word 'mosaic': it was a link with the Greek work for the muse. Perhaps that is a true and accurate word for this activity, involving us in so much physical work, yet linking this with thoughts and ideas beyond stones and cement.

If you have never worked in mosaic and are now tempted to try it, I am sure you will find it is not only a learning and practice of skills, but liberation for the imagination which will become a major influence in your life.

Mosaic and the surface

Is mosaic just a good decorative finish for other things such as walls and floors? It was 'rediscovered' by architects and promoted by commercial mosaic firms for this function in modern

151

114 *Back to basics: nursery murals*

115 *Back to basics: structure patterns*

times, and there seemed to be a brief mosaic renaissance in the 'fifties and 'sixties. The production of standard glass tesserae, mainly in Italy, provided a ready supply of material, and the use of brown paper backing resulted in a kind of exterior wallpapering. Vast areas of buildings have been covered in this way. Regrettably, much of this 'movement' was not accompanied by any real understanding of colour in relationship to space and form. Artists, who might have helped,

were rarely called in and much of what set out to be an enlivening of concrete modernism often finished up as monotonous application of meaningless pattern. It is important to see form, function and decoration as a whole, otherwise mosaic is simply the cosmetics of design and, paradoxically, can dull rather than brighten.

The same warning can be taken on the small scale. Any possible surface might be covered in mosaic. Kits of ready-made patterns can be bought at the home improvement shops. There have been mosaics on bottles, lamp-shades, table mats — all manner of mis-shapen pieces of

'modernist' design. Much of this has come and gone, and, hopefully, we are left with a clearer view, and a genuine reappraisal and up-dating of mosaic.

My purpose is to stimulate the practice of mosaic. Proliferation is welcomed, but you will gain more from doing mosaics by referring back to the simple basics of design in function and decoration and by understanding some of the great Roman and Byzantine 'classics', or the exotic Mexican or Asian examples, or by studying the great developments in modern art. Decoration goes deeper than surface application. This is not to imply that there is some elitist education in design to be acquired before you can do good work; on the contrary, I suggest that good work will result from an awakening of our own creative impulses. The learning of simple practical processes through mosaic is a way of initiating unlimited possibilities. The source of this energy is ourselves: it is stimulated and externalized by the physical material and process of mosaic; it is guided by the great traditions from history. The results of it all are actual pieces of work, each unpredictable and unique.

Mosaic is a simple technique. If you have grasped the processes set down in this book in their broad principles, you are equipped for work. The rest is application and invention. The ultimate quality of your work will result from you more than from lists of materials or recipes. As in all education, the awakening is the important part — all else follows. Mosaic is a creative process analogous with natural processes. Master the simple basics, make a start, persevere, allow things to happen . . . and who knows what results will follow?

116 *'Footprint and Mandala': floor piece as welcome sign*

Glossary

Andamento The way a mosaic goes or flows. The coursing of the tesserae into structural or rhythmic patterns.

Cartoon A full-size drawing done in preparation for the final work. Can be placed over the base or wall and either traced over or pricked through to transfer the design.

Cement 1. Calcined limestone, a fine powder which, when mixed with water, slowly sets to rock-like hardness. Often known as Portland cement.
2. The word is also generally used for the paste made of the above with sand and used for setting the tesserae. More correctly this should be called mortar.

Ceramic mosaics Commercially produced small square ceramic tiles. Good range of colours. Best if the colour is in the final body of the clay – not just surface glaze presented only by one face.

Collage The sticking down of flat material onto a picture or the total use of such material to make pictures. An important aspect of the history of modern art. Mosaic can have similarities with collage, when broken tiles, crockery, etc. take the place of the more usual paper, fabric, etc.

Concrete Cement mixed with coarse aggregate such as pebbles, rock fragments and/or coarse sands.

Cosmati A form of floor decoration in which pieces of cut marble are assembled in geometric patterns around circular units. Not strictly speaking mosaic but having affinities through materials and methods.

Emblema The central panel of a Roman mosaic. Usually the most highly worked part. Often pictorial, contrasting with surrounding abstract patterns.

Gesso Gypsum with adhesive used as a ground in painting. Can be used as setting for small tesserae.

Gold and silver Metallic leaf embedded in glass squares which can be used as tesserae.

Grout The cement or mortar rubbed into the cracks between the tesserae.

Hardie and hammer A chisel fixed in heavy rigid support, point upwards. Tesserae are cut or trimmed by being held against this point while being struck by a chisel edge hammer.

Hydrochloric acid Diluted, this acid is used for cleaning the surface of a mosaic when marked with cement scum. Sometimes called 'muriatic acid' because it is used for cleaning walls. Must never exceed in strength 1 part acid to four parts water.

Icon Simply an image but in a special sense a contemplative object. Usually has visually engaging qualities such as the frontal gaze from a holy face to induce an intimate perceptual relationship between object and observer. Because of its static 'timeless' quality, mosaic is particularly suited to icons, as in Byzantine Art.

Japanese nippers Pincers or cutters with spring loaded handles for instant opening on release of hand pressure.

Key patterns Patterns with interlocking mutually dependent components. Like keys in locks. Much used in Roman art as running borders.

Lime Slaked lime or calcium hydroxide. Can be used in mortars for greater smoothness and slower setting. Alkaline before setting and can be corrosive.

Mandala A symmetrical, single-centred form used as a focus for attention in meditation. A feature in Indo-Buddhist arts. Suited to interpretation in mosaics as it allows for orderly structuring of tesserae around a centre. Can involve free improvisation in western modern practice.

Marble Crystalline form of calcium carbonate. A traditional material for mosaic tesserae. Found in a range of colours (e.g. white, black, green, pink) also veined and mottled. Capable of being ground and polished to a fine surface.

Micro-mosaics Work using very small tesserae. The opus patterns are not obtrusive and the

overall colour effect resembles painting.

Mortar Cement, sand and water mixed to a stiff paste. Sometimes lime is added for slower setting. Lime and sand only is a slow setting mortar now superseded by cement mixtures.

Naïve art Art produced by untutored or self-taught individuals in whom the will to make is predominant. The direct simplicity and decisive nature of mosaic makes it suited to such non-academic use. Some remarkable examples, sometimes of great size and ingenuity, exist; often collage-type mosaic, using broken scrap material and natural sources (e.g. pebbles and shells).

Nylon mesh A mesh made of fibres enclosed in nylon. It is used for transferring tesserae which are stuck onto it to the wall or site. The mesh becomes incorporated in the cement bed.

'Op' art A style of modern painting which utilizes the dazzle or optical effect of sharply contrasting elements (often black and white) in flat patterns. Great similarity with the use of tesserae in mosaic. 'Op' art compositions are ideal for translation into mosaic. Mosaic itself is a kind of optical art utilizing the effect of small units on the field of vision.

Opus Term used to designate a way of working in mosaic or a style (Latin *opus* – a work) as below.

Opus musivum The curving lines of opus vermiculatum used over the entire picture-image and background. The most expressive painter-like opus.

Opus palladianum The use of irregular shaped tesserae fitted together according to their shapes; like miniature crazy-paving.

Opus regulatum Laying of tessera in a regular grid pattern of verticals and horizontals; like tile setting.

Opus sectile The cutting and placing of pieces of stone or other material to correspond to areas of the picture. Sometimes quite large areas. Really a kind of stone inlay.

Opus tesselatum The placing of tesserae in orderly straight lines (usually horizontal). Bonding similar to brick laying. Usually for backgrounds and infilling.

Opus vermiculatum The following of the lines of image or design by the tesserae. The lines of tesserae curve to follow the drawing in worm-like way (Latin *vermis* – worm).

Ostia style Style used in the old Roman city of Ostia. Entirely black and white marble with very simple but highly suggestive modelling of figures and animals.

Pigments Additives to cements to change colour. Can be natural materials like fine sand or earth pigments as used in painting, but a good range of proprietary brand special cement colourants is available.

Plaster Plaster of Paris as used in sculpture and dental work. When mixed with water, sets rapidly to solid bulk. Liquid and pourable before setting and can be useful in reverse method fixing of tesserae.

Plasticine A non-setting modelling material. Useful as temporary setting bed in double reverse method.

Pointillism (or divisionism) A derivative of impressionist painting in which the total colour effect is achieved by juxtaposing very small brush marks (points or dots of colour) instead of mixing the colour. Colour is an optical effect. Much relevance to mosaic as a similar and parallel effect in painting.

'River' A running together of lines of grouting into one continuous line resembling a crack. Visually unpleasant and a sign of unsatisfactory bonding. To be avoided.

Silicone paper Paper impregnated with silicone and anti-adhesive, placed underneath nylon mesh in the mesh support technique to prevent adhesion.

Sinopia The drawing done directly onto the ground or support to be covered over by the cement and tesserae. Traditionally done with red earth pigment mainly as under drawing for fresco. The word is from Sinope, a region in Asia Minor where the pigment occurs naturally.

Smalti Melted opaque glass, set into flat cakes and then broken by hand into small rectangular blocks. Marketed in this form. Uniquely Italian, notable for its great colour range and brilliance.

Stucco A form of hard plaster used in architectural moulding. Can also be used as a 'cement' for setting tesserae. Stucco duro is a particularly hard version sometimes incorporating hair as a reinforcer.

Terrazzo Floor decoration in which a random collection of coloured stone chips is mixed with cement and poured into place. On setting, the surface is ground smooth to reveal the chips as a random colour pattern. Not a true mosaic. Much used in modern floor surfaces.

Tesserae The pieces used in mosaic. Strictly speaking cubes (Latin *tessera* – a cube) but the

word used generally for all small pieces.

Trompe l'oeil Eye-deceiving effects. Extreme naturalism making images indistinguishable from 'real' objects. Surprisingly, this is possible with mosaic.

Vitreous mosaics Commercial mosaics produced as small glass squares. Excellent range of colours.

Bibliography

ANTHONY, G.W. *A History of Mosaics* Boston 1935

BERRY, J. *Making Mosaics* Studio Vista, London 1966

BULL, B. *Mosaics: The Secret Tools and Techniques* Triton Books, London 1976

CLARKE, J.R. *Roman Black and White Figural Mosaics* New York University Press 1979

Encyclopedia of World Art Volume IX 'Mosaics' McGraw Hill, New York 1963

FISCHER, P. *Mosaic, History and Technique* McGraw Hill, New York 1971

GRABAR, A. *Byzantine Painting* Skira, Geneva 1953

GRABAR, A. *Greek Mosaics of the Byzantine Period* UNESCO London 1964

HASWELL, J.M. *Mosaics* Thames and Hudson 1973

HENDRICKSON, E. *Mosaics: Hobby and Art* Elek, New York 1957

HETHERINGTON, P. *Mosaics* Hamlyn 1967

HUTTON, H. *Mosaic Making* Batsford, London–New York 1966

JENKINS, L. and MILLS, B. *The Art of Mosaic Making* Princeton 1957

LAUPPI, W. *Mosaics with Natural Stones* Sterling, New York 1974

LOVOOS, J. and PARAMORE, F. *Modern Mosaic Techniques* Watson-Guptill, New York 1967

L'ORANGE, H.P. and NORDHAGEN *Mosaics – From Antiquity to the Early Middle Ages* Oslo 1958. English translation Methuen 1966

POWELL, H. *Pottery and Mosaics* Blandford Press, London 1965

REYNAL, J. *et al. The Mosaics of Jeanne Reynal* October House Inc., New York 1964

ROSSI, F. *Mosaics, a Survey of their History and Technique* Milan 1968, English translation, Pall Mall Press, London 1970

SEVERINI, G. 'Mosaico e Arte Muralle nell'antiquita e nei tempi moderni' in *Felix Ravenna LX* (1952) pp.21–32.

STRIBLING, M.L. *Mosaic Techniques – New Aspects of Fragmented Design* Crown Publishers Inc., New York 1966

UNGER, H. *Practical Mosaics* Studio Vista, London 1965

WILLIAMSON, R. *Mosaics, Design, Construction and Assembly* Lockwood, London, New York 1963

YOUNG, J.L. *Mosaics: Principles and Practice* Rheinhold, New York 1963.

Stockists of mosaic materials

Many materials useful to the mosaicist are standard products for building and home repairs and are obtainable from suppliers found in any region. These include such things as cement, sand, plaster, adhesives, plywood and tools. Tile merchants often stock square 20mm ($\frac{3}{4}$in) ceramic and glass pieces papered as wall cladding. They frequently have damaged or broken tiles for disposal which are useful for scrap projects. For the special materials of the mosaicist you have to search further. Below is a list of some stockists.

UK

Paul Fricker Ltd, Well Park, Willey's Avenue, Exeter, Devon

Elder Reed & Co. Ltd, 105 Battersea High Street, London SW11

Proctor & Lavender Mosaics Ltd, Solihull, Warwickshire

Edgar Udny & Co. Ltd, 83 Bondway, Vauxhall, London SW8

USA

F.E. Beigert Co. Inc., 4801 Lemmon Avenue, Dallas, Texas

Dillon Tile Supply Co., 252–12th Street, San Francisco 3, California

The Mosaic Shop, 3522 Boulevard of the Allies, Pittsburgh 13, Pa.

Leo Popper & Sons Inc., 143–147 Franklin Street, New York, NY 10013

Index